Decorative Textiles from Arab & Islamic Cultures

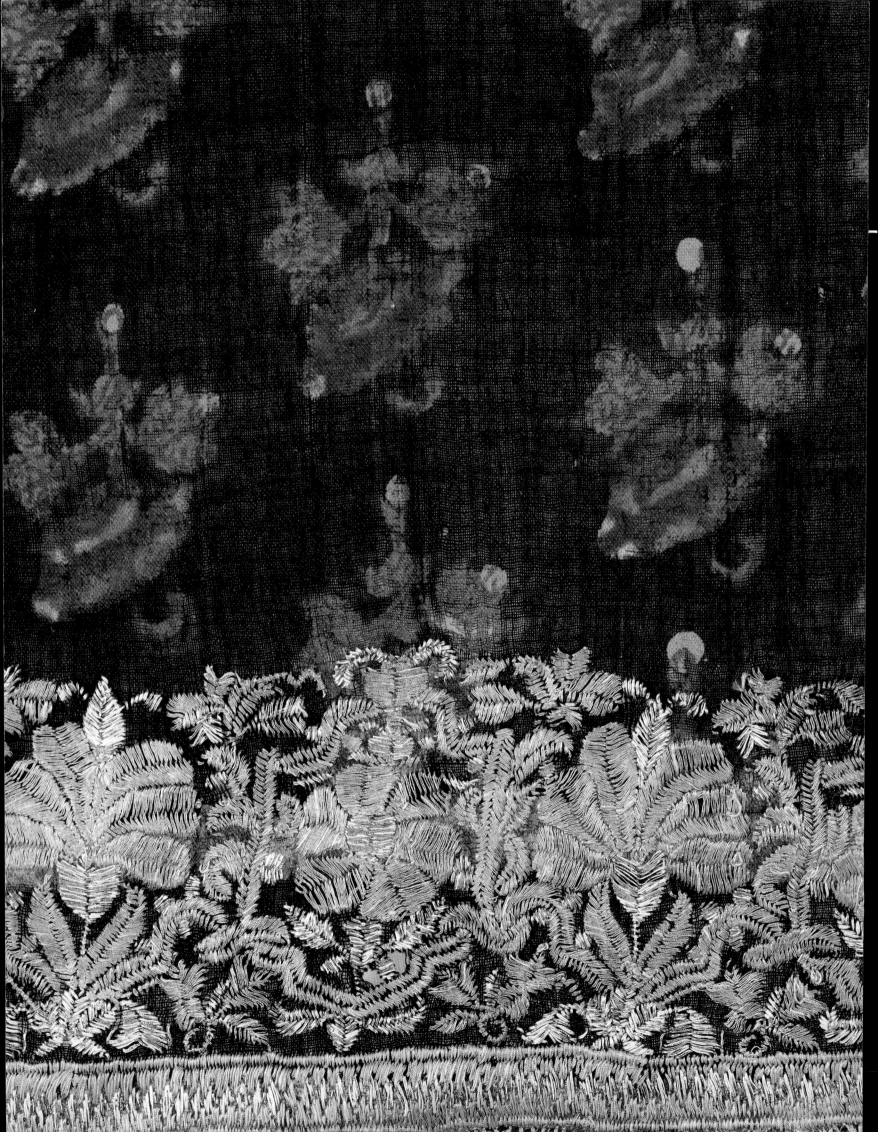

Decorative Textiles from Arab & Islamic Cultures

Selected works from the Al Lulwa Collection

Text by Jennifer Wearden

Al Lulwa Collection

The term *al lulwa* in Arabic means a pearl. The pearl is the most valuable and precious gem and ornament in Arab culture and notably in the Arabian Gulf. It is the name of my late grandmother Shaikha Lulwa Nasser Mubarak Al Sabah, a woman of admirable vision and insight. This collection is a tribute to her.

Altaf S. Al Sabah

In support of the revival of craft traditions in the Arab world

Text and images © Al Lulwa Collection/ Altaf Al Sabah
Texts © Jennifer Scarce and Jennifer Wearden

ISBN 978 1 907372 87 2 (PB EDITION)
ISBN 978 1 907372 95 7 (HB EDITION)

British Library Cataloguing in Publication Data

A catalogue record for this book is available from the British Library

Produced by Paul Holberton publishing
89 Borough High Street, London SE1 1NL
www.paul-holberton.net

Designed by Heather Bowen

Map and diagrams by ML Design
Photography by Stephanie McGehee
Arabic calligraphy by Jasser AlShammari

Printing by die Keure, Bruges

FRONT COVER: Detail of no. 33
FRONTISPIECE: Detail of no. 13
PAGE 6: Detail of no. 52
PAGE 22: Detail of no. 27
PAGE 84: Detail of no. 33
PAGE 134: Detail of no. 48
PAGE 178: Detail of no. 73

Contents

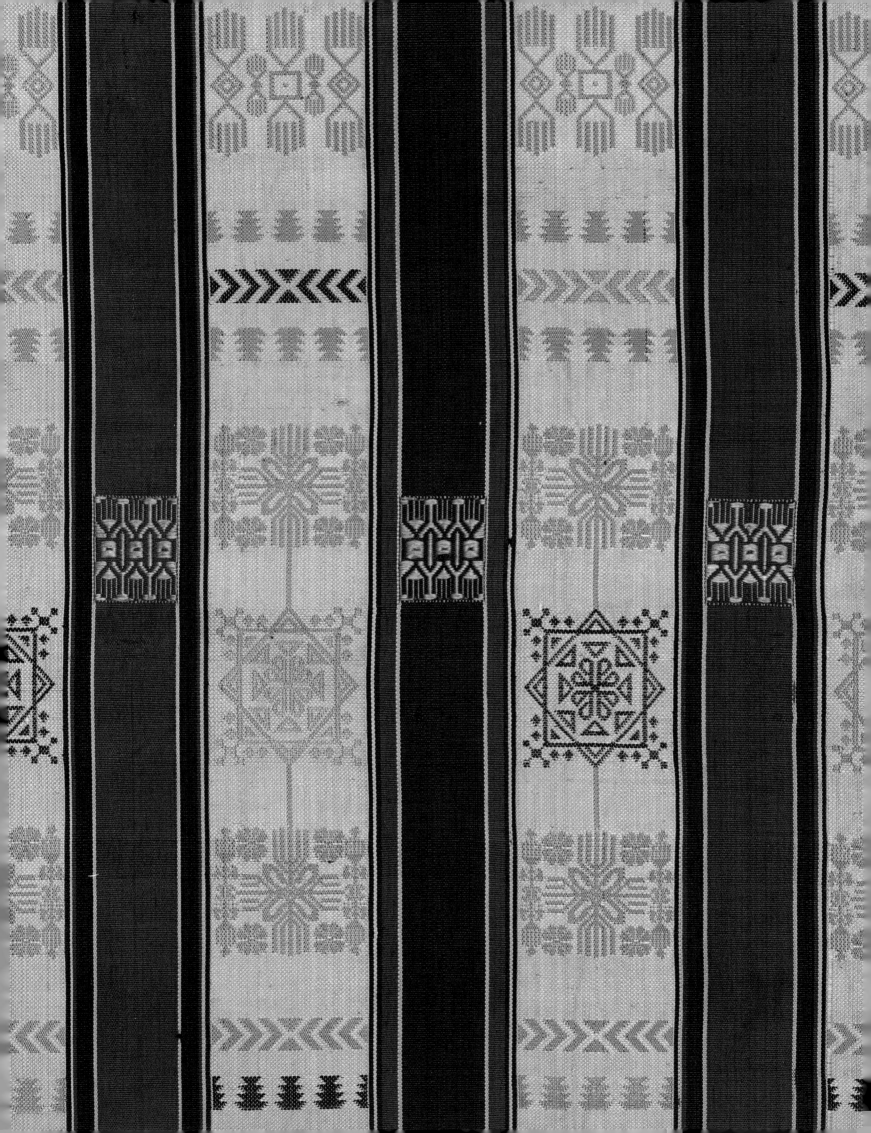

Preface

"All crafts are customs and colours of a civilization"
Ibn Khaldun, *Al muqaddimah*

In the early 1980s, I began the acquisition and assemblage of a personal dossier of traditional decorative textiles and embroideries originating in the Arabian Peninsula, the Middle East, North Africa, Iran and India. They include ceremonial as well as everyday domestic textiles and embroideries, often connected with birth, marriage and death. They range from printed textiles, dye-patterned cottons, brocades, velvets to silk embroideries. The acquisition started as an act of joy and learning guided by my eyes, steered by my heart. I loved wearing my traditional *thoubs*, Kashmiri shawls, Palestinian, Egyptian and Ottoman dresses. Many of the weavings and embroideries hang blissfully on the walls of my home.

In the light of the rapid vanishing of many craft traditions in the Arab and Islamic world in general, and the slow extinction of many of the fine hand skills related to traditional textiles and embroideries in particular, I thought it relevant to showcase some notable pieces of late Islamic decorative textile arts to be enjoyed and appreciated today as they were in the past.

As a researcher and writer in material culture and traditional arts, I support the preservation of all relevant evidence attributed to a culture, past and present, in particular the preservation of craft traditions and all their interconnected moral and intellectual values of ingenuity, diligence, creativity and skill.

This past wisdom and insight, these "colours of a civilization", I believe can be of benefit to contemporary creative expression, cultural understanding and exchange.

Altaf S. Al Sabah
Kuwait, 2015

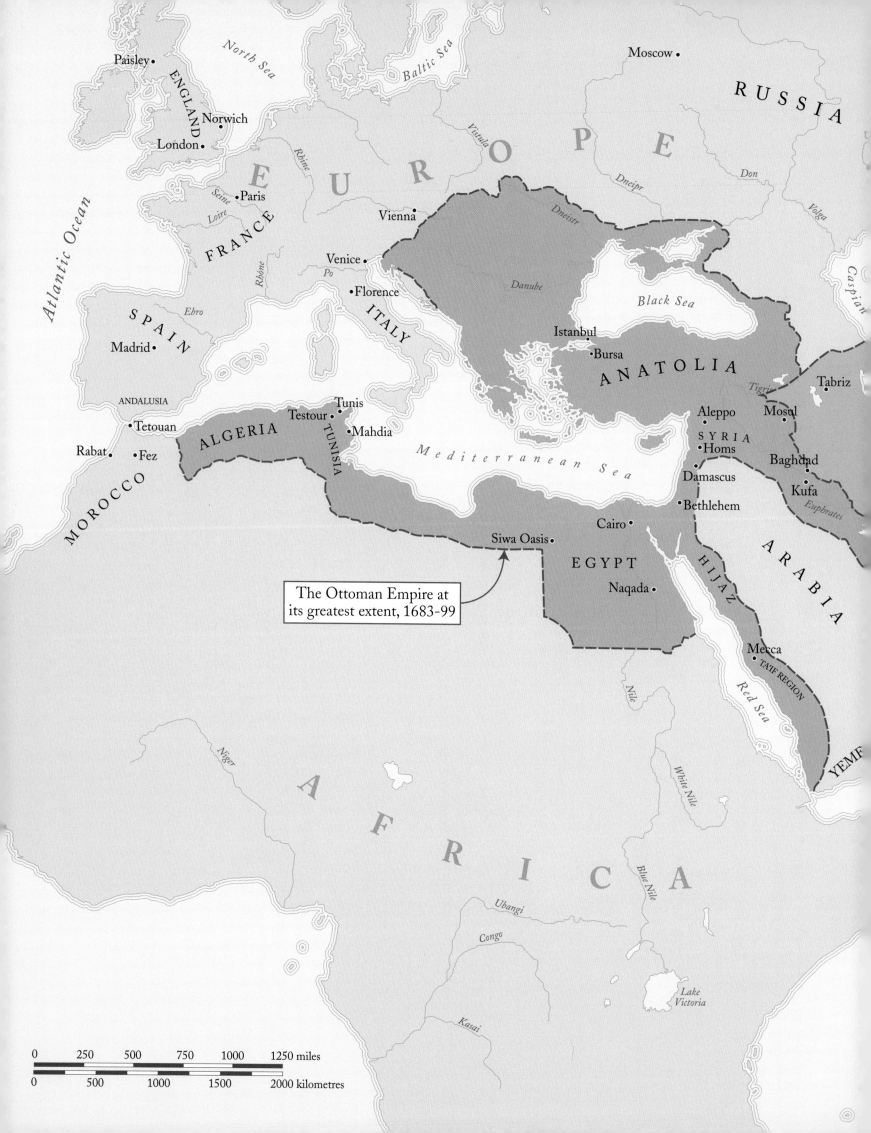

Paisley •

North Sea

Baltic Sea

Moscow •

RUSSIA

ENGLAND

Norwich •

London •

E U R O P E E

Rhine

Vistula

Dneiper

Don

Atlantic Ocean

Seine

• Paris

Vienna •

Dneistr

Volga

FRANCE

Loire

Rhône

Venice •

Danube

Black Sea

Caspian

Po

• Florence

SPAIN

Ebro

ITALY

Istanbul •

• Bursa

ANATOLIA

Tigris

• Tabriz

Madrid •

Aleppo •

Mosul •

ANDALUSIA

Tunis •

Testour •

SYRIA

• Tetouan

ALGERIA

• Mahdia

Mediterranean Sea

• Homs

Baghdad •

Rabat •

• Fez

TUNISIA

Damascus •

Kufa •

Euphrates

MOROCCO

• Bethlehem

Cairo •

ARABIA

Siwa Oasis •

The Ottoman Empire at
its greatest extent, 1683-99

EGYPT

HIJAZ

Naqada •

Niger

AFRICA

Mecca •

TA'IF REGION

Nile

Red Sea

YEMEN

White Nile

Blue Nile

Ubangi

Congo

Kasai

Lake
Victoria

| 0 | 250 | 500 | 750 | 1000 | 1250 miles |

| 0 | 500 | 1000 | 1500 | 2000 kilometres |

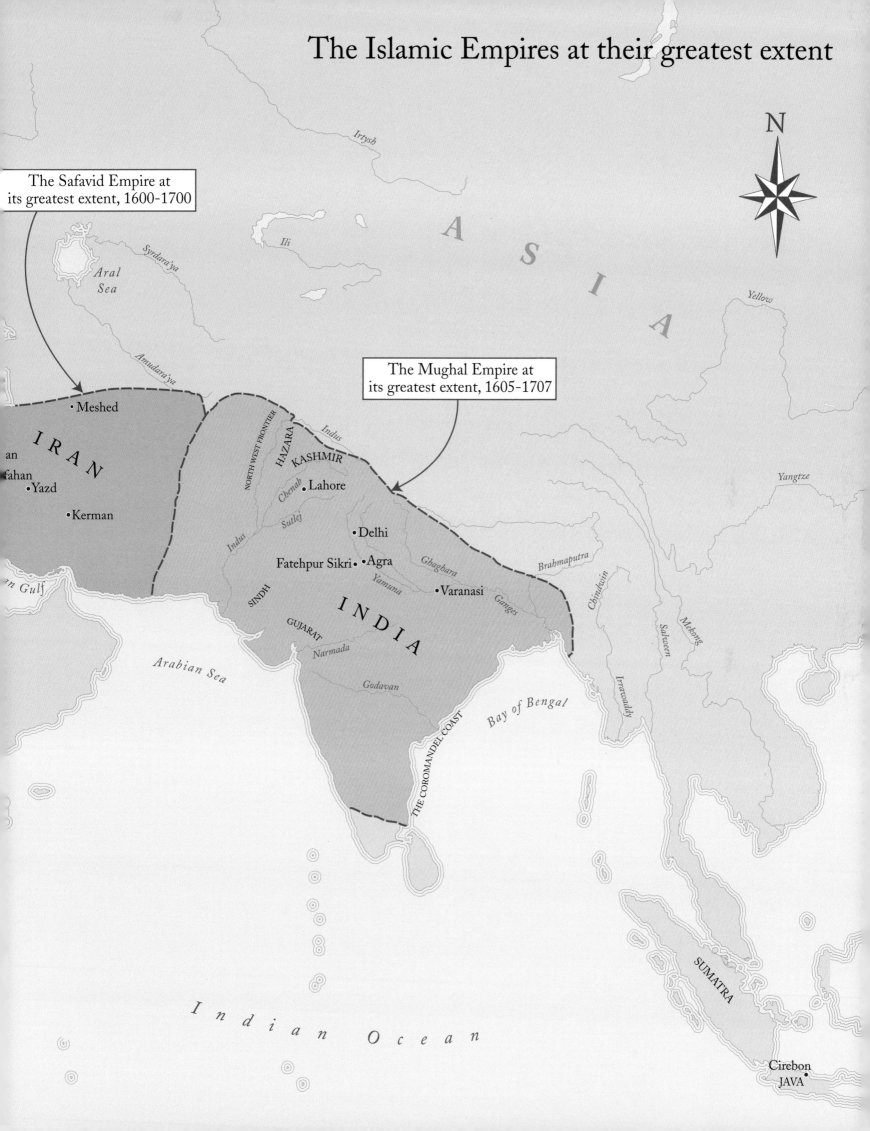

The Islamic Empires at their greatest extent

N

The Safavid Empire at its greatest extent, 1600-1700

The Mughal Empire at its greatest extent, 1605-1707

A S I A

Irtysh

Ili

Yellow

*Aral
Sea*

Syrdara'ya

Amudara'ya

Yangtze

• Meshed

IRAN

an

fahan

• Yazd

• Kerman

NORTH WEST FRONTIER

HAZARA

KASHMIR

Indus

Chenab

• Lahore

Sutlej

Indus

• Delhi

Fatehpur Sikri • Agra

Yamuna

Ghaghara

Brahmaputra

Chindwin

Ganges

• Varanasi

an Gulf

SINDH

GUJARAT

INDIA

Narmada

Godavan

Salween

Mekong

Irrawaddy

Arabian Sea

THE COROMANDEL COAST

Bay of Bengal

I n d i a n O c e a n

SUMATRA

Cirebon •
JAVA

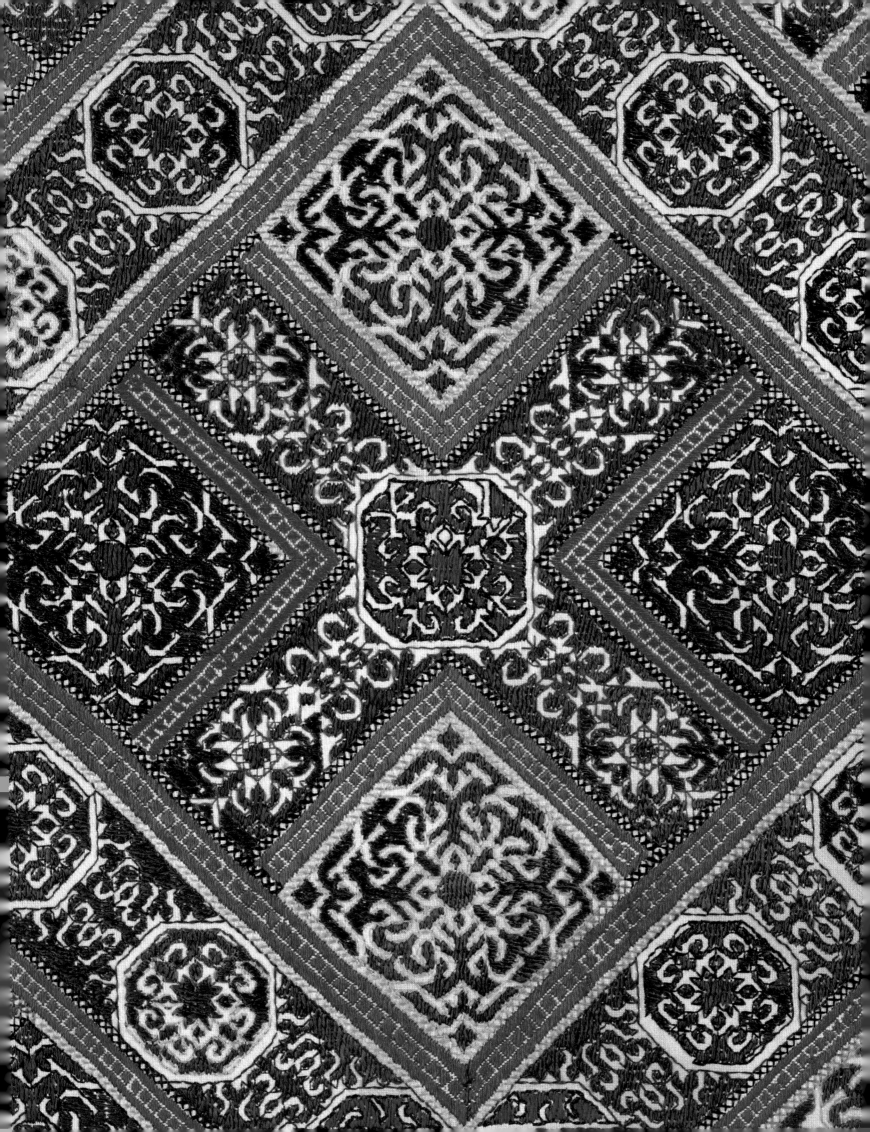

Introduction

Textiles are flexible, versatile and adaptable, not least because they are the product of an impressive range of materials – cotton, wool, silk, linen, camel and goat hair – and of techniques – weaving, knotting, plaiting, interlacing and felting – which create many types of texture. Complementary techniques, such as the use of natural and mineral dyes in many tones and shades of colour, or supplementary weaves in metallic threads to create luxurious brocades, or embroidery in a range of threads and stitches, or appliqués of contrasting fabrics, gold and silver plaques, beads of glass or coral, pearls and gemstones enrich them still further.

These resources, incorporating the legacy of the pre-classical, classical and non-classical cultures of the Middle East and the Mediterranean, contributed to the formation of the rich vocabulary of design which became the outstanding feature of Islamic textiles. Abstract, figural, geometric and foliate motifs were composed into complex patterns which, when worked into fine silk brocades and velvets, were valued for their role in the subtleties of court ceremonial and fashion. These textiles were also much admired beyond the Islamic lands. Their heritage reaches back well over a thousand years, even though their very high perishability means that for the earlier part of the tradition our knowledge is reliant very largely on written sources. These, however, attest to the superb quality and quantity of textiles at the courts of the period.

In the year AD 917 after years of antagonism between the Christian Byzantine state and the Islamic Caliphates of the Ummayads in Damascus and the Abbasids in Baghdad, Zoe, Dowager Empress of Byzantium, sent an embassy to Baghdad to negotiate an armistice. When the Greek ambassadors, John Rhadinos and Michael Toxaras, arrived at the court of the Caliph Ja'far al-Muqtadir (ruled 908–29), they received a sumptuous reception so memorable for luxurious ceremonial that contemporary Arab descriptions were collected and recorded later by the historian Al-Khatib al-Baghdadi (1002–1071). Here is the account of Abu Muhammad, grandson of Caliph al-Muqtadir:

> The number of hangings in the Palaces of the Caliph was thirty-eight thousand. These were curtains of gold – of brocade embroidered with gold – all magnificently figured with representations of drinking vessels, and with elephants and horses, camels, lions and birds. There were long curtains, both plain and figured, of the sort made at Basinna [in Khuzistan], in Armenia, at Wasit [on the river Tigris], and Bahasna [near the Greek frontier]; also embroideries of Dabik [on the Egyptian sea-coast] to the number of thirty-eight thousand; while of the curtains that were of gold brocade, as before described, these were numbered at twelve thousand and five hundred. The number of the carpets and mats of the kinds made at Jahrum and Darabjird [in Fars] and at Ad-Dawrak [in Khuzistan] was twenty-two thousand pieces; these were laid in the corridors and courts, being

OPPOSITE
Woman's shawl
(detail of no. 32)
Cotton embroidered
with floss silk
North West Frontier,
Hazara region,
20th century
INV.66

spread under the feet of the nobles, and the Greek envoys walked over such carpets all the way from the limit of the new Official Gate right to the presence of the Caliph – but this number did not include the fine rugs in the chambers and halls of assembly, of the manufacture of Tabaristan and Dabik, spread over all the other carpets, and these were not to be trodden with the feet.

Abu Muhammad continues his description with the escorted tour of the two Greeks through many lavishly decorated apartments staffed by beautifully dressed courtiers and attendants.

The account is remarkable not least because the only decorations and furnishings mentioned are the vast numbers of textiles; there is no evidence quoted of wood or metal fixtures. The textiles are varied – shimmering plain and figured silk brocades, embroidered pieces, carpets, mats, rugs – and their origins from Armenia, Egypt, Iran and Iraq indicate the resources available to the Abbasid caliphs. At their capital Baghdad they were successors of the Zoroastrian rulers of Sassanian Iran (224–651), whose territories extended to Syria, Iraq and Central Asia and who had reigned from their capital of Ctesiphon (on the Tigris, near Baghdad) since 226 in "the most magnificent palace ever built" according to the Arab geographer Ibn Khurradadhbih, writing in 864. Textiles were essential to their elaborate court ceremonial – textiles such as the legendary carpet, the so-called 'Spring of Khosrau', which the Arabs had found in the palace in 642, during their campaigns into Iraq and Iran. They marvelled at its design of a stylized garden woven in silks and embellished with gold, silver, jewels and pearls. From their Mediterranean territories the Arab caliphates took over the late Greco-Roman decorative repertoire, based on scrolling foliage and vines and including floral forms derived from the civilizations of the ancient East such as Pharaonic Egypt. Collectively the survival and fusions of the Byzantine and Sassanian traditions offered a secure infrastructure in both technique and design for the development of a flourishing textile industry in the lands where Islam was the dominant religious, scientific and cultural influence.

Gradually from the late seventh century onwards a distinctive, though richly varied, visual and material culture evolved. This was identifiable throughout the region, and especially in cities such as medieval Baghdad, Cairo, Damascus, Fez and, later, Isfahan, Bursa and Istanbul – spread by conquest, diplomacy, trade and migration of craftsmen. Architecture in stone and brick decorated with glazed tilework, carved and painted plaster and wood and also the portable crafts of pottery, metalwork, glass and ivory were essential at all levels from the luxury of courts to the needs of everyday life. Additionally the arts of Arabic, Persian and Ottoman calligraphy and manuscript illumination satisfied refined aesthetic tastes. Within this system of integrated arts and crafts textiles held a dominant position well justified by their versatility in material, technique, design and function, and their adaptability to the widely differing environments of capital cities, with their formal rituals of court and administration, and the provincial centres, rural villages and nomadic encampments with their more modest needs. Textiles, as the sophisticated fabrics of workshops which employed more people than any other urban occupation, or as the relatively simple product of villager and nomad, formed the major industry of the pre-modern economies of the Near and Middle East, North Africa and Europe.

Considering the domination and vitality of the industry textiles should have ideally survived in gratifyingly large quantities. Made, however, of organic materials, they are perishable and therefore subject to decay; such have been the hazards of time, climate, natural disasters, political turmoil and war that textiles have survived more by chance than by any systematic collection. The surviving record is obviously incomplete and requires cautious interpretation. Archaeology either as the result of controlled excavation or by

FIG. 1
Tiraz fragment
(detail of no. 48)
Woven linen
Egypt, Mamluk Dynasty;
14th/15th century
INV.162

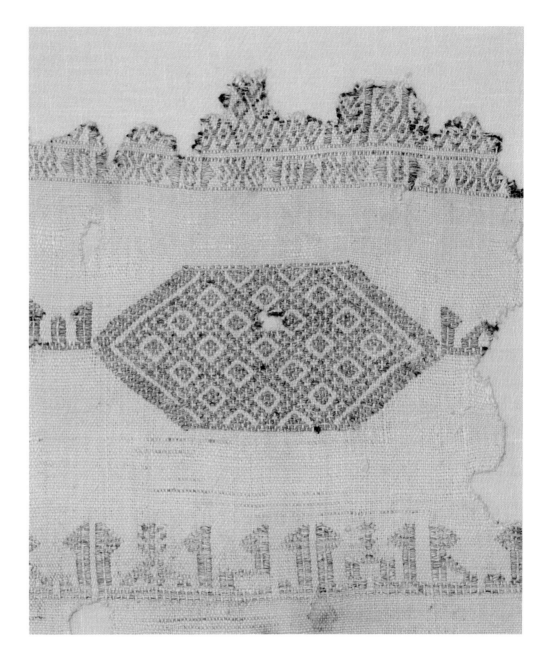

illegal plundering has provided quantities of textiles recovered from the burial grounds
and rubbish mounds of Fustat and Old Cairo, dating to the period of the Fatimid,
Ayyubid and Mamluk caliphs who ruled Egypt from the tenth to early sixteenth centuries.
These are mainly linen fragments woven and embroidered in coloured silks with geometric
designs and sometimes with stylized Arabic inscriptions (fig. 1). While these textiles are
valuable evidence, there are problems of interpretation concerning provenance and date.
Comparable difficulties also arise with later textiles, for example lengths of silk brocades
and velvets provisionally dated to the late fifteenth and sixteenth centuries and attributed
to the Iranian cities of Isfahan, Kashan and Yazd, though there is little evidence to link
them to identifiable workshops (reliable dates on early textiles are very rare). Parallel visual
material is seen in Arabic, Persian and Ottoman paintings, dating from the thirteenth
century onwards, which illustrate manuscripts of epic and romantic poetry, historical
and geographical works and scientific treatises. These offer lively and colourful scenes
showing the function of textiles in dress and furnishings – carpets, curtains, hangings
and cushions – but can be stylized to the extent that they do not correspond to surviving
pieces. Conservative use of designs in both textile and illustration also makes it difficult
to establish a sequence of dates.

One of the most important features of Islamic society, particularly in the steadily developing urban centres, was the high level of literacy in Arabic, Persian and Ottoman Turkish, the languages of religion, administration, law and commerce, science, poetry, history and geography. It would be logical to assume that among this wealth of literature there would be plenty of evidence concerning textiles. The information, however, is variable and erratic. The Qur'an certainly acknowledges the role of fine textiles among the rewards of Paradise (Sura 76, verse 21):

> Upon them shall be green garments of silk and brocade; they are adorned with bracelets of silver.

Ibn Khaldun (1332–1406), one of the greatest Arab scholars, who travelled extensively and worked in Algeria, Tunisia, Egypt and Spain during the fourteenth century, recognized the importance of textiles. His work *The Muqaddimah*, or *Introduction to History*, is a pioneering analysis which values direct social and ethnographical observation as a means of understanding culture. He states:

> When civilization flourishes and the luxuries are in demand, it includes the refinement and development of the crafts. Consequently, these are perfected with every finesse, and a number of other crafts, in addition to them, are added as luxury customs and conditions demand. Among them are those of the cobbler, the tanner, the silk weaver, the goldsmith and others. When the civilization is fully developed, these different kinds are perfected and refined to the limit. In the cities, they become ways of making a living for those who practise them.

Facts about the textile industry have otherwise to be gathered from varied sources, mainly useful regarding function and commercial value rather than aesthetic and creative qualities. The Arab historian and geographer Al-Masudi (896–956) wrote during the tenth century an encyclopaedic work, *The Meadows of Gold*, which includes descriptions of the sumptuous rituals and ceremonies of the Abbasid court at Baghdad, with references to furnishings and garments. Valuable but summary information about textiles is also found in the *hisba* manuals – practical guides for market inspectors in charge of weights and measures, giving regulations for materials and lists of workshops and craftsmen. Ibn al-Murarrad's (d. 1503) *hisba* for Damascus in the fifteenth century lists a hundred categories of weaver, ten workshops for wool and ten workshops for the knitting of mats.

Sources such as wardrobe inventories, accounts, commissions for furnishing and garment fabrics, and dowry lists, which could offer precious detail about the role of textiles and clothing in society, are unfortunately rare. They share the same risk of destruction as the textiles which they would once have listed and described. There is, however, one as yet unique source, the many documents found in the Geniza or storeroom of the Palestinian synagogue of Old Cairo, which was demolished in 1889–90. This archive, well preserved in Egypt's dry climate, with documents in Aramaic, Hebrew and Judaeo-Arabic, mainly consists of religious, philosophical and liturgical texts but also includes letters, court records, marriage contracts, degrees of divorce, wills and dowry lists from the tenth to the fifteenth centuries. It is this latter group which offers information about contemporary conditions of textile production, use and trade at a level of society beneath the privileged circles of a ruler's court. Textiles also acquired an increasingly international reputation, as they were valued and recorded by European merchants and visitors such as the Venetian Marco Polo (1254–1324), who spent more than twenty years in the thirteenth century travelling through Turkey, Iran and China. He observed that Tabriz was a well-established centre of both industry and trade:

The people of Tabriz live by trade and industry; for cloth of gold and silk is woven here in great quantity and of great value. The city is so favourably situated that it is a market for merchandise from India and Baghdad, from Mosul and Hormuz, and from many other places; and many Latin merchants come here to buy the merchandise imported from foreign lands.

While information about textiles collected from both primary and secondary sources is valuable, there remain problems of attribution which arise from lack of context, especially concerning ownership. Textiles are mobile, easily passed from their place of manufacture as trade goods, frequently offered as diplomatic and personal gifts, recycled, altered and fashioned into new pieces. Where terms exist in Arabic, Persian and Ottoman Turkish documents it is difficult to match them with surviving textiles. It is equally difficult to identify collections and inventories. The splendid wardrobes of the Fatimid caliphs of Cairo cannot be reconstructed from descriptions and a few surviving garments. Textiles were an important means of storing wealth but nothing remains of the four thousand pieces of decorated cloths which the Abbasid Harun al-Rashid is reputed to have left on his death in 809. There were probably also collections of splendid furnishings and garments listed and stored in the Safavid palaces of Isfahan, but these have long gone. A few figured woven silk and velvet coats of sixteenth- and seventeeth-century date, diplomatic gifts to Russia and Sweden, are preserved in the Armouries of the Moscow Kremlin and Stockholm, but these are exceptions. The Topkapi Palace at Istanbul is unique as the only collection where the pieces – from the enormous wardrobes of the Ottoman sultans and their families, of about 2500 items dating from the late fifteenth to early twentieth centuries – are stored together with corresponding inventories and archives. At the Topkapi all types of textile are represented – Turkish silk brocades and velvets, painted and embroidered linens and cottons, and Persian, Italian and Spanish and later French imports, demonstrating the cosmopolitan taste of the Ottoman court.

The principal collections of textiles and clothing are now in museums in Europe, America and the Middle East, and also the treasuries of historic houses, churches, monasteries and shrines; among some of them it is possible to trace a history of patronage and ownership. There are also private collections, which reflect the owner's taste and specialized interests. The strengths of the collection published here are concentrated in the textile production of the nineteenth and early twentieth centuries, which, thanks to the basically conservative nature of textile technique and design, preserve and continue the traditions established in the medieval Islamic world. They are important in an assessment of Islamic textiles both for their quality and as illustrations of survival and adaptation in a major industry.

The collection ranges widely in region, material and technique. There are textiles and garments from North Africa, Syria, Arabia, Iran, Turkey and the Indian subcontinent linked by a shared vocabulary of ornament – evidence of the international nature of Islamic design. Materials represented are silk – the most prestigious of fibres, requiring highly respected weavers – wool, cotton and linen. Decoration is based on variations of weave and colour and embellishment through embroidery, printing and appliqué and illustrates the work of both professional and domestic workers. One of the most distinctive features of Islamic design is the evolution of an increasingly abstract and repetitive repertoire of motifs which are shared among all media – metalwork, woodwork, ceramics, tilework and textiles. In textiles the main themes are based on angular and geometric shapes such as vertical and horizontal striped bands; hexagons and octagons which can be linked and infinitely extended; stylized and rhythmic scrolls of foliage and flowers; and Arabic calligraphy, of which the letters can be formed into continuous borders, panels and

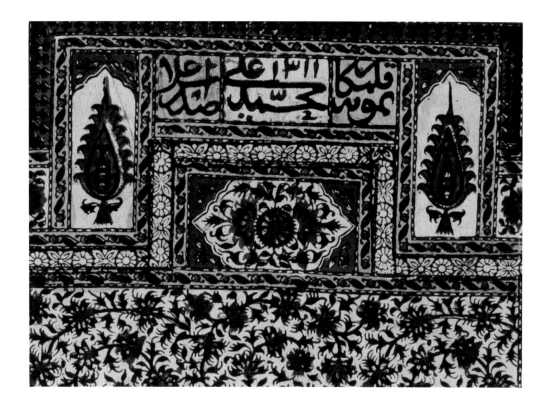

FIG. 2
Prayer mat
(detail of no. 26
showing signature)
Resist- and block-
printed cotton
Iran, probably Isfahan,
dated AH 1311/ AD 1893
INV.80

medallions. These motifs can be used separately or combined into complex patterns, of which the repetitive and two-dimensional features are ideal for textile production, especially where varying lengths are required – for hangings, curtains, robes and shawls.

Textiles are used for the service of religion in all cultures. In Islam specifically religious textiles are few – reserved for the *kiswa* curtains for the Ka'aba at Mecca and covers for the tomb of the Prophet Muhammad at Medina. Donating these textiles became a religious duty which gave great prestige, and rulers competed for the privilege. The practice is known from the early days of Islam, but was spectacularly observed from the sixteenth century onwards by the Ottoman sultans, who regularly sent heavy silks or velvets of black, green or red embroidered or woven in gold thread with inscriptions from the Qur'an. Both curtains and covers were periodically replaced but, as they deserved respect, were preserved and recycled as drapes for the sarcophagi of Ottoman shrines. An Ottoman silk tomb curtain of eighteenth-century date well illustrates this type of textile (no. 50). Finely woven with Arabic inscriptions in gold against a red ground, it conforms to the liturgically correct principle that design is subordinate to content. The sharply angled bands combine the names of Allah and Muhammad and quotations from the Qur'an with the full impact of different proportions of Arabic calligraphy.

The rituals of Islamic prayer, involving a sequence of postures which include kneeling and prostration on the ground, also necessitated textiles, which therefore became associated with religion. Interiors of mosques in Turkey, Egypt and North Africa are closed and covered with carpets. In Iran, however, the interiors are usually open paved courts, which at prayer times need covering. The worshipper can use a small portable mat which can be made in a range of fabrics and techniques such as the knotted pile of a carpet, embroidered silk and printed cotton. An example here (fig. 2; no. 26), printed with the date AH 1311 (AD 1893) and the maker's name, Muhammad Ali, shows the basic directional design of a stylized *mihrab* or prayer niche within ornate borders. Prayer mats may equally be used at home, especially the finely embroidered silk pieces, and additionally as wall hangings.

Interiors in the Islamic lands traditionally have little specialized furniture or furnishings, but could be transformed very often by the use of textiles. Hangings, curtains, covers for floors and mattresses, bags for storage of bedding and clothing, and cushions could

adapt a space as needed for dining, sleeping or entertaining at all levels of society from caliphs' palaces to modest homes. The main difference in furnishings between rich and poor was the quantity, quality and richness of the textiles. Portable furnishings were few – bookstands, small braziers, trays and containers for serving food and drink, and boxes for jewellery and other personal accessories. The textiles of these draped interiors were complemented in design by panels of polychrome ceramic tiles, floors of intricate stone mosaic and screens and doors of carved and inlaid wood located in both public and private buildings. To this principle the basic Islamic repertoire of abstract and repetitive motifs was ideally suited. Examples of textile inspiration are seen in the repeated patterns of foliage medallions worked in the blue and turquoise tile mosaic panels of the Blue Mosque of Tabriz, dated to 1465, and equally in the radiating geometrical motifs of Egyptian carved and inlaid wooden doors of the fourteenth century. The exquisite designs produced by the artists and craftsmen of the *kitabkhaneh* court atelier of sixteenth-century Iran were templates for manuscript illustrations, leather bookcovers, carpets and embroidered hangings and covers.

The dominant role of textiles in Islamic-influenced society ensured that a well-established industry was guaranteed plenty of work, as is evident from the range and quality of surviving pieces and from literary sources. Cities became famous for specialized textiles – Damascus, Aleppo and Homs in Syria for the quality of brocaded silks, Mosul in Iraq for delicate transparent fabrics, and Kashan and Yazd in Iran for silks and velvets. While the textile industry and trade were international, particular nations had their own specialities. In the Egypt of the Fatimids and Mamluks Coptic weavers dominated Cairo's workshops, drawing on a long-established tradition dating from Roman and Pharaonic times. They had advanced techniques such as the use of a flying shuttle to ensure a smoothly woven surface, and they could rely on expert technical support to supply plant and mineral dyes, including madder root for red, indigo for blue, saffron for yellow, copper verdigris for green, and a range of mordants, bleaches, quicklime and starches to fix the colours and finish a textile. Armenians were highly skilled weavers, whose carpets were treasured by the Abbasids. Their reputation continued into the thirteenth century, as Marco Polo observed:

> They weave the choicest and most beautiful carpets in the world. They also weave silk fabrics of crimson and other colours of great beauty and richness, and many other kinds of cloth.

Textiles were woven in professional workshops supervised by guilds whose officials were responsible for maintaining standards, negotiating conditions and payment of craftsmen and the training of apprentices. Such workshops attracted major commissions, especially for large silk textiles, as they employed a specialized labour force who were skilled in many techniques of weaving and decoration and could handle complex looms. A Syrian bed-cover of late nineteenth-century date (no. 18) illustrates the tasks involved. A ground of silk and cotton satin is decorated with a design of floral sprays around a central medallion, each brocaded in a supplementary weave using silver metallic thread wrapped around a yellow silk core. There was also a demand for textiles in which the woven fabric was secondary to lavishly embroidered decoration. This type of work could be produced in professional workshops or contracted to domestic workers; in both cases the standards were equally high. Cream linen fragments and samplers from Mamluk Egypt, ranging between the thirteenth and fifteenth centuries, are finely embroidered with geometric designs in blue and red silks using counted thread stitches. Embroideries were also produced in Iran, where the women of Kerman, according to Marco Polo, were famous for the range and quality of their needlework:

The gentlewomen and their daughters are adepts with the needle, embroidering silk of all colours with beasts and birds and many other figures. They embroider the curtains of nobles and great men so well and richly that they are a delight to the eye. And they are no less skilful at working counterpanes, cushions and pillows.

A woman's trouser leg in the collection (fig. 3; no. 38) of nineteenth-century date is a good example of the continuity of technical skill and design in Iranian textiles. This work with a cotton base, completely masked with diagonal stripes of varied floral motifs closely embroidered with coloured silks in small stitches, may be compared with another piece (fig. 4; no. 37) worked in a fine weave. North Africa had an equally impressive tradition of embroidered textiles valued for their fabrics, design, range of stitches and harmony of colour. These qualities are seen in a fine linen scarf from Algeria (no. 1) of late nineteenth-century date which is embroidered with a rhythmic floral scroll design in coloured silks and gold thread.

While textiles monopolized the furnishings of interiors they played an equally important role in the clothing of the people who moved among the palaces and houses and mingled in the streets and markets of the Islamic world, contributing to a colourful and vibrant public life through ceremonies, processions and rituals. The impact of dress as a powerful visual symbol was well understood at all levels of society. Dress identified public rank, social status within the family and community, occupation, religious belief, wealth and much more. Dress featured in court ceremonies and in the celebrations of birth, transition from childhood to adult life, marriage and death. Sumptuary laws attempted to define privilege by prescribing choices of colour, fabric and garment. Surviving accounts of dress range from the glowing descriptions of sumptuous garments worn by the Abbasids in Baghdad recorded by Al-Masudi in the tenth century to the much later reports by European visitors to the Safavid and Ottoman courts of the sixteenth and seventeenth centuries, where clothes were conspicuously displayed at receptions and processions. The dress of the Fatimids of Egypt surpassed even the splendours of the Abbasids. In Cairo the Caliph Al-Muizz (ruled 953–75) created a Dar al-Kiswa – House of Clothing – responsible for the production, management and distribution of garments and accessories to all members of the court and their families according to their rank. About a hundred thousand pieces of cloth were looted from the storerooms of the caliph's wardrobe in 1067, which gives a good idea of the extravagant resources devoted to dress. None of these garments have survived but the Mamluk historian Al-Maqrizi (1364–1442) was extremely interested in Fatimid ceremonial and recorded the detail of their court dress. He describes the turbans, robes and accessories of each rank, noting the use of white silk brocaded and embroidered in gold and silver. Colours were important; white was the official colour of the Fatimids, symbolizing splendour and light, in contrast to the black worn by the rulers and officers of the Abbasid court.

Once a tightly regulated and identifiable dress code was established it was possible to use clothing as a means of donating rewards and favours in the hope of ensuring allegiance and loyalty. The ruler would give a splendid and exclusive garment – *khil'a* – as a robe of honour to selected courtiers and officials. This custom was inherited from Byzantine and Sassanian practice and gave prestige to both donor and recipient. Robes of honour were also treated as diplomatic gifts to foreign rulers and dignitaries. Queen Christina of Sweden, for example, had received in 1644 a magnificent Iranian silk velvet coat worked with a figural design of graceful young men against a background of flowers, still preserved in Stockholm. A distinctive version of the robe of honour developed early in Islamic society that made use of Arabic calligraphy as both decoration and means of communication. This version was called a *tiraz* – referring to bands of Arabic inscriptions

woven or embroidered around the neck and sleeves and at the shoulders. A full *tiraz* inscription includes the name and titles of the ruler and date and place of manufacture. Dated pieces indicate that *tiraz* production began early. A inscription on a turban fragment in the collections of the Museum of Islamic Art in Cairo has both the name of the owner, Samuel ibn Musa, and a date provisionally read as AH 88 (AD 708). The earliest known *tiraz* workshop was founded by the Umayyad Caliph Hisham (ruled 724–43) in Damascus and then the system was soon established in Egypt, Iran and North Africa. Ibn Khaldun summarizes the political importance of *tiraz*:

> It is part of the royal and governmental pomp and dynastic custom to have the names of rulers or their peculiar marks embroidered on the silk, brocade or pure silk garments that are prepared for their wearing.

FIG. 3
Woman's trouser panel
(detail of no. 38)
Cotton embroidered
with silk
Iran, 1st half 19th century
INV.9

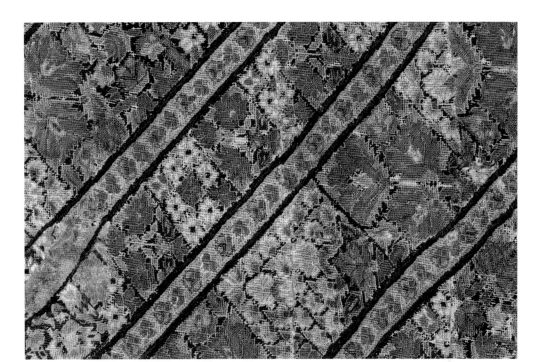

FIG. 4
Woman's trouser panel
(detail of no. 37)
Woven silk
Iran, 1st half 19th century
INV.156

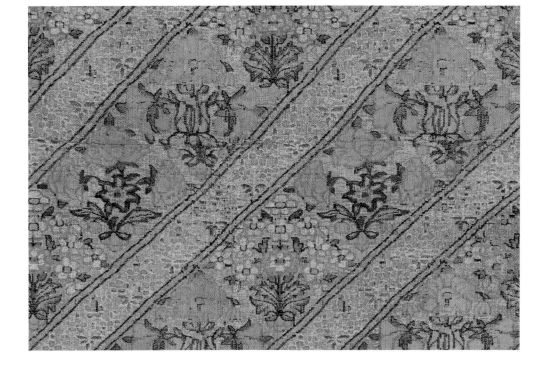

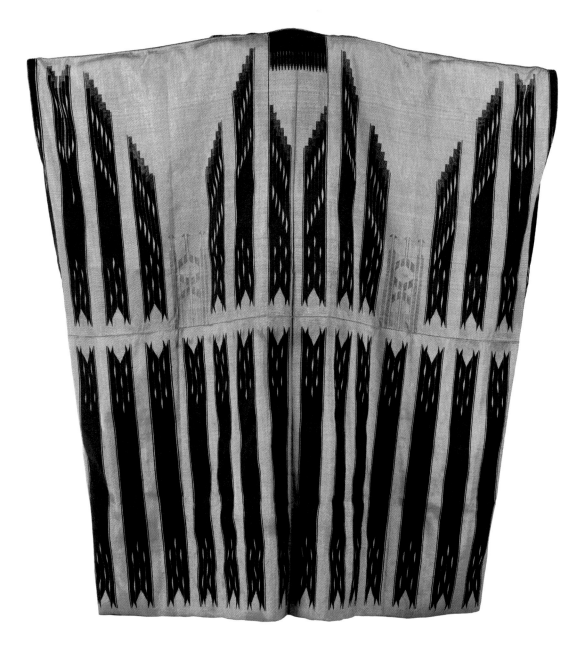

FIG. 5
Man's *abba* (no. 33)
Silk and metal thread
with tapestry woven
decoration
Syria or Iran,
late 19th/early
20th century
INV.145

Tiraz was in decline by the late fourteenth century and was never revived: there was no place for it in the structures of the Ottomans who had replaced the Arab rulers of Egypt and Syria. A linen fragment from Egypt of fourteenth- or fifteenth-century date (see fig. 1; no. 48) illustrates the last type of *tiraz*, in which the decoration is confined to a band of linked hexagons and the inscription to repetition of the word 'dominion', replacing an informative text. The practice, however, of integrating inscriptions into the design of a textile remarkably survived in various forms into the nineteenth and twentieth centuries. A Tunisian wedding veil of late nineteenth-century date, woven of fine silk (no. 52), expertly combines alternating red stripes patterned with spaced geometric motifs with bands of Arabic inscription – 'God makes our good fortune rising and our happiness lasting' – into a balanced design. An example of a man's *abba* or outer robe from Egypt and Syria of silk finely woven with vertical stripes of geometrical motifs includes an inscription *Masha'Allah* – 'As God wills' – worked across the back in angular Kufic script which blends effortlessly into the design (no. 59). The tradition of offering clothing as a diplomatic or even personal gift – a *khil'a* or robe of honour – also continued, as is seen in two striped silk *abba*s (fig. 5; no. 33; also no. 46) formerly in the possession of Major-General Sir Percy Cox (1864–1937), who was involved in the politics of the Arab world.

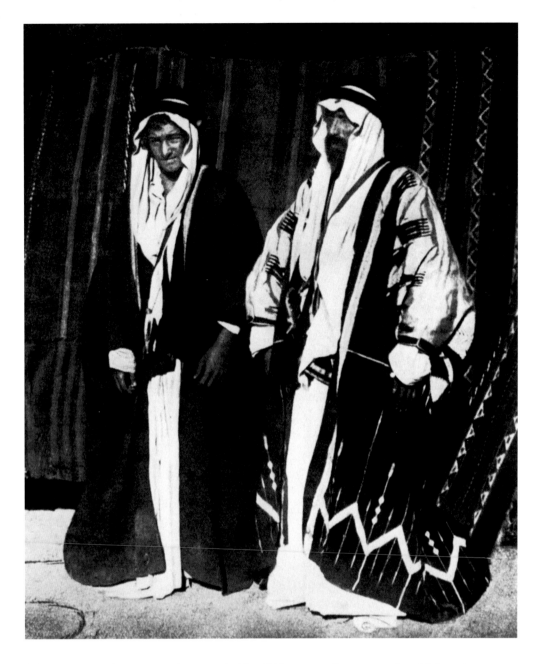

A late nineteenth-century photograph (fig. 6) illustrates the manner in which such a magnificent ceremonial *abba* would be worn.

The retrieval of information about the clothing traditions of the Islamic lands is a fascinating process of collecting and interpreting a range of sources which, of course, mainly concentrate on the luxurious dress of the courts, whose rulers and officials were the patrons of the textile industries and their products. There is, however, some precious evidence of the taste of the middle classes, who much admired the fashions of the court and tried to imitate them within their means. There is, for example, valuable documentation relevant to court fashion in the archives of the Cairo Geniza dating from the tenth to fifteenth centuries, such as marriage contracts and trousseau lists where valued garments are robes of fine fabric gilded, embroidered with gold thread and embellished with applied decoration of gems and pearls. Perhaps the graceful overdress – *thobe* or *thoub* – in the collection from the Arabian peninsula dating from the mid twentieth century (no. 72) whose fine fabric is adorned with a cascade of gold and silver motifs is a descendant of this tradition? Many questions need to be asked and answered about the textiles and dress of the Islamic world as they evolve in response to contemporary society.

Jennifer M. Scarce

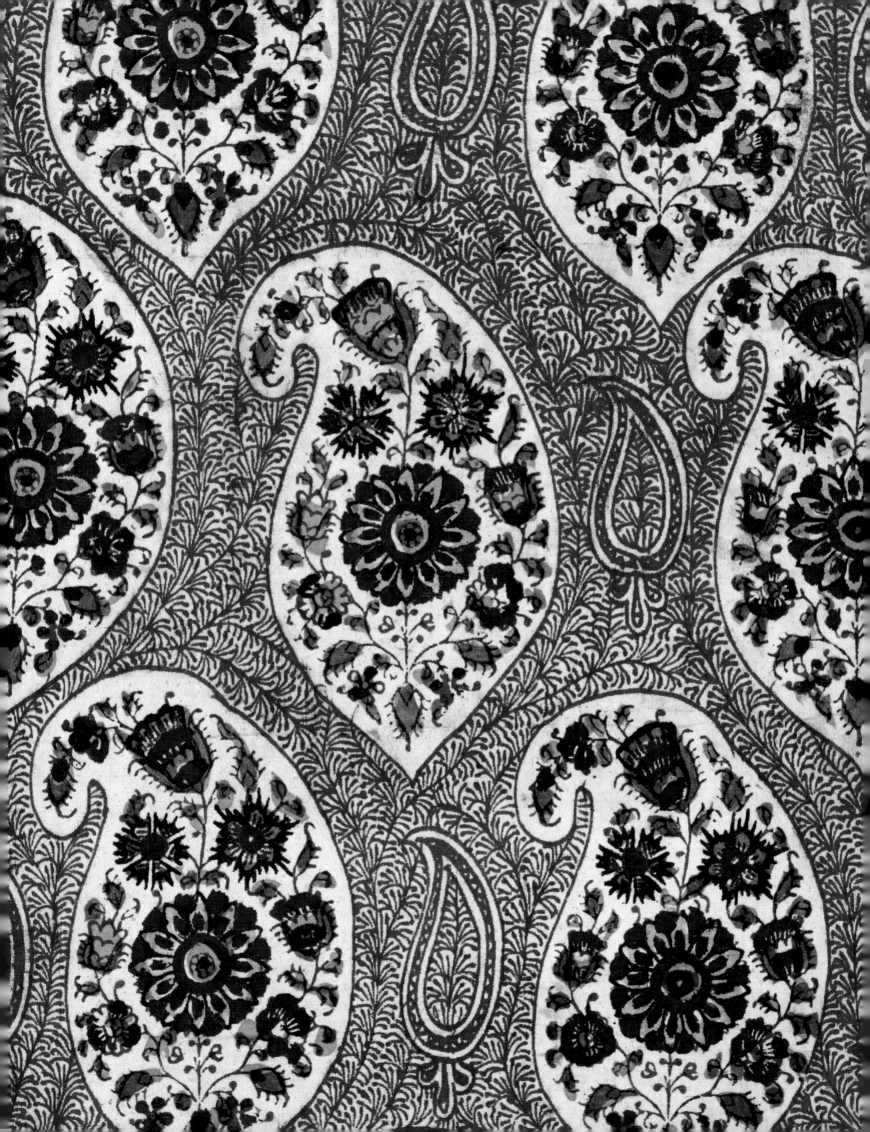

Floral Decoration

Floral patterns, based on the forms of flowers, leaves and fruit, both naturalistic and stylized, are the most frequent decoration used in Islamic textiles. Drawing a stem with leaves on either side of it and a flower on top is a simple idea and is the basic floral motif. It can be used as an isolated sprig or the stem can be extended into a sinuous pattern for borders, with leaves and flowers growing along its length. As a continuous pattern such stems are an ideal design to combine with stripes. When the leafy stem is curled into scrolls and used as a background for other motifs the style is known in the West as 'arabesque' or sometimes 'moresque' because of its frequent use in Islamic art. It is, however, difficult to reproduce as a textiles design and so more naturalistic forms were favoured.

In some textiles the flowers have been woven, printed or embroidered in such detail that even as stylized motifs their taxonomic identity is instantly recognizable. By the middle of the sixteenth century characteristic Ottoman textile designs were floral, based on a combination of well-loved blossoms – the tulip, rose, carnation, hyacinth, peony, cherry blossom and pomegranate; and to this day these continue to form the basis of textile designs across areas previously under Ottoman rule. Most floral motifs, however, are not recognizable and are simply representations of flowers from the designer's imagination. The textile designer is a creator of fantasy but occasionally a floral motif might have a life of its own and might evolve without the designer being aware of what is happening. The most wonderful example of this is the *boteh*, which we know as a tear- or drop-shaped motif usually filled with small leaves and flowers; it has a rounded bottom and a pointed top curving gently to one side. It began life in the late seventeenth century as a naturalistic floral sprig, a stem with a few leaves and three or four flowers. By the early eighteenth century the uppermost flower was drooping to one side; by the middle of the eighteenth century the leaves and flowers were less well-defined and the sprig was fast becoming an outline containing flower heads and foliage; by the beginning of the nineteenth century it had taken the form we are familiar with today.

There is a tendency for floral patterns to become increasingly formulaic as they are repeated and copied over time, so it is a good designer who can inject his creations with the vitality and beauty we admire in real flowers.

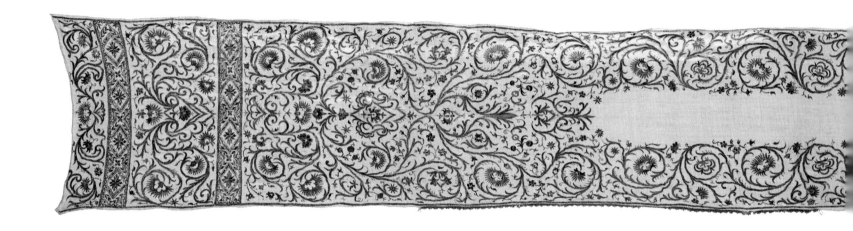

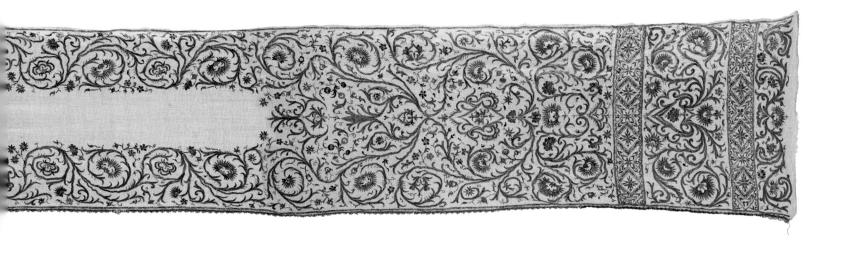

1

Tanchifa or *beniqa*

Linen embroidered with silk
and metal thread
Algeria, late 19th century
L: 309 cm × W: 36.5 cm

This very long and beautifully decorated
scarf combining the functions of a towel
and a headscarf is called a *tanchifa*. It was
used in the *hammam* after bathing and
was wound around the woman's head so
that her wet hair would dry under gentle
pressure. A similar but smaller scarf, called
a *beniqa*, was sewn to form a hood and
was used in the same way. This pattern of

delicate golden stems scrolling out from
a central row of rounded segments is
directly descended from an earlier tradition
of more solid shapes, embroidered in
red and blue, which were inspired by
the Florentine and Venetian velvets that
were so popular in the Ottoman court.
For most of the 19th century these scarves
were embroidered almost entirely with
purple, but, as the lines of the pattern
became more refined, pastel colours were
used in the small flowers and then metal
thread replaced the purple silk to create
this sumptuous version. *Inv.163*

2
Tensifa (part)

Silk and cotton satin embroidered
with floss silk
Morocco, Tetouan, 19th century
L: 236 cm × W: 45.5 cm

This brilliantly coloured length of satin
was made to hang in front of a mirror,
covering the reflective glass and warding
off the evil eye. The mid point of the side
embroidered with isolated motifs would
have been secured on a hook or nail above
the mirror, the two halves would have
been neatly folded to form a pointed
arch and the two ends, with their mass
of embroidered flowers, would hang side
by side over the glass; one of these ends
is missing. A mirror cover or *tensifa* such
as this was used during festivals and would
also have been draped over a woman's
mirror for a period of forty days after
her wedding to protect her from evil and
from jealousy. Only the end borders are
heavily decorated because only they remain
unfolded or undraped as they hang in front
of the glass. The pattern is traditional and
always consists of a vertical stem with a
large blossom to either side and a curving
arrangement of leaves separating these
from the flower-heads which extend to the
sides. Along the bottom there is a narrow
band of white embroidery or *rivière*, which
was replaced by a strip of ribbon in more
modern pieces. Mirror covers in this form
are unique to Tetouan. *Inv.32*

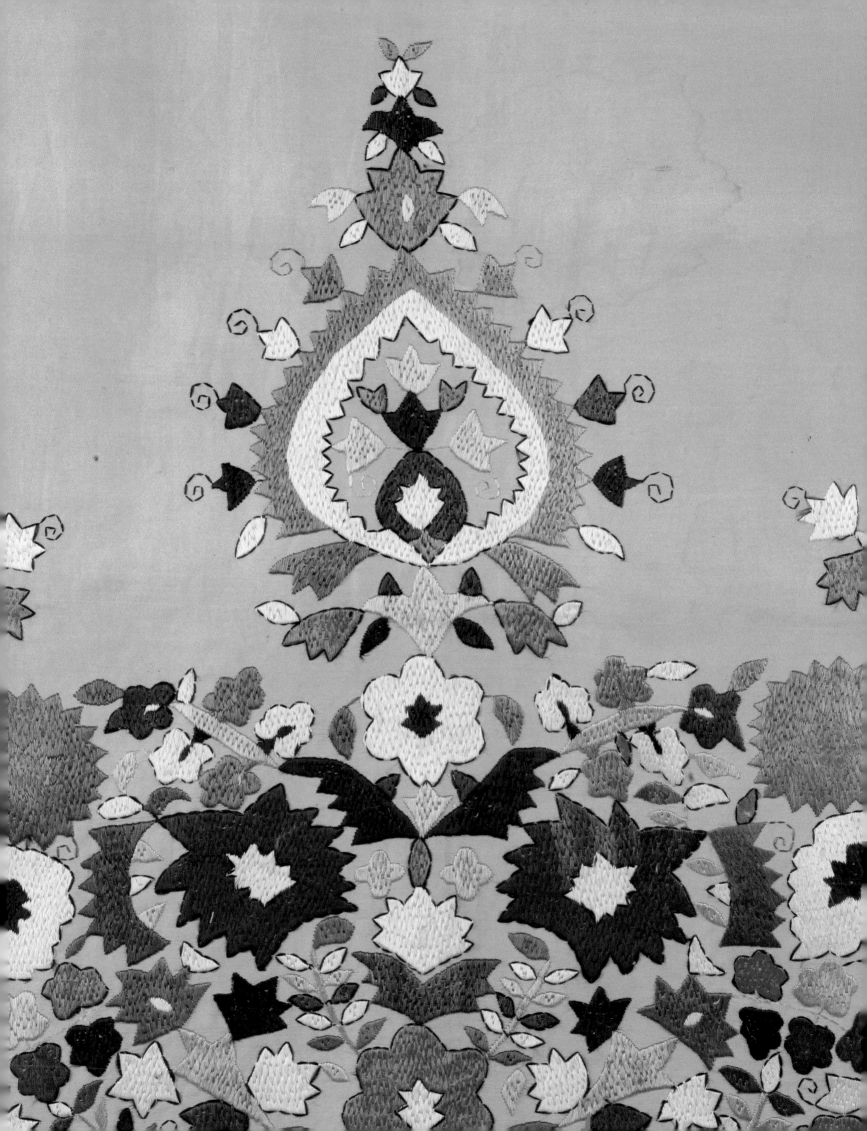

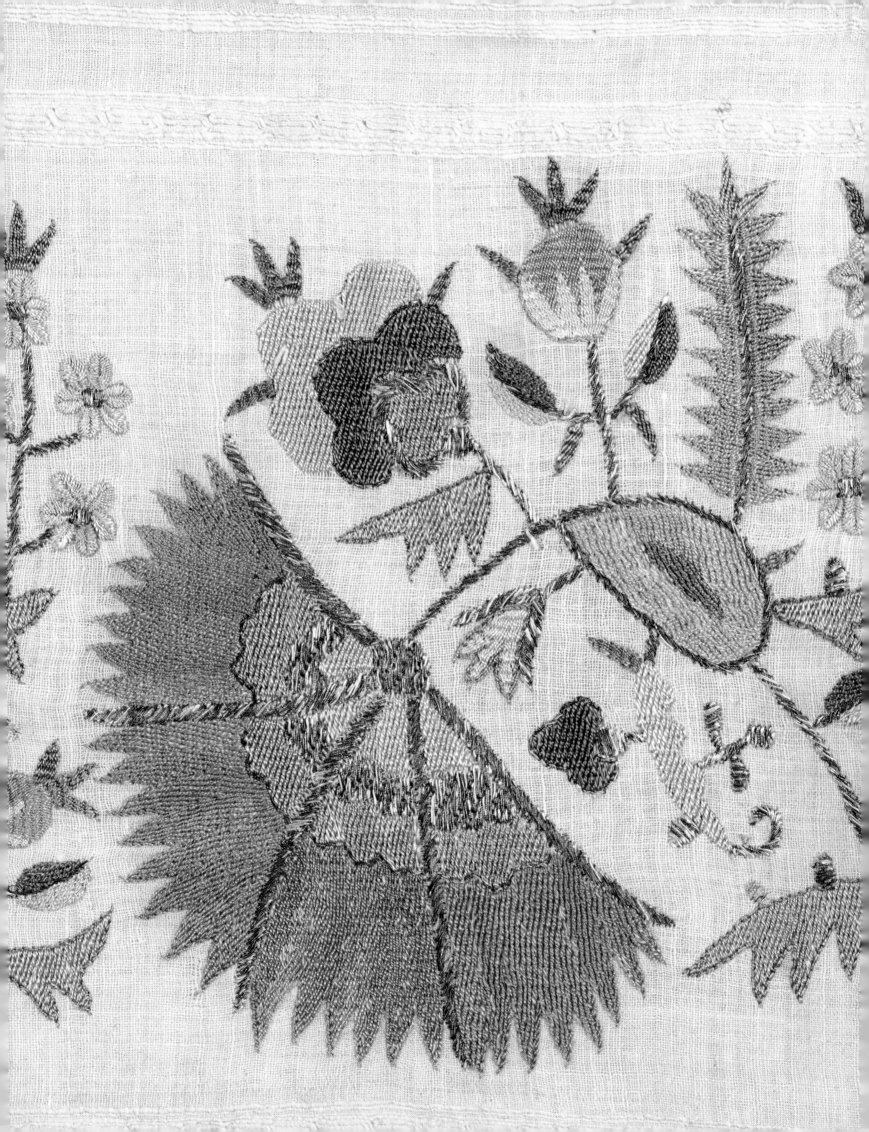

3

Peştamel

Linen and cotton embroidered with silk
Ottoman, 18th century
L: 236 cm × W: 130.5 cm

This large cloth, called a *peştamel*, was used
to wrap around the body while resting in
the *hammam* (public baths) after bathing.
It was made from three lengths of linen
and each length had an embroidered
border top and bottom; as the embroidery
has not been worked over the seams, it
is likely that each piece was embroidered
separately and then sewn together to form
the complete wrap. This would permit
three embroiderers to work simultaneously,
thus reducing the length of time required
and probably reducing the cost to the
buyer. The details of the various flowers
have been repeated with such accuracy that
it is unlikely to have been done by hand.
Printing blocks or cardboard templates may
have been used, but a common method of
design transfer was pricking and pouncing:
a design is drawn on to parchment or paper
and a needle is used to prick dozens and
dozens of small holes along the lines; the
parchment is placed on the fabric and a
bag of finely ground charcoal is pressed
down on it so that the black powder passes
through the holes, transferring the outline
of the pattern, which would be completed
with pen and ink and then embroidered.
Inv.14

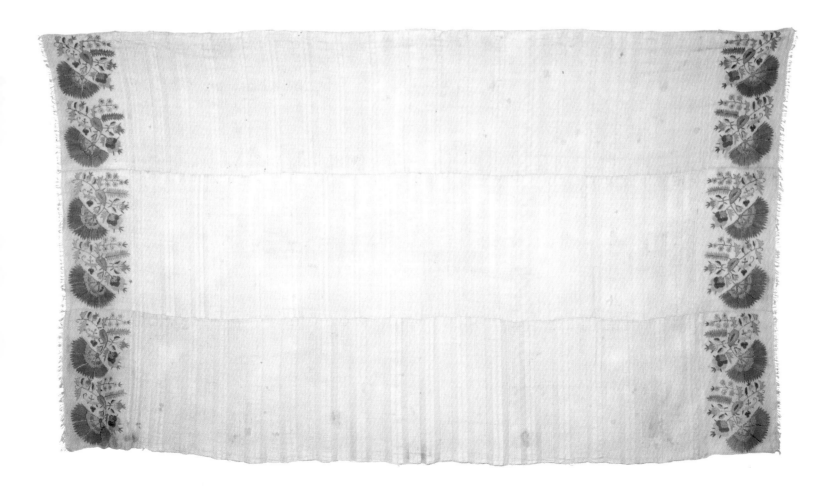

4

Peştamel border

Linen embroidered with silk and
metal thread
Ottoman, mid to late 18th century
L: 92 cm × W: 153 cm

This is one of the end borders from a
peştamel, a large cloth to wrap around
the body after bathing. Extra pieces of
fabric have been added to the sides at
a later date, possibly so that it could
be used to cover the seat of a small sofa:
the undecorated cloth would cover the
seat, the embroidered flowers would
hang down in front and the extra pieces
would be tucked down the sides to keep
it in place. The flowers include pink
carnations, drawn as spiky fan-shapes
and sprays of bell-like blue hyacinth
blossoms. Both flowers were greatly

favoured by Ottoman artists and first
appeared in the middle of the 16th
century. With roses and tulips they
formed the characteristic repertoire of
Court art, gradually finding their way
into provincial workshops and then into
domestic embroidery created within
the home. The colours – delicate shades
combined with silver-gilt thread – are
typical of the 18th century (see no. 24)
and the embroidery is double-sided,
identical on the front and on the
back. This is a hallmark of Ottoman
embroidery from the 18th century
onwards and was achieved by carefully
counting the number of warp and weft
threads over which double darning
stitches, known as *pesent*, were worked.
Inv.171

5
Napkin

Cotton embroidered with silk
and with metal thread
Ottoman, 2nd half 19th century
L: 106 cm × W: 51 cm

Several Turkish words can be used to
describe embroidered napkins, including
peşkir, makrama and *yaşlik*. In English such
textiles are often called towels, implying
they had only one function, whereas within
a Turkish household they would be used
as covers and decoration as well as to clean
fingers and protect garments during a
meal. Napkins are invariably rectangular
with embroidered borders along the two
ends. Although it is more common to find
napkins embroidered with coloured silk,
sometimes the same designs were worked
almost entirely with metal thread with only
highlights in silk. The metal thread in this
piece is a silver-gilt strip wound around a
yellow silk core. The yellow core provides
a golden tint that is enhanced and turned
almost coppery by the use of coral silk for
the alternate pairs of small leaves, and the
glitter of the metal thread would have made
a pleasing impression if used on special
occasions. *Inv.12*

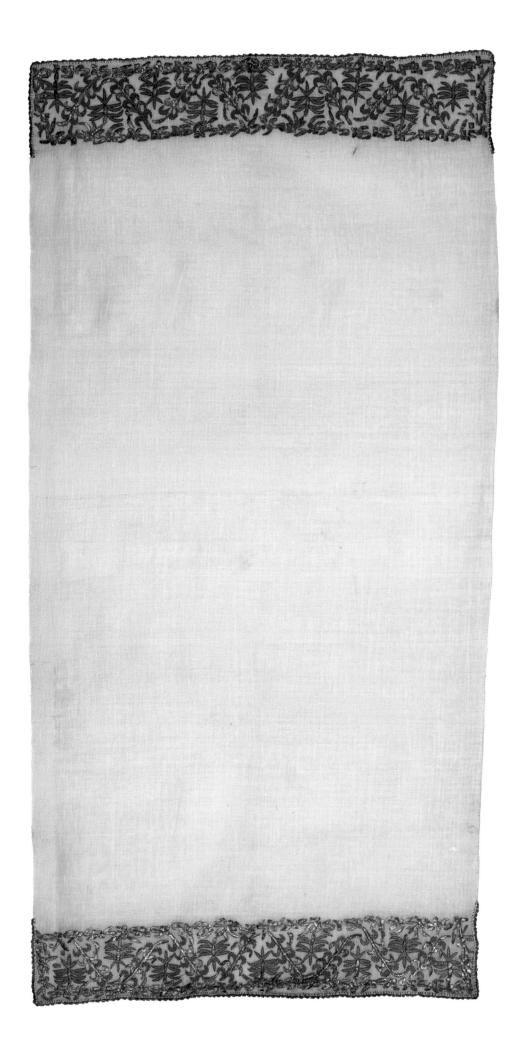

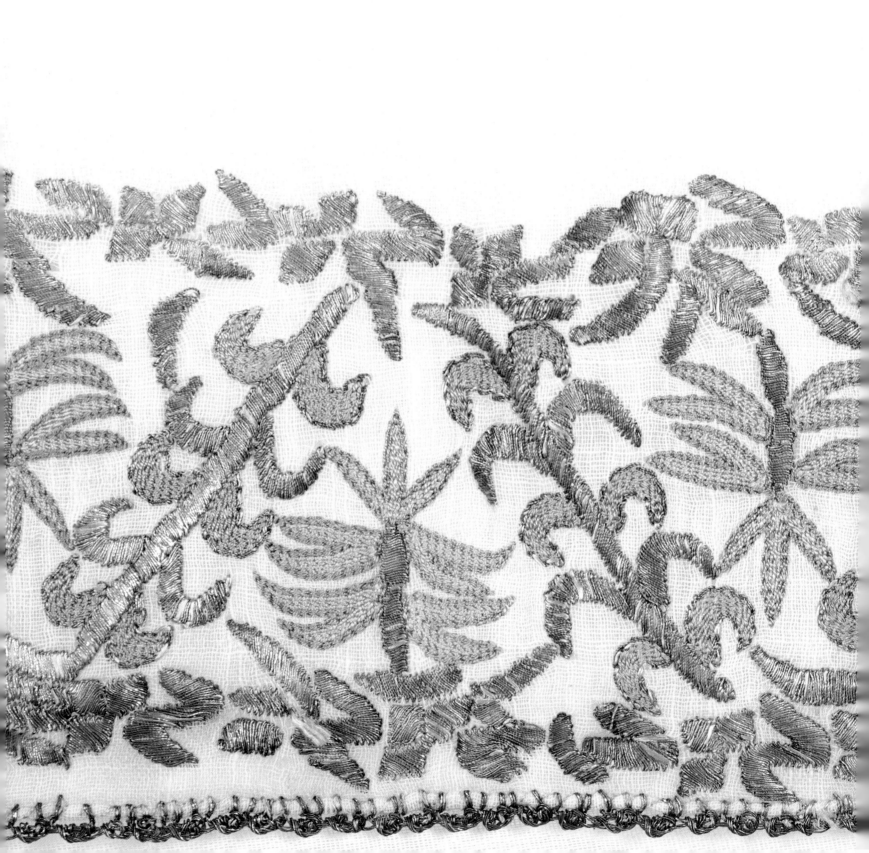

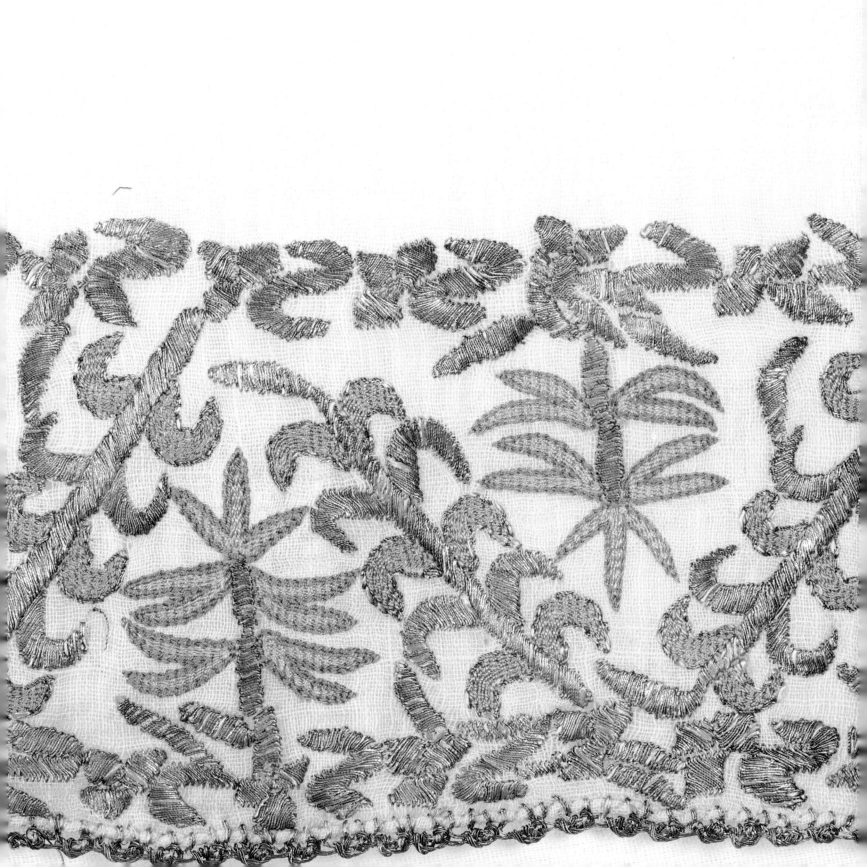

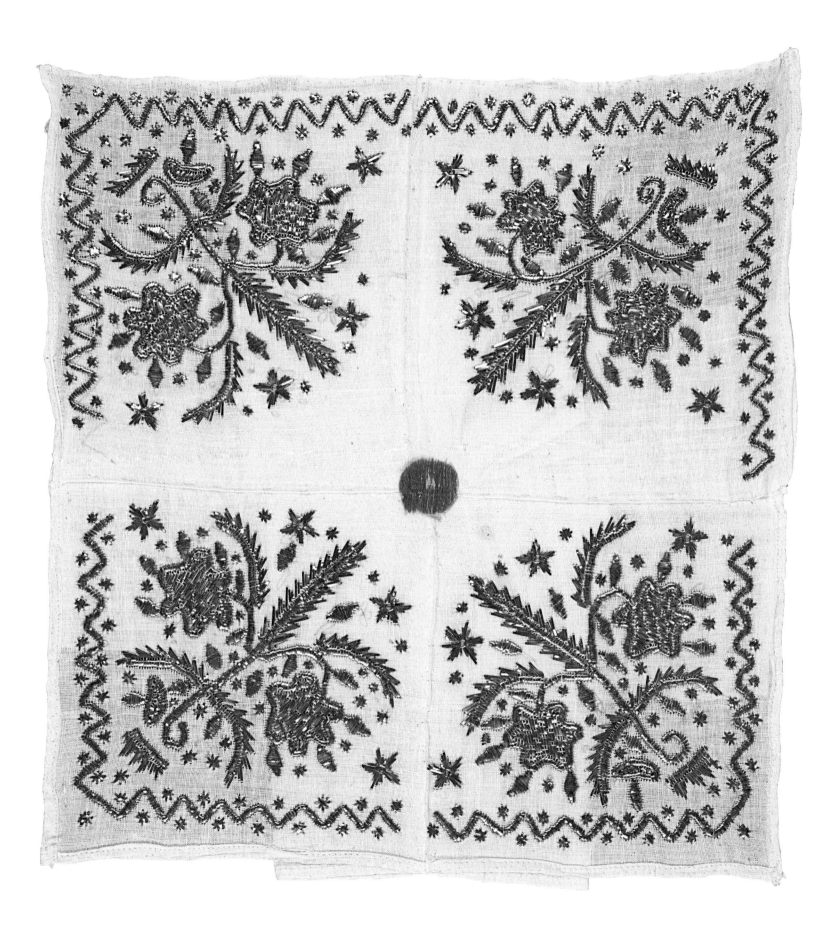

6
Cover

Cotton embroidered with metal thread
Ottoman, 19th century
L: 40 cm × w: 40 cm, folded and secured
with ribbon to show the corner motifs

The Ottomans produced an amazing array
of wrappers and covers for a wide variety
of uses. They were versatile pieces and their
precise purpose, if they had one, is not
always easily identifiable. They could have
been used as napkins, as a cover for the
Qur'an on a reading stand, draped around
a woman's cap or even twisted with scarves
and pinned to her hair with jewellery. The
decoration of this cover is confined to the
corners, where there is a narrow border
with a large diagonally placed floral spray.
A link has been made between the two by
placing small stars within the zigzagged
line and then scattering more around the
flowers. The fact that the line of the border
is different in one corner suggests this
cover was not embroidered in a professional
workshop but was made at home for
personal use. However, there is an oral
tradition which says that artefacts ought
to include a deliberate mistake, for only
God is perfect. The odd corner, therefore,
may alternatively be a sign of the maker's
humility. Compare no. 54. *Inv.165*

7
Shawl border

Wool twill tapestry with added borders
of woollen twill
Kashmir, mid 19th century
L: 92 cm × W: 140.5 cm

The simplicity of elongated *boteh*s
alternating with slim cypress trees belies
the complexity of this design. Both motifs
have been reduced to an elegant shape
with nothing impeding the flow of line
which defines them. Imagine, for a
moment, the designer with these outlines
on a page: the curving of the neck of the
boteh mirrors the base of the cypress tree
and it begins to divide the background
into sections by enfolding itself around
an upside-down tear-drop. To create more
segments the designer allows a pair of
extremely thin cypress branches to grow
from the base of each tree and adds a
pair of inward-leaning *boteh*s below
the base; other lines are drawn around
and through the pairs of *boteh*s to form
root-like patterns. The cypress trees
contain a formal design of stylized flowers
and leaves on a vertical stem and its
rigidity matches the upright nature of that
unbending motif, whereas the leaning and
curving *boteh*s are filled with movement.
Twisting stems and angled blossoms seem
intent on bursting out of the motif and
their energy is in stark contrast to the
stillness of the cypress trees. Everything
is in balance. *Inv.2*

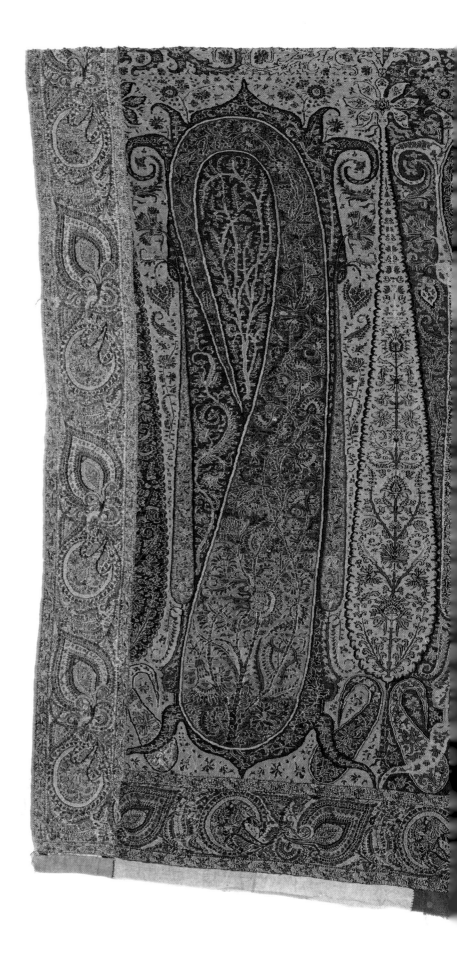

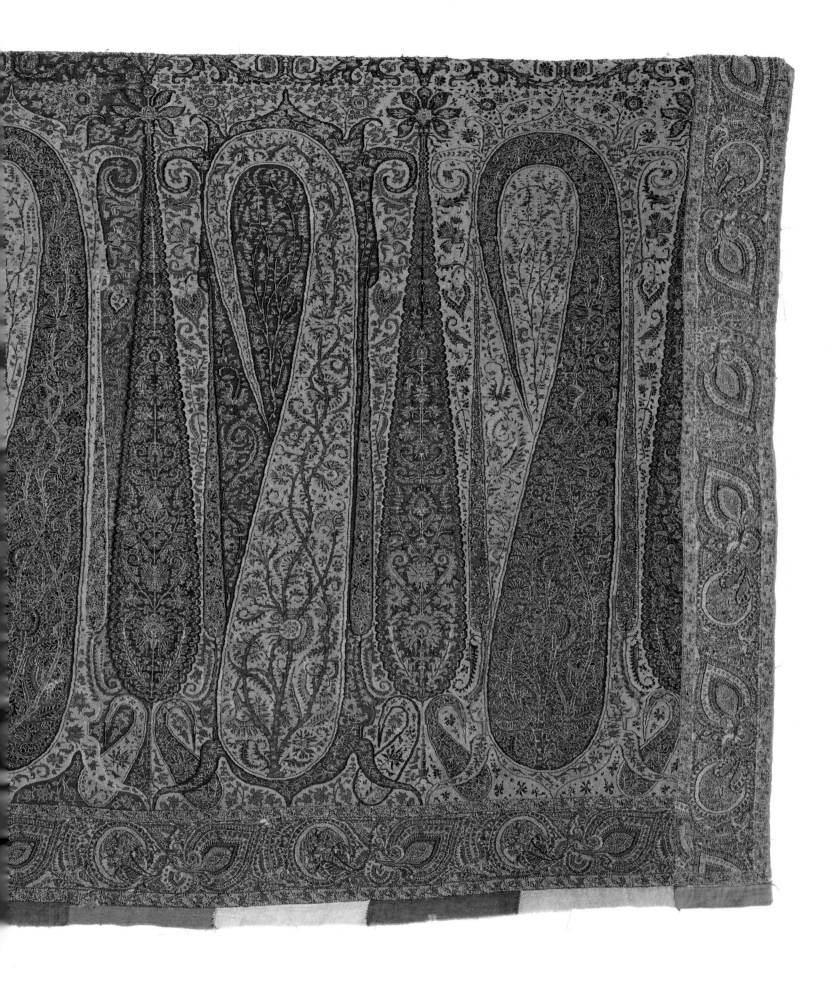

41

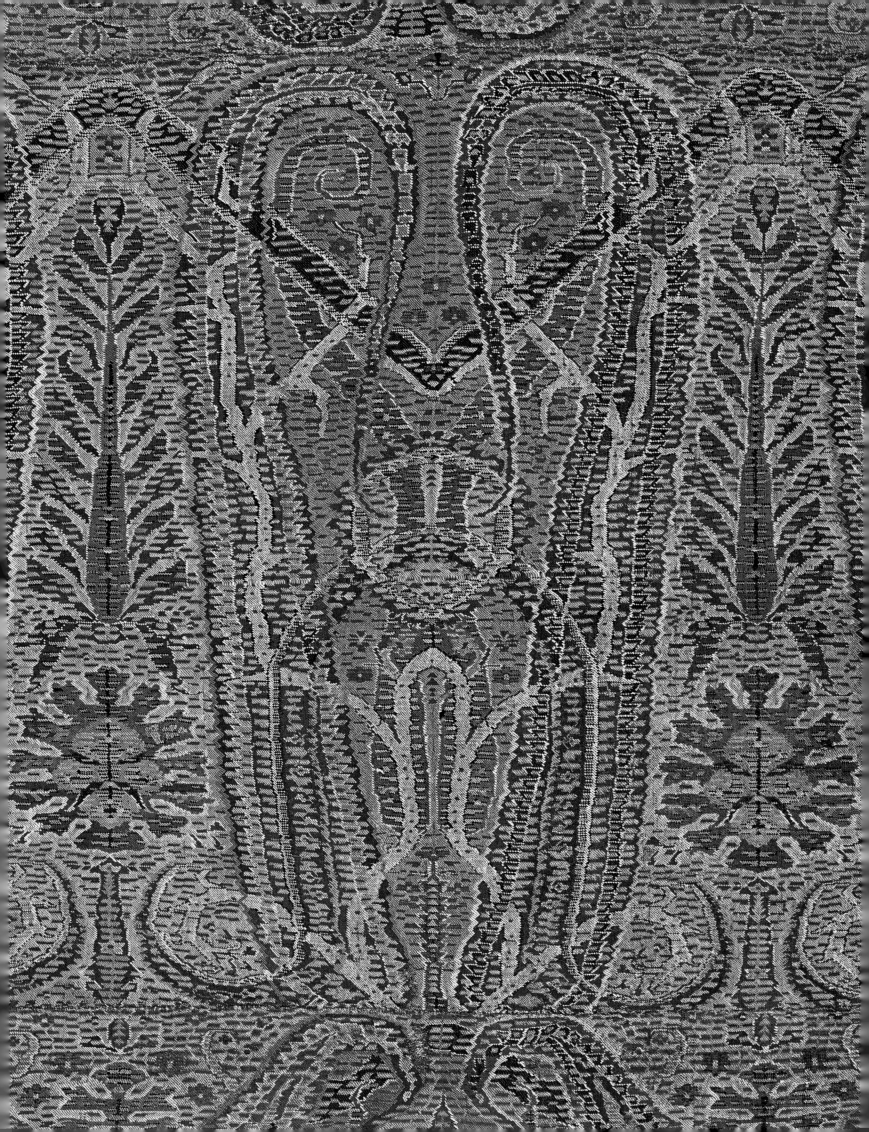

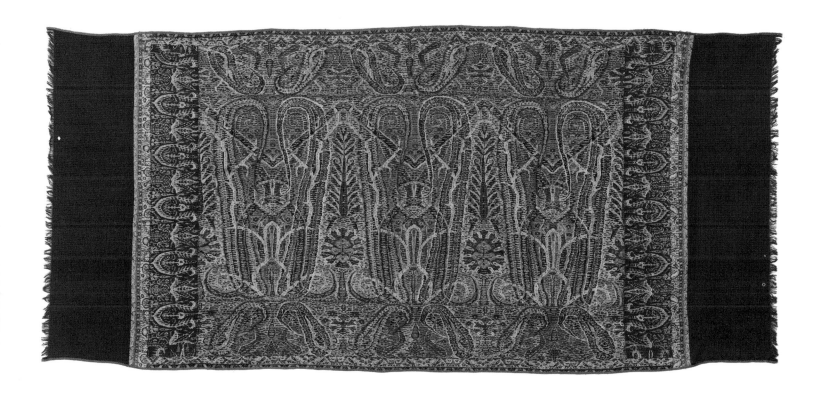

8
Shawl (pieced)

Wool twill tapestry
Kashmir, mid 19th century
L: 200 cm × w: 89.5 cm

All textiles are vulnerable to wear and tear.
Some textiles are so valuable because of
the skill and time required to make them
that they are carefully repaired, patched
and sometimes recycled. By combining
side and end borders from one or probably
two 19th-century shawls and then adding
plain red borders to the ends, the fragile
life of these textiles has been prolonged.
In the central part of the shawl there is a
wide panel with three pairs of elongated
*boteh*s and a narrower border above and

below with small *boteh*s, all of which are
worked in the same combinations of colour;
the colours of the side borders, however,
are quite different and suggest they were
taken from a different textile. In the 1830s
it became fashionable to combine the
simple shape of the *boteh* with abstract
lines, in this case with a dark zigzag and
pale coral-like structures. These interlace
with the lines of the *boteh*, sometimes going
over and sometimes under, adding layers
of visual interest and almost hiding the
basic design. In between the pairs of *boteh*s
is an uncomplicated arrangement of a
rosette and leafy stem together forming
the shape of an elegant cypress tree. *Inv.76*

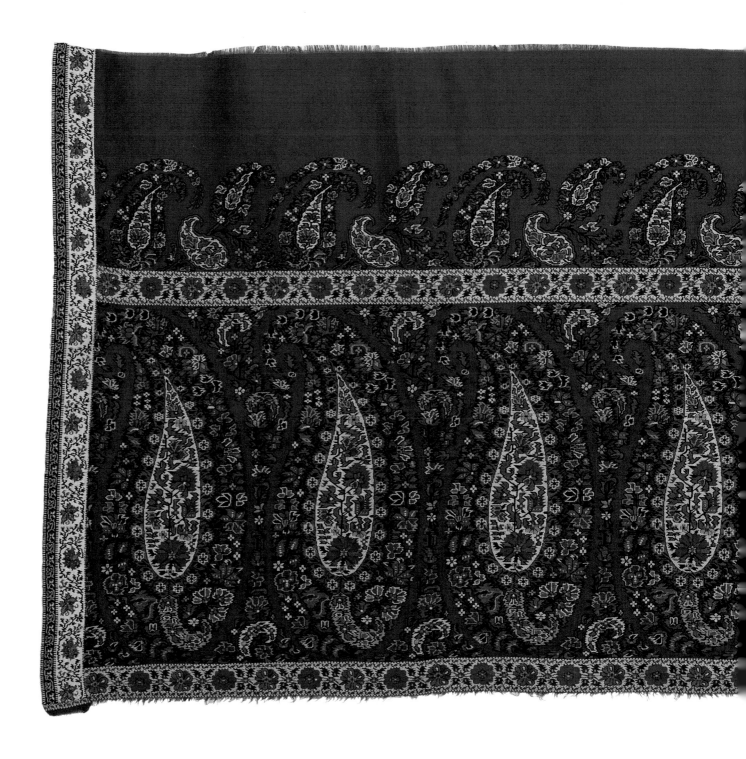

9
Shawl border

Silk and wool twill tapestry
Kashmir, 19th/20th century
L: 55 cm × w: 126 cm

The technique of twill tapestry is a time-consuming process requiring great dexterity: a three metre length about 125 cm wide could take up to a year to weave, so not all shawls were made on a single loom – the borders were often woven separately and then added to a central panel, thus reducing the length of time required. There is a simple repetition of *boteh*s in the main border and at first sight each one seems to have a solid red outline, but this is not the case; the *boteh*s are not outlined and the red is simply the ground on which the tiny flowers and leaves are creating the patterns. The smaller *boteh*s in the upper border are more widely spaced and are leaning to the right. There is a lack of balance between these and the large upright ones below; this suggests that something is missing – that there was originally a narrow border along the bottom, with small *boteh*s probably leaning to the left. *Inv.18*

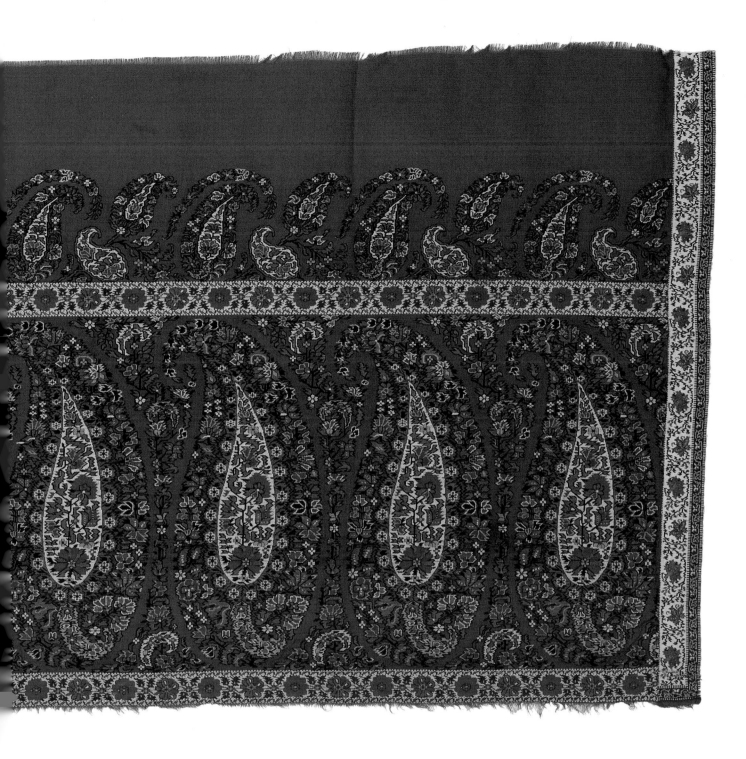

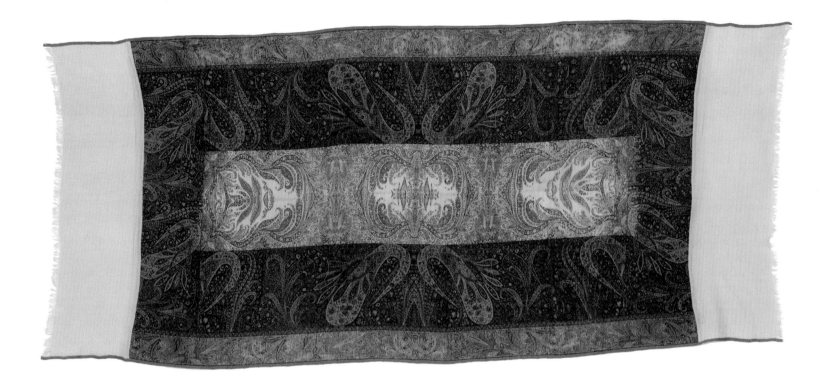

10
Shawl

Silk and wool twill tapestry
Kashmir, mid 19th century
L: 210 cm × w: 91 cm

This is another example of a 19th-
century shawl being given a new lease
of life: a seam in the centre indicates that
worn areas have been removed and the
remaining parts have been joined together
so carefully that the seams are barely
visible. White borders have been added
to the ends, balancing the brightness of
the central panel and contrasting with
the dark main border and its shadowy *boteh*s,
pale ones leaning towards each other,
linked at the top with a crescent moon,
and red ones almost toppling over. The
palmette between the bases of the pale
*boteh*s is repeated on a smaller scale in
the central panel of the shawl where
there are no solid outlines, only feathery
marks, so that the patterns are light and
flimsy. The twill tapestry technique is
characteristic of Kashmir shawls and,
depending on the pattern being woven,
there would be up to 1000 separate bobbins
used in each row. It is a time-consuming
technique requiring great manual dexterity,
and, as the patterns became more and
more complex, the weavers struggled under
pressure to complete commissions quickly.
By the middle of the 19th century their
workshops were in decline because the
use of the Jacquard loom in Europe enabled
first Paris, then Norwich in England
and finally Paisley in Scotland to copy the
style of the Kashmir shawl more cheaply.
Inv. 77

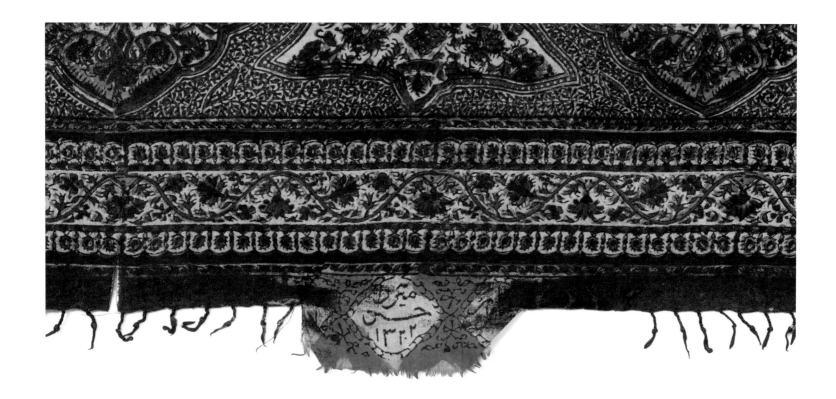

11
Cover

Resist- and block-printed cotton
Iran, probably Isfahan, dated AH 1322/
AD 1904
L: 190 cm × W: 123 cm

Glimpses of the brilliant white cotton ground are all that lighten this rather sombre cover with its murky dark red and dark blue. The main decoration is the *boteh*, both large and small, elongated and fat and sometimes pregnant – one large *boteh* containing many smaller ones. By the end of the 18th century this compact tear-drop shape, curving to one side, had evolved from naturalistic floral sprays found in

earlier Mughal and Persian art. It rapidly grew in popularity and was a favourite motif for the decoration of shawls, lengths of silk cloth and especially of printed cottons. It could be used as a small, simple shape curving left in one row and right in the other, as we see in the centre of this cover, or it could be used as a large outlined space and filled with arrangements of small *boteh*s, leaves and flowers. Its versatility was limited only by the imagination of the designer. A small panel containing the date and the maker's name, Mirza Hassan, extends at the bottom of the cover and a small section extends at the top. *Inv.83*

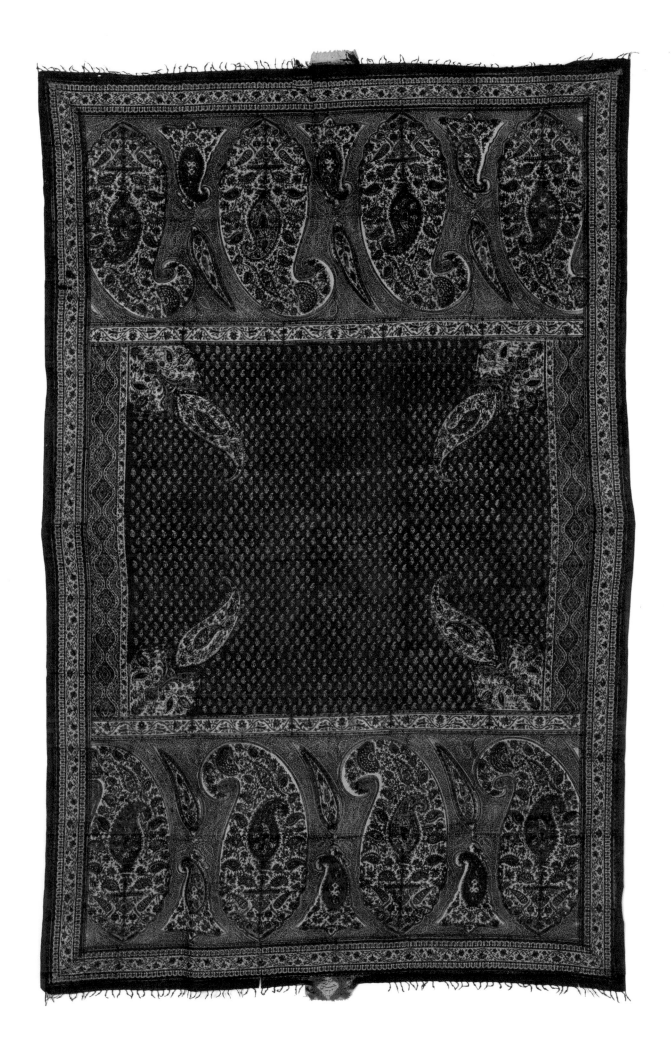

49

12
Woman's shawl (part)

Cotton embroidered with floss silk
Sindh, 20th century
L: 163 cm × w: 43 cm

The three large motifs in each border of
this panel are simplified forms of a popular
Persian and Mughal design in which a
spray of round blossoms with horizontal
leaves at its base sits on top of a small vase.
Single blossoms in the shape of a fan have
been embroidered close together to fill the
main part of the shawl. By off-setting
the blossoms in adjacent rows the designer
has created a tight trellis with a strong
sense of diagonal movement. This panel
would have been joined to one or two
similar pieces to make a complete shawl,
known as an *abochini,* and it would have
draped beautifully around the woman,
despite being covered with embroidery,
because the surface darning stitch means
that the threads are virtually absent from
the reverse side, leaving the fabric soft and
pliable. The front is almost entirely covered
with long stitches of untwisted (floss) silk.
Shawls and head scarves worked in this
way belong to a group of embroideries
known as *phulkari* (literally, 'flower work'),
items made in the home to be given as
gifts, especially at weddings. Floss silk
reflects light better than twisted silk, so the
choice of technique and material were well
suited to creating a dramatic, supple shawl
that would reflect light in interesting ways
as it moved with the wearer. *Inv.38*

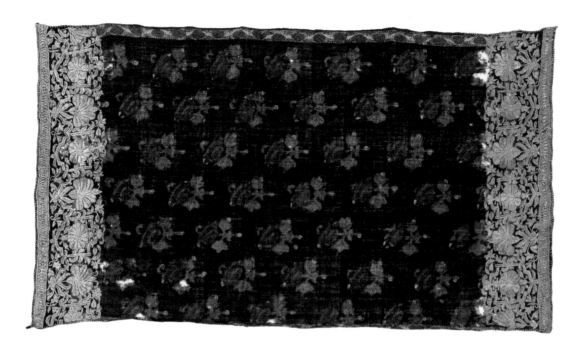

13
Handkerchief

Resist-dyed, block-printed cotton
embroidered with metal thread
Turkey, second half 19th century
L: 89 cm × W: 51 cm

In all probability, this handkerchief was
specifically designed for people who
regularly took snuff, a powder made from
ground tobacco leaves. A pinch of snuff
would be held in the fingers and then
inhaled or 'snuffed' through the nose, usually
producing a violent sneeze. For this reason,
sellers of snuff often sold darkly coloured
handkerchiefs to their customers, not only
for wiping fingers but also for blowing noses.
In order to print a design on to an almost
black ground, the makers began with a

length of white cotton and put a resist –
a paste or a wax – in the places where they
would later block-print the flowers; the cloth
was dyed, taking the dark colour everywhere
except for the areas covered by the resist.
When this was removed the flowers, leaves
and yellow spots were printed. One carved
wooden block was required for each colour,
so five were needed for this design – one
for the light red, one for the dark red, one
for the yellow, one for the green and one
for the dark veins in the leaves. Yet another
technique was added to the complex
printing, and two borders, heavy with metal
thread, were embroidered across the ends,
making this an exceptionally beautiful object
for such a mundane purpose. *Inv.60*

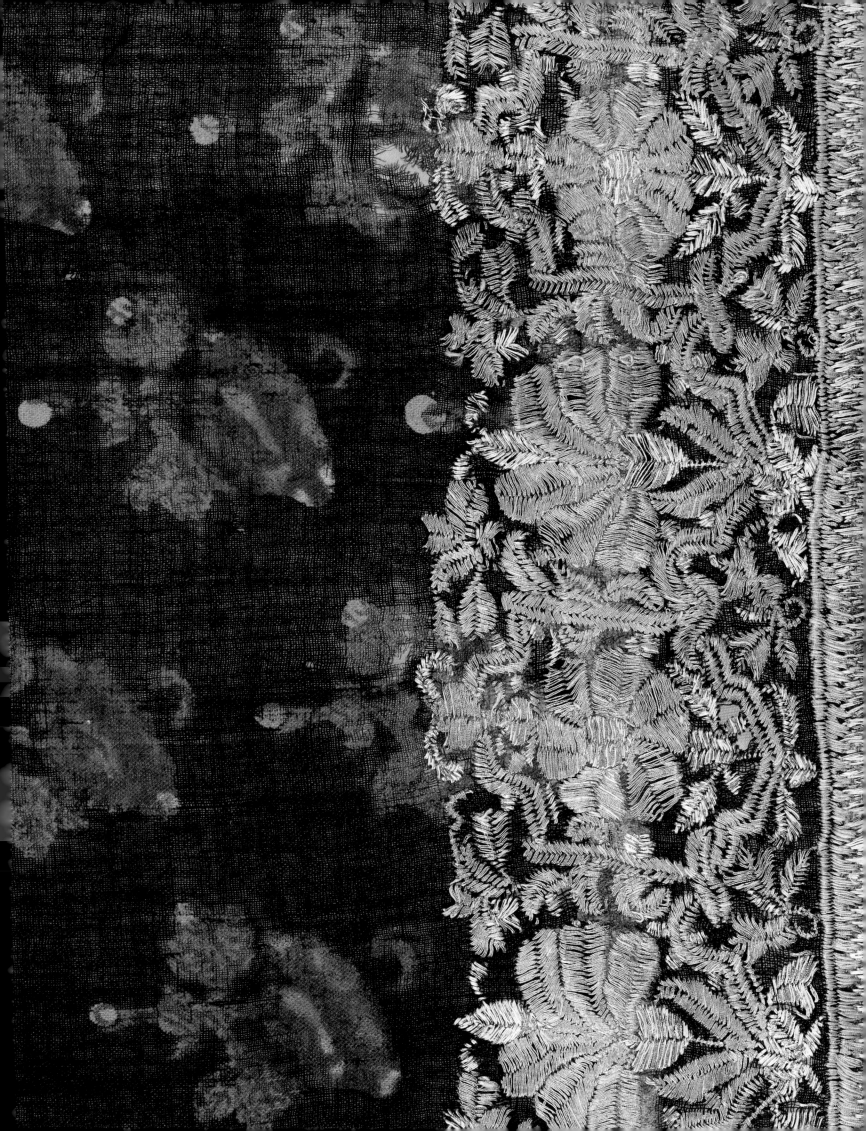

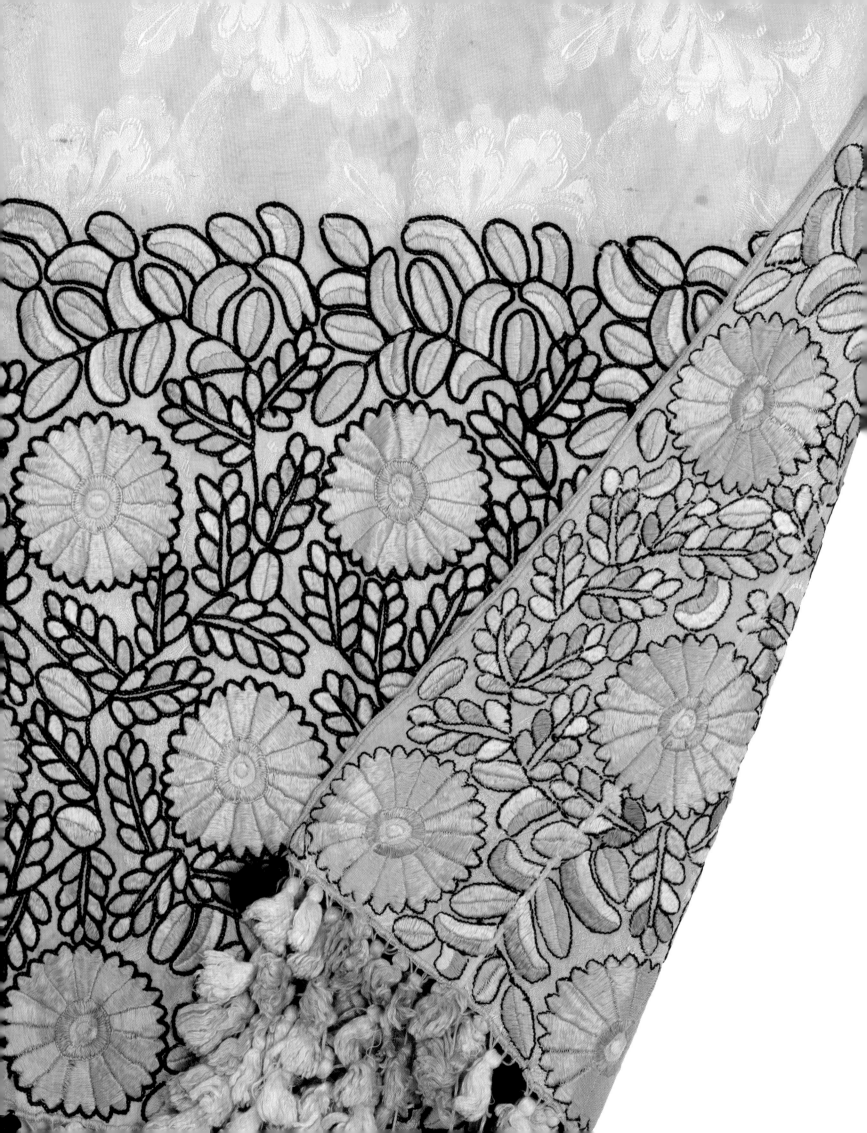

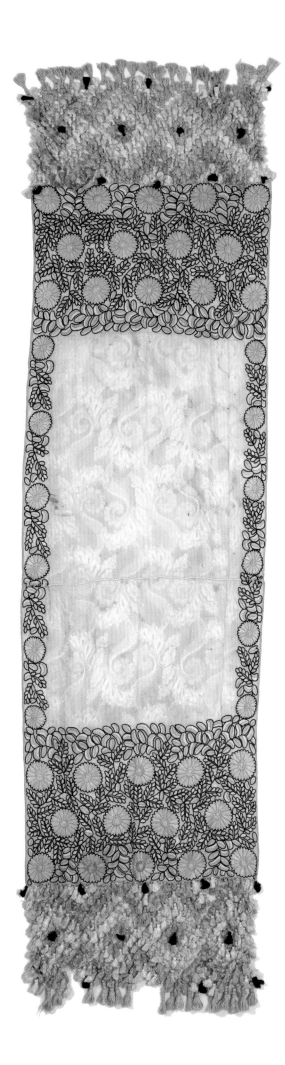

14

Tkek

Woven silk embroidered with floss silk
with added floss silk tassels
Morocco, Rabat, late 19th/20th century
L: max. 255 cm × w: 69 cm

This is a wide sash, called a *tkek*, which
would have been folded lengthways and
used to secure a woman's trousers around
her waist. The ground of these sashes was
almost always white and this one has been
woven with a design of leafy scrolls, white
on white, like patterns in ice. In complete
contrast, black thread has been used to
create an extremely strong outline around
the rosettes and leaves in the embroidered
borders. These were once brightly coloured
with pinks, mauves and greens but they
have faded a little over time. Great care has
been taken to ensure that the embroidery
is double-sided, the same on the back
and the front, so that nothing less than
perfection is seen as the ends of the sash
sway with the wearer's movements. To
add length, weight, texture and additional
movement to the sash, complex fringes have
been added to the ends. These are formed
by long purple threads attached to the white
silk ground, crossed and secured by short
silk tassels to form a net. The coloured
tassels form a pattern of diamonds and half
diamonds which create another contrast,
this time between the gentle curves of the
rosettes and leaves and the angularity of
the diamonds. *Inv.74*

15
Two panels from a curtain

Linen embroidered with silk
Ottoman, late 17th/early 18th century
L: 176 cm × W: 42 cm

Curtains were not common in an Ottoman
house but they were occasionally used in
doorways, over hearths and over shelves
fitted into niches in the walls. Three widths
of embroidered linen would have been
sewn together to make the curtain; the two
side pieces would have been identical but
the central one was usually a mirror image
of the others with its pattern and colours
reversed. The strong colours of these panels
– red and blue with small amounts of green,
white and yellow – are typical of Ottoman
embroidery in the 17th and early 18th
centuries. There is no shading, only solid
colour. Originally the white motifs would
have been outlined with black but, because
black dyes are used with an iron mordant,
they eventually rot. Most fibres require a
mordant in the form of a metallic salt to
bind the pigment. The dye that produced
the inky black colour of the embroidery
thread would have been fixed with an
iron mordant and over the years the iron
oxidized – it rusted – causing the black silk
thread to disintegrate and fall out, leaving
only stitch holes to mark the fact that it had
once been there. *Inv.169*

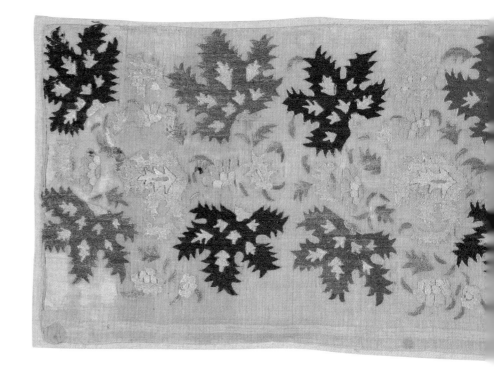

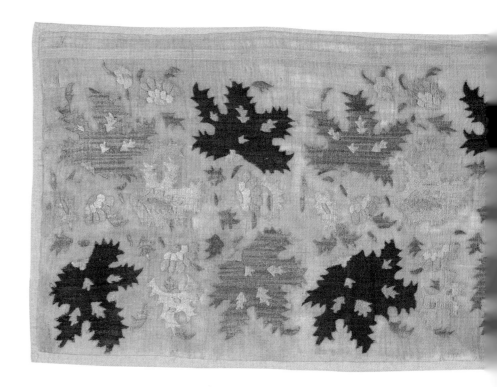

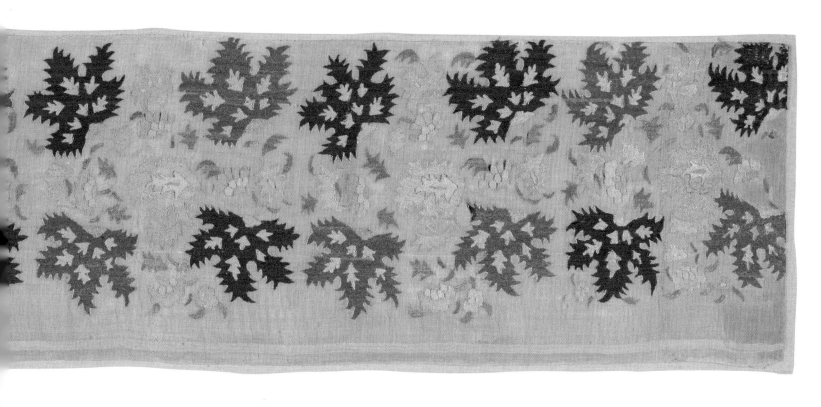

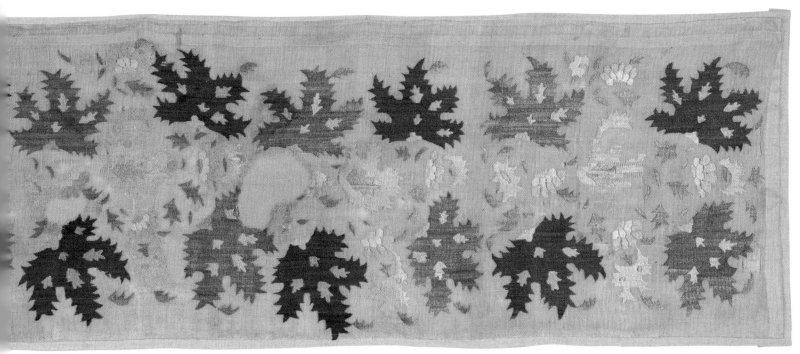

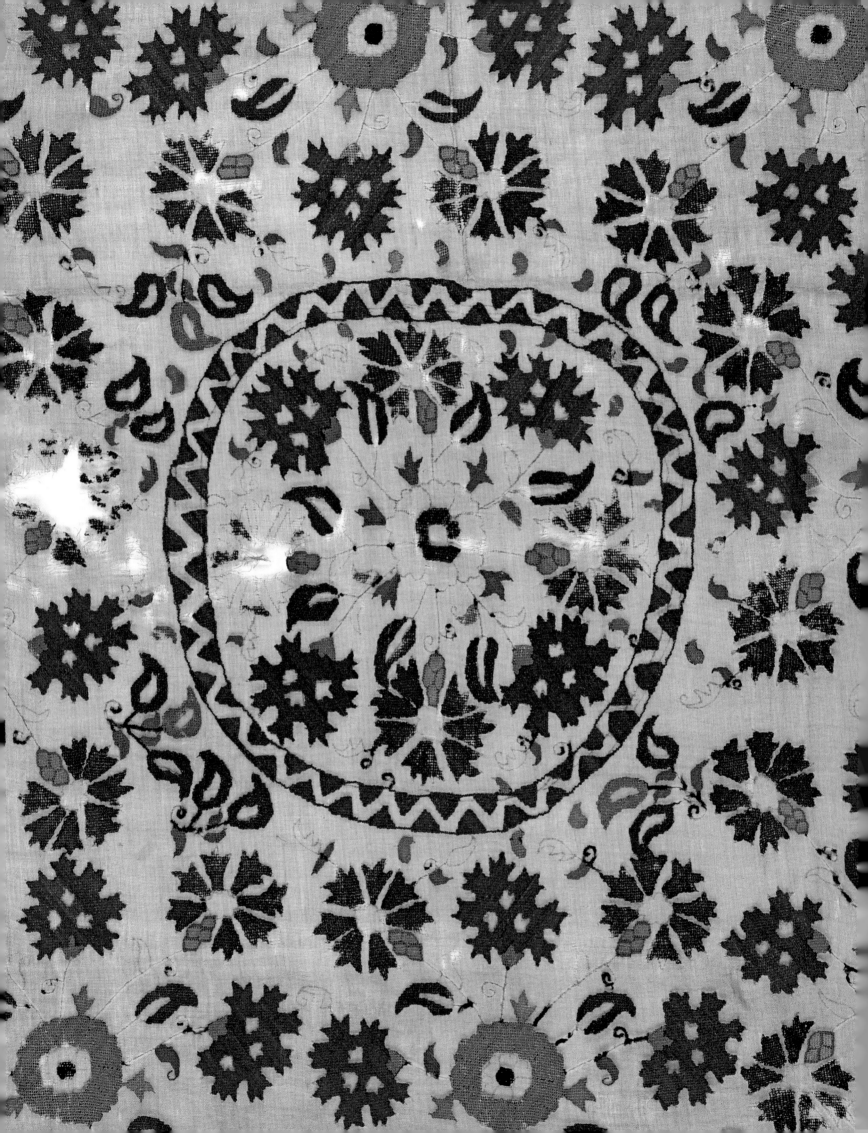

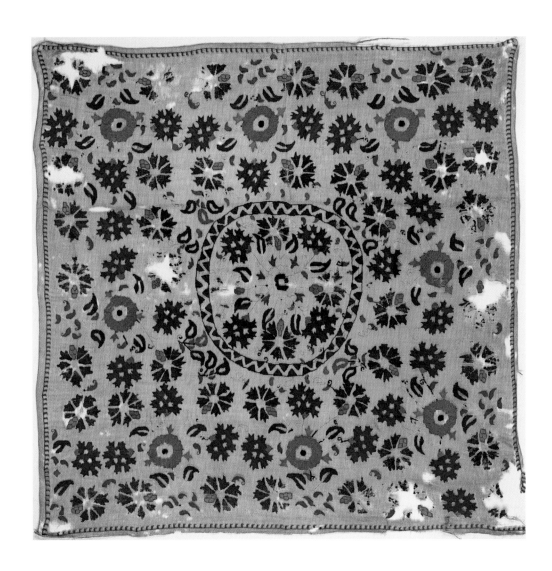

16

Kavuk örtüsü

Linen embroidered with silk
Ottoman, late 17th or early 18th century
L: 94 cm × W: 94 cm

The *kavuk örtüsü* is a specially designed, lightweight, square cloth which would have been placed over a man's turban when it was not being worn in order to protect it from dust and from disrespectful treatment. Ottoman turbans were elaborate constructions indicating the rank of the wearer. They were made by sewing together and stuffing many layers of cotton cloth and were removed like a hat, not unwound. A *kavuk örtüsü* or turban cover is easily identifiable because of the circle in the centre, which was placed directly over the turban. The apparently random arrangement of blossoms around the centre is misleading because they actually form three concentric circles with additional flowers added to fill the corners. It is easy to see the underdrawing where the embroidery threads have worn away, especially in the central circle. There were several ways in which the design to be embroidered could be transferred on to fabric: it could be drawn directly on the cloth by hand or drawn around templates, or pricked and pounced (see no. 3); or a printing block primed with ink could be used. The larger floral motifs on this turban cover were probably printed because they are identical and it would have been difficult to achieve such uniformity and delicacy of detail by other means, but the smaller motifs were drawn by hand. *Inv.164*

17
Kavuk örtüsü

Linen embroidered with metal thread
Otttoman, late 18th century
L: 95 cm × w: 95 cm

Workshops specializing in the manufacture
of metal threads were mentioned in
Ottoman texts as early as the 17th century.
Closely associated with jewellers and other
metal workers, the men wrapped a metal
strip around a silk thread by using a small
hand-turned spinning machine. Metal
thread is rare in Ottoman textiles before
the 18th century but gradually became
popular, sometimes used to add highlights
and sometimes, as in this example, used
to work the entire piece. This *kavuk örtüsü*
or turban cover has a particular charm
because the design is not perfect: too
many floral motifs were printed or drawn
in rows and insufficient space was left for
the characteristic circle in the centre to
be drawn correctly. This squashed circle
engages our imagination and leads us to
consider under what circumstances the
hapless embroiderer was working. It is
unlikely to have come from a professional
workshop. Perhaps the cover was
embroidered by a woman in the seclusion
of her home and either used within her
family or sold through intermediaries
in the bazaar. Such domestic production
accounted for a large percentage of
Ottoman embroidery and was often
controlled by merchants or agents
who provided the materials and patterns
and sold the finished products, taking
a commission on each sale. Textiles like
this, with mistakes, are to be treasured
because they show the hand of the maker.
Inv.173

18
Bed cover

Silk and cotton satin brocaded with
metal thread
Syria, late 19th century
L: 179 cm × w: 169.5 cm

The greatest challenge facing any textile
designer is the loom. The technical
limitations of all but the most complex
looms restrict the designer to relatively
simple, repeating patterns. On the other
hand, embroidery and printing are
comparatively free and flexible and limited
only by the ability of the craftsman.
Although the design of this woven bed
cover is simple in format, with a border,
corner motifs, a central roundel and a
scattering of small floral sprays, it would
have been difficult to weave. The silver
metal thread wound around a yellow silk
core has been brocaded – this is a hand-
weaving technique in which the weaver
uses separate bobbins for each motif, up
to 14 bobbins per row for this cover, and
works the metal thread carefully backwards
and forwards to form each pattern. It is
a time-consuming method but it avoids
wasting metal thread and it was used at
times when the cost of the thread was
greater than the cost of labour. The relative
rigidity of the design and the lack of detail
are overshadowed by the opulence and
shimmer of the silver thread. *Inv.79*

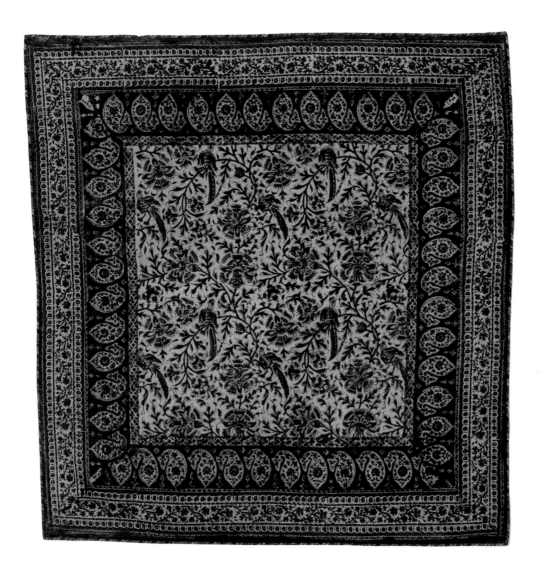

19
Cover

Resist- and block-printed cotton backed
with roller-printed cotton
Iran, Isfahan, late 19th century
L: 81.5 cm × W: 77 cm

The backing on this cover has been pieced
near the striped facing, disrupting the flow
of the conjoined red *boteh*s, which twist
and turn as if they were trying to separate
and, by doing so, form smaller white *boteh*s
within their tear-drop necks. This textile
has been printed using copper rollers on
which the precise details of the pattern
have been etched. One machine could be
loaded with up to 16 rollers, each carrying
one portion of the design to be printed
in a particular colour. Iran did not possess
this technology but Britain and Russia
did and many of their printed cottons were
exported to Iran. The clarity of the dyes
and the precision of the pattern contrast
with the dark red and blue of the hand-
printed cover. Effort and skill had been
required to produce by hand the pattern
of flowers and leaves with their delicate
tendrils and two types of bird perched on
the stems, ones with straight legs and ones
with bent legs, but as with most handicrafts
there are errors in the placement of the
motifs, especially around the corners of
the borders. This cover incorporates the
conflict between traditional and modern
technologies, hand-made versus the perfect
machine-made, familiar versus novel. *Inv.81*

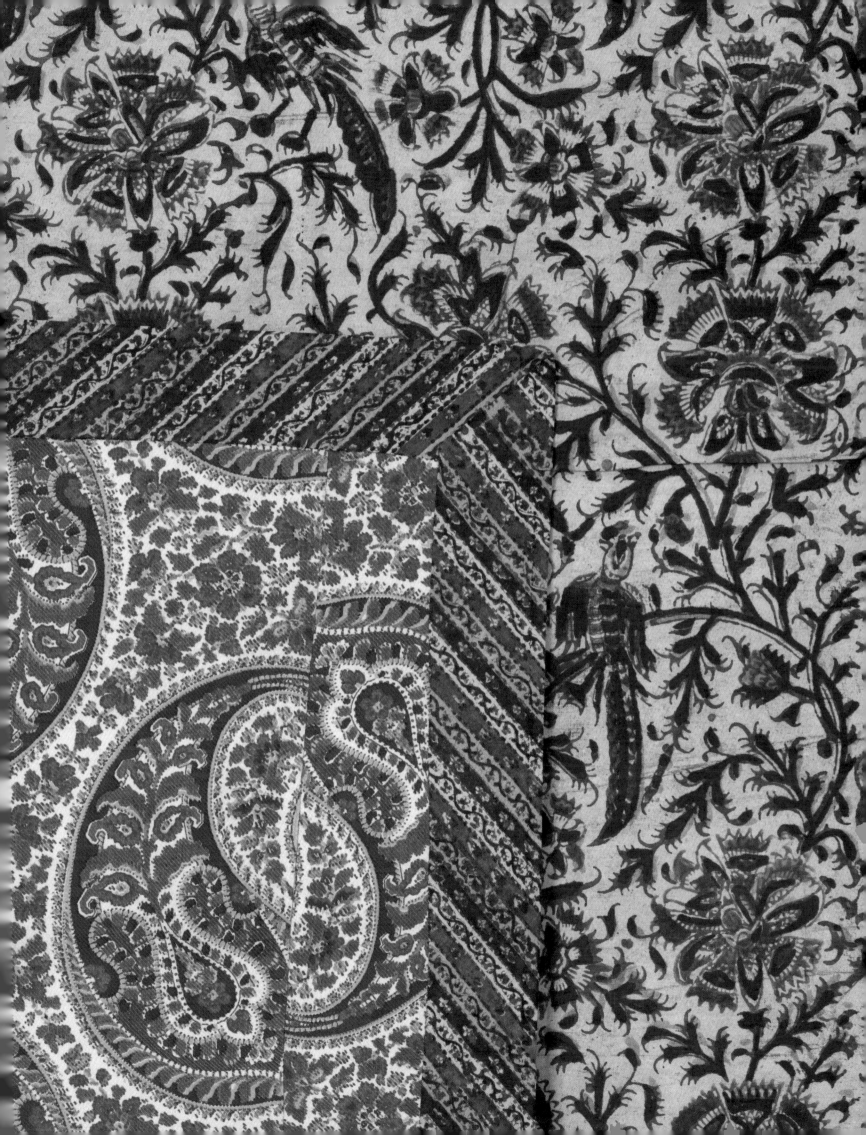

20
Border or valance

Silk velvet embroidered with metal thread
Mughal India, 17th/18th century
L: 192 cm × W: 30 cm

The capital of the Mughal Empire moved
from Agra to Fatehpur Sikri, to Lahore,
back to Agra and finally settled in Delhi,
but the Court itself was always mobile,
moving from one place to another, often
on hunting and sometimes military
expeditions. Entire cities made of tents
were used to house the Emperor's retinue,
and sumptuous textiles were an essential
element of the portable residences.
Hangings decorated the walls of the tents
and divided the space to provide privacy.
Decorative hangings in the Mughal Court

often had designs similar to those worked
in inlaid marble on the walls of the palaces,
and in the 17th century the most popular
motif was a large flowering plant set within
an arched niche. The same format, on a
much smaller scale, has been used on this
border, which may have decorated the edge
of a raised platform within either a room
or a section of a tent. The rounded mid-
section of each column compliments the
rounded vase, the leafy tendrils at the base
of the vase curve sufficiently to balance
the sweep of the arch and the empty space
around the petals of the flower so, despite
the repetition of a single motif, the whole
has a restful and harmonious rhythm to it.
Inv.142

21
Hanging

Silk warp ikat
Iran, Yazd, mid 19th century
L: 117 cm × W: 180 cm

'Ikat' is the name generally given to textiles in which the pattern has been resist-dyed on to the warp threads before weaving begins. In some parts of the world – for example India – patterns may also be resist-dyed on to the weft, creating what is called a 'double ikat'. In Central Asia the patterns are abstract, but in Iran it was more usual for the dyers to create designs of cypress trees and birds sandwiched between multiple borders. The process was lengthy: areas of the pattern not requiring a specific colour had to be covered by a resist in the form of either a wax or a paste, or they had to be tightly bound with thread so that the dye could not penetrate. After dyeing with one colour the resist had to be removed and then re-applied in the appropriate areas for the second colour. In this hanging five separate dye baths and five separate applications of a resist were required to create the pattern: there were two red dye baths, two blue dye baths and one of yellow. This combination added pink, red, yellow, orange, green, blue and dark blue to the original white warp threads. The patterning is all in the dyeing process. When the warp threads were transferred to the loom the weaver could quickly complete the length in plain weave, probably in as little as a day or two, whereas the dyers would have laboured long and hard. *Inv.130*

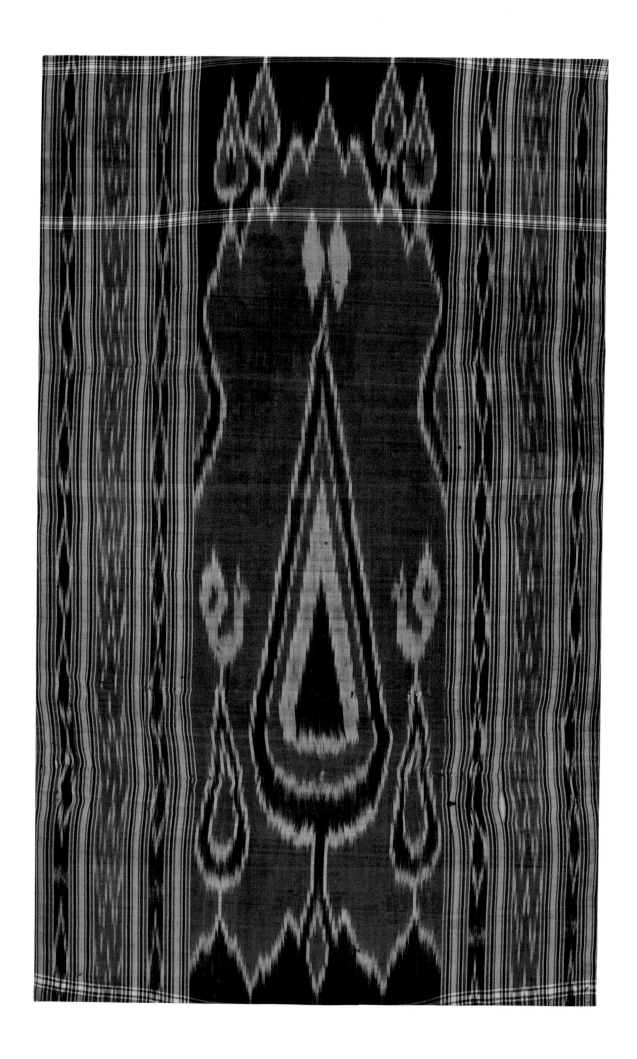

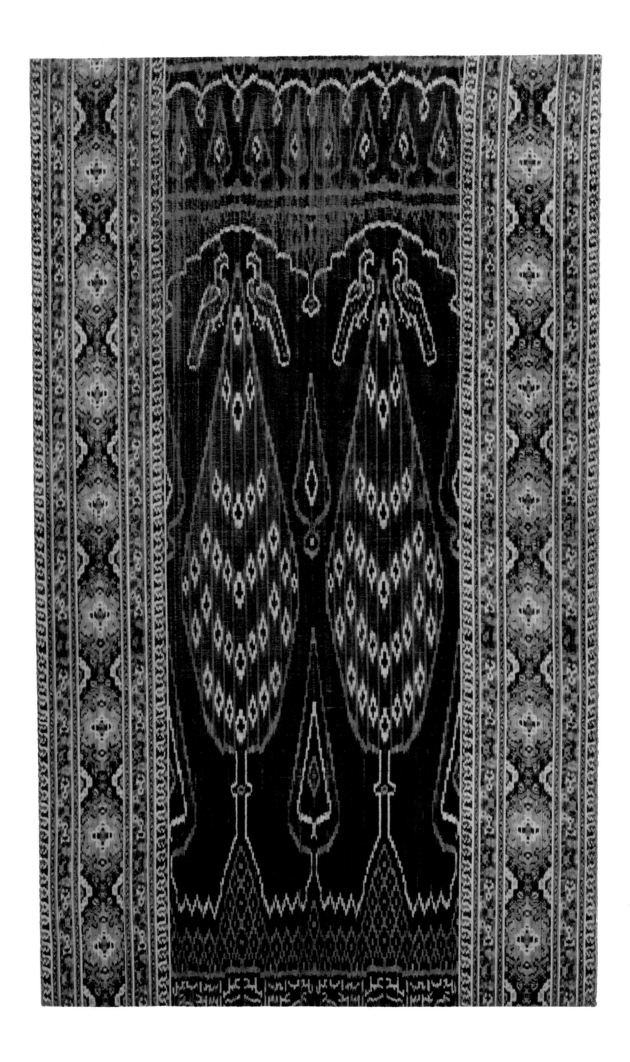

22
Hanging

Silk velvet warp ikat
Iran, Kashan, late 19th/early 20th century
L: 191 cm × w: 116.5 cm

The most sumptuous and costly ikats (for ikats see no. 21) are velvet. Velvet has a thick pile and is a difficult fabric to weave, requiring a particular type of loom to accommodate one warp for the ground and another warp for the pile, so it is usual for it to be woven in specialist workshops. Combine this with the lengthy and highly skilled process of resist-dyeing and it is understandable that velvet ikat was highly prized. Four separate applications of a resist and four dye baths were required to create this design of patterned cypress trees and birds. The dyes were man-made, synthetic dyes in red, orange, purple and turquoise. The first synthetic dye was made in 1856 by an English chemist called William Perkin. Synthetic dyes quickly replaced natural dyes in many places because they offered a wide range of bright colours, were easier to use and there was an element of novelty about them. There is an inscription woven along the bottom of this hanging stating that it was the work of Sayed Ismail. Although he may have been the designer or dyer, it is more probable that he was the owner of the workshop in which it was made. Rather like a modern 'designer label' it is an indication of the pride taken by the manufacturer in creating this hanging and the pride taken by the purchaser in recognizing its worth. *Inv.131*

23
Namazlık

Cotton and silk velvet embroidered
with couched metal thread and spangles
Ottoman, late 19th century
L: 153.5 cm × W: 92 cm

This example of a mat or hanging known
as a *namazlık*, decorated with a *mihrab*
shape, is embroidered with metal thread
in a technique known as *dival*. A purple,
or sometimes dark red or dark blue, velvet
was used as the ground fabric against which
the metal threads would glitter. All the
elements of the French-inspired design
– the scrolls, the basket, the flowers and
tassels – were drawn on to cardboard
and then cut out and pasted on to the velvet
and then metal thread was couched over

the cardboard shapes. In this example the
thread is a silver-gilt strip wound around
a yellow silk core and the cardboard creates
a slightly raised pattern with a flat surface
and sharp, precise edges. To soften this
and give a rounder profile in places, the
embroiderer has added cotton padding
under some of the larger flowers. A
second type of metal thread, an angular
gilt purl, has been used in addition to
copper or gilt spangles to add texture to
the centre of these large flowers. This type
of work was always done in professional
workshops and purchased from the bazaar,
and, because the preparation was a lengthy
process, these embroideries were expensive.
Inv.93

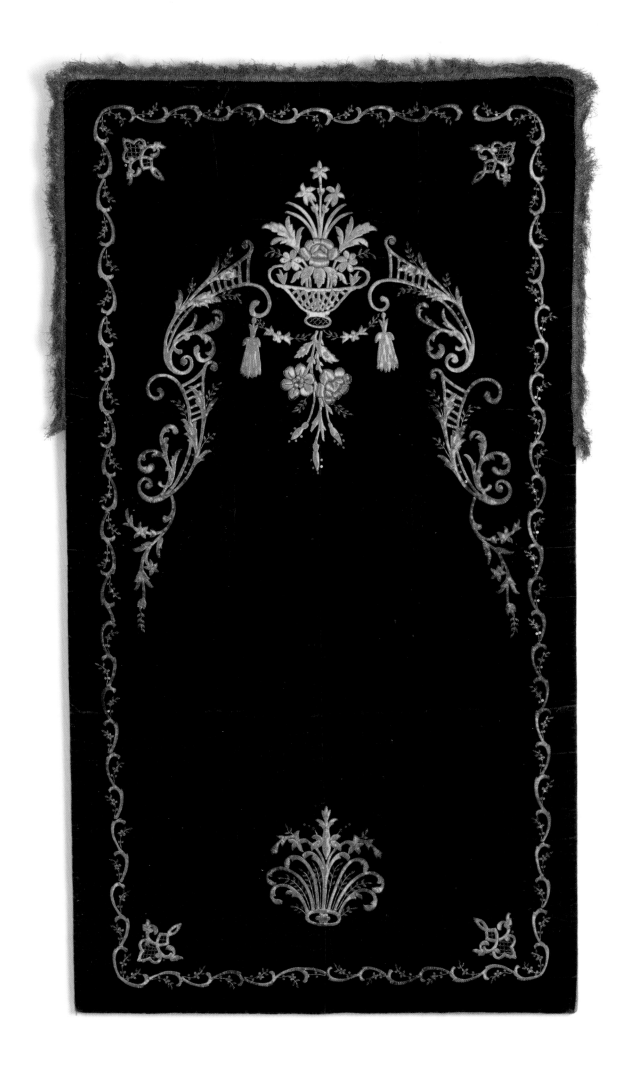

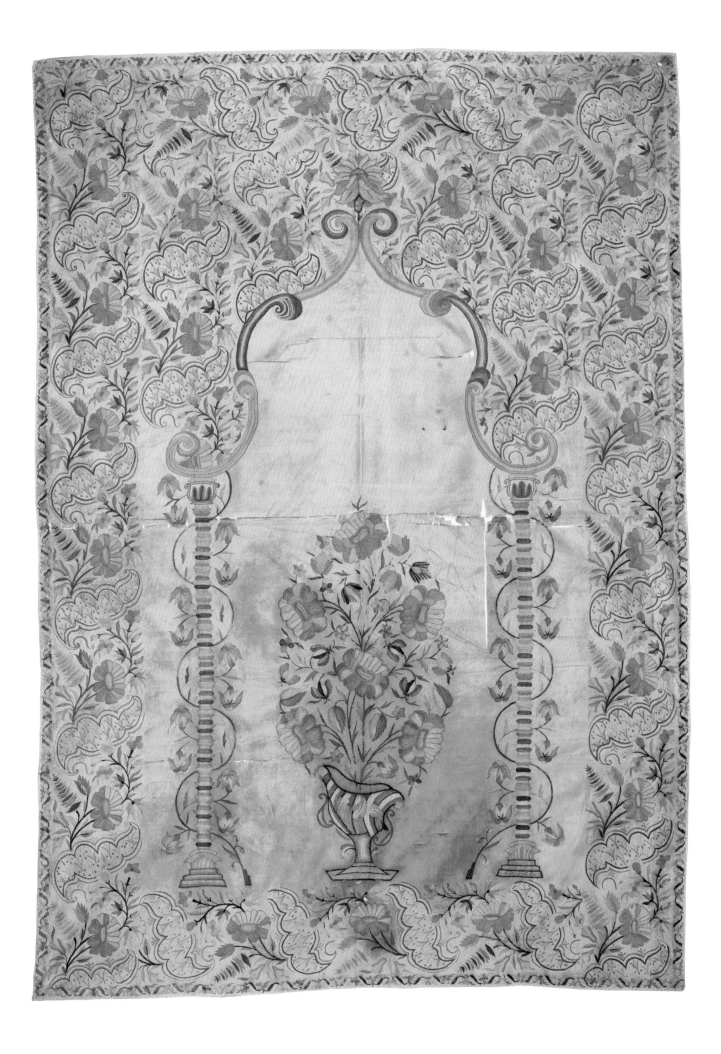

24
Prayer mat or hanging

Silk embroidered with silk
Ottoman, late 18th/early 19th century
L: 176 cm × w: 126 cm

The Ottomans loved flowers and in the middle of the 18th century they began to combine them with elements of European Rococo. This is a typical design with a large spray of flowers in an asymmetrical vase, graceful s- and c-scrolls, curving and flowing patterns interrupted by large stylized leaves, and all worked in soft shades of pinks, blues and yellows. This is in sharp contrast to the strong reds and blues and almost abstract flowers of older embroideries (nos. 15 and 16). It was not only the designs and the palette that changed in the 18th century, but a new embroidery technique was introduced from India called tambour work (in Turkish, *kasnak işi*). It is a chain stitch made with a fine metal hook and it can be worked very quickly, covering a large amount of ground with little real effort. The wide border and the spandrels in the upper half of the mat/ hanging are filled with a repeating pattern formed by two motifs – a large stylized leaf and a long curving stem bearing leaves and flowers. Their outlines were printed on to the silk ground and then embroidered with a tambour hook. *Inv.155*

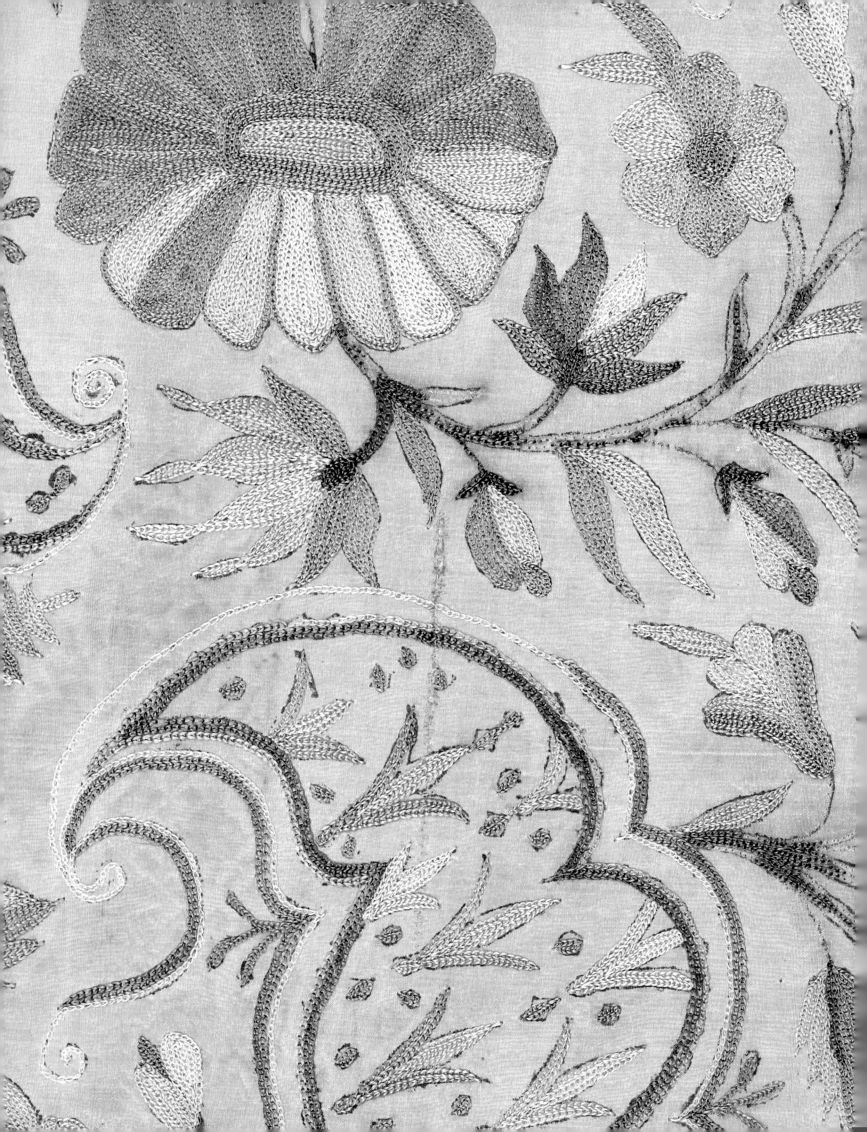

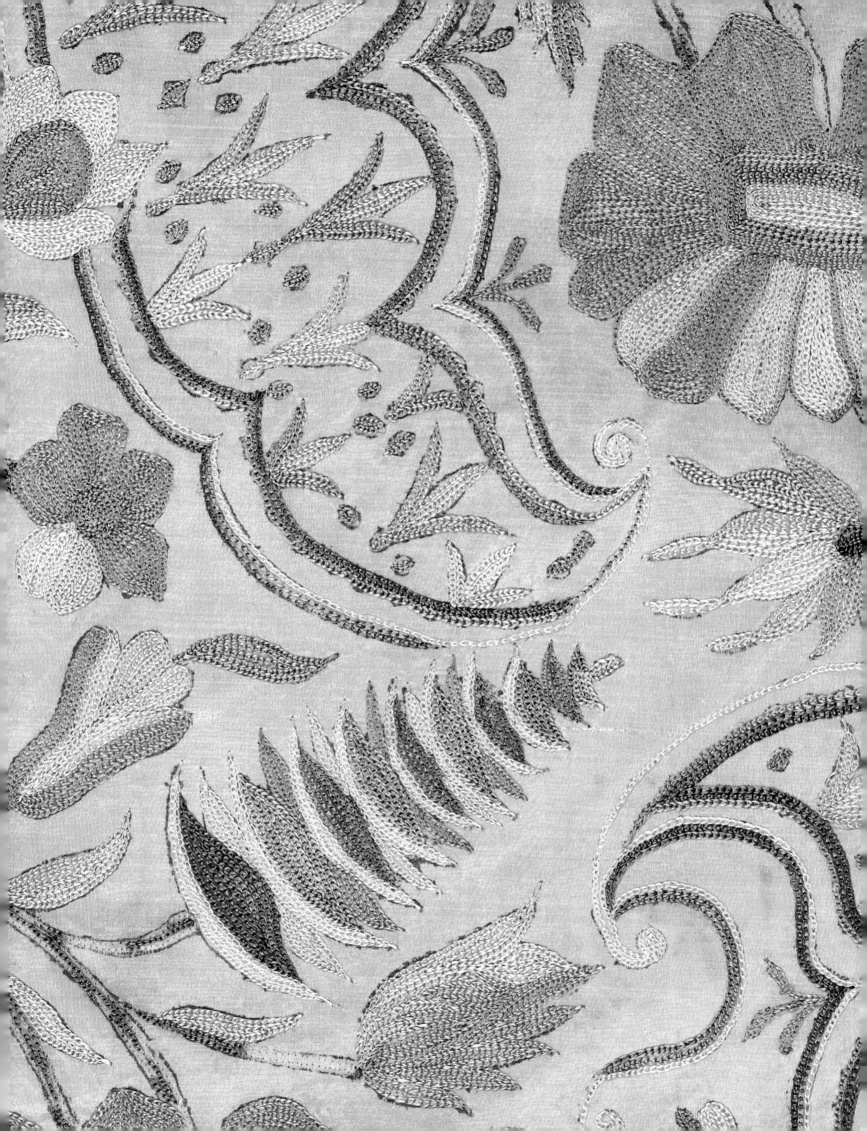

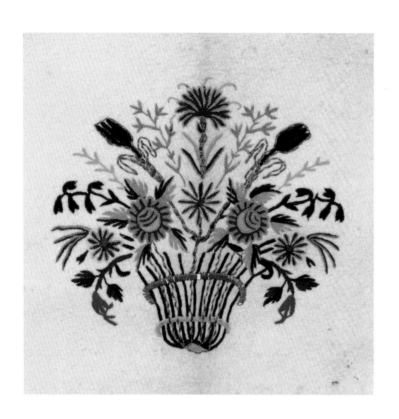

25
Namazlık

Felted wool embroidered with wool
and metal thread
Syria, 20th century
L: 125 cm × W: 109 cm

Designers often delight in tricks, in their
ability to create illusions. This bright and
delicate flight of fancy is worked with
unpromising materials – thick felted
wool, relatively thick woollen threads and
simple chain stitch – yet the fine lines of
the design and the care with which the
embroiderer followed the intricate details
have created a picture of great lightness.
This is a prayer mat, known in Ottoman
lands as a *namazlık*, meaning 'for prayer'.
Although they could be placed on the floor

at prayer time, something as decorative
as this may have been hung on the wall
to indicate the direction of Mecca. The
design follows the standard format with
an arch towards one end, a pillar or column
to each side and lamps hanging from the
apex, but then the designer has added a
fantastic scene. Impossibly balanced on
top of the pillars are two mosques with
their domes and minarets on either side
of a large dome supported only by flowers.
More lamps are hung in the mosques, lots
of them are strung between the minarets
as if to brighten the star-lit sky, and three
types of metal thread have been used in
the embroidery to add actual brightness
to the textile itself. *Inv.69*

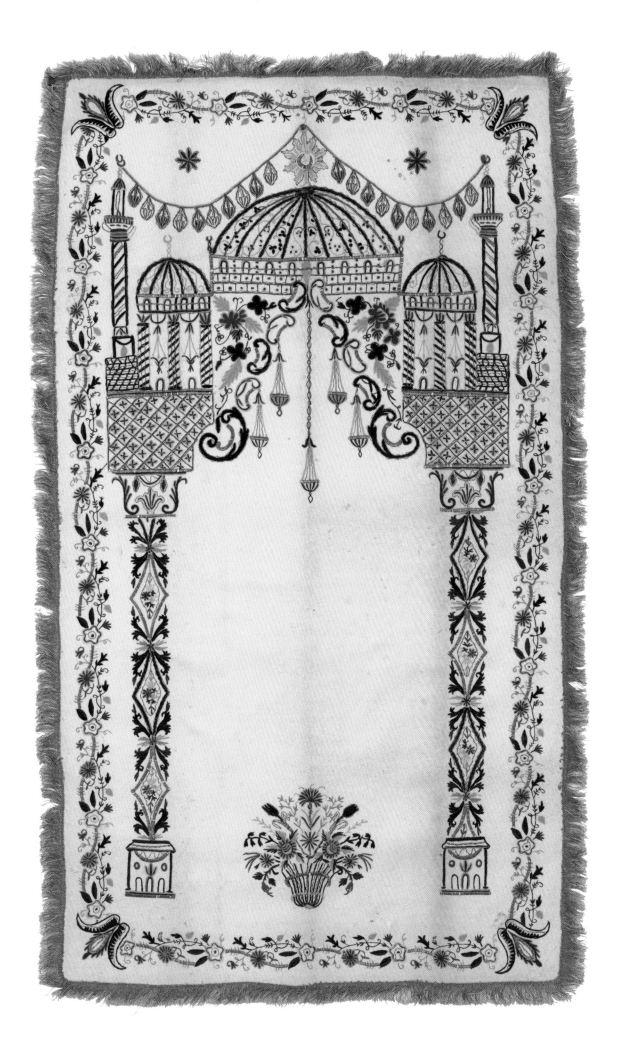

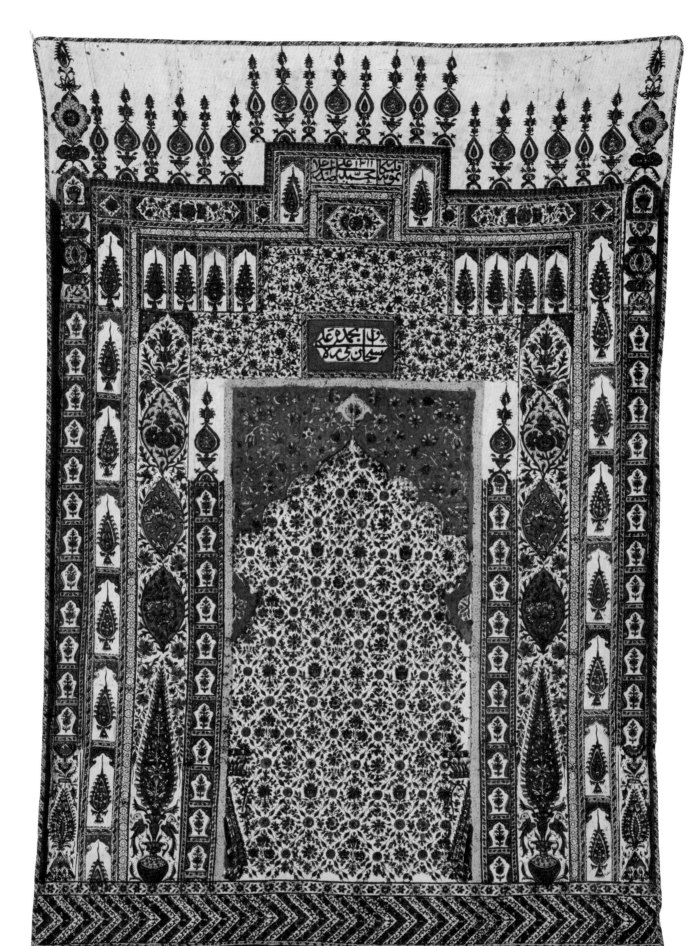

26
Prayer mat

Resist- and block-printed cotton
Iran, probably Isfahan, dated AH 1311/
AD 1893
L: 120 cm × w: 85 cm

There are small discrepancies in the vertical lines of pattern down the sides of this mat which permit whoever examines it to appreciate the complexity of fabric printing and the need to plan carefully before committing printing block to cloth. In the vertical border near the sides the printer was unable to obtain eight complete niches, each containing a pointed tree, and has seven and a half down one side and eight trees on the other but in only seven niches. He faced a similar problem with the innermost border of smaller niches containing a flower, and has twelve almost complete ones down one side and eleven down the other. He was working with a wide selection of printing blocks in different sizes and had to select the ones he needed to build up, detail by detail, the patterns he required, so slight miscalculations in this elaborate compilation should be forgiven. Variety in detail is the characteristic of this type of prayer mat. In the diamond shapes of the central niche, for example, there are eight different flowers, each encircled by a wreath. The eye never tires of looking at something so complex. A justly proud manufacturer included the date and his name, Muhammad Ali, in a small panel towards the top of the mat together with the words 'A Sample of Qalamkar' and 'Highest Quality'; the following verse is printed in the panel below: 'How perfect my Lord is, The Most High, and I praise Him'. *Inv.80*

27
Prayer mat

Resist- and block-printed cotton
Iran, probably Isfahan, dated AH 1313/
AD 1895
L: 137 cm × W: 94 cm

The eye should be drawn to the central panel in one of these printed cotton prayer mats, to the arch shape which represents the *mihrab*, and the choice of this luminous red ground achieved the desired effect. Two shades of red have been used with darker red *boteh*s randomly printed to fill the space between the larger, white ground ones. Taken as a whole, these white *boteh*s are a little too big and are out of proportion to the rest of the design. However, their curves and slightly irregular placing add liveliness to the otherwise stately architectural borders that surround them. The narrow red and white border is an Iranian version of a delicate hand-drawn pattern found on cotton panels printed in India. These were made along the Coromandel Coast and in Gujarat for export to Iran and set a high standard in terms of detailed patterns and bright, clear colours. Persian printed cottons are sometimes called *qalamkari* from the Persian words 'qalam' (pen) and 'kari' (workmanship) because some details on the finest pieces were added with a pen. There are no drawn details on this mat, but it is a good-quality piece, copying the fashionable red and white Indian border and using bright colours, adding a strong yellow to the lower border and to the square panel above the centre to guide the eye once more to the *mihrab*. There is a stamp on the reverse of this mat, at the top, which shows through to the right side; it gives the date AH [1]313 together with the word *Qalamkar*. *Inv.27*

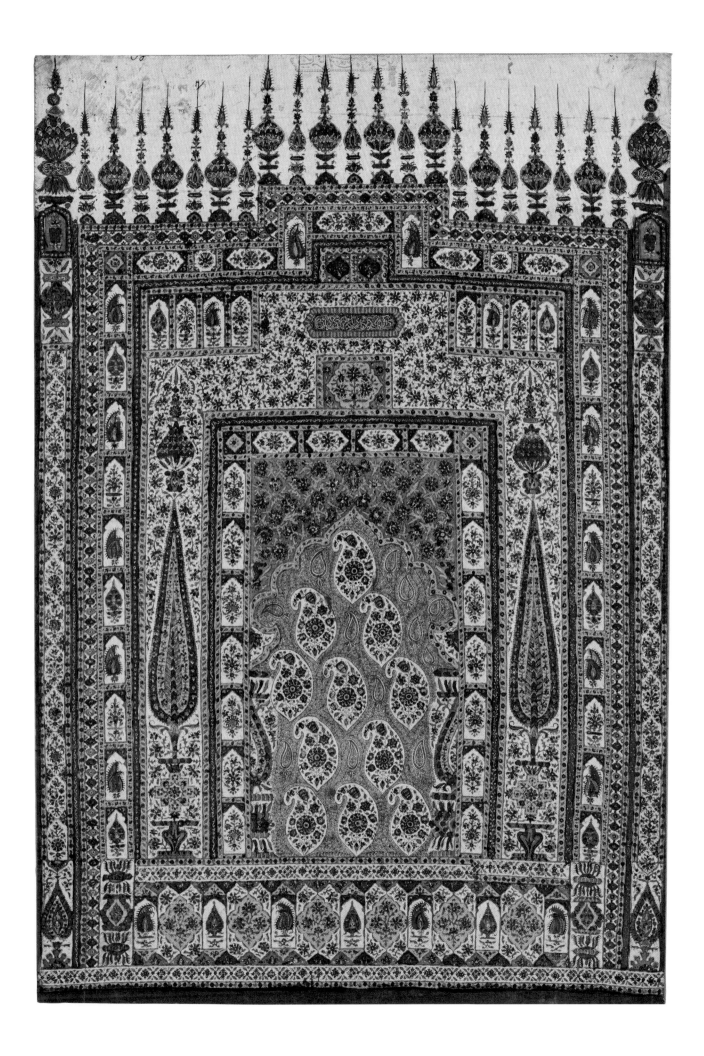

Geometric Patterns

Geometric designs are the most characteristic feature of Islamic art and are found in their most perfect form decorating both the interior and exterior of buildings, symbolizing the principles of *tawhid* (the unity of all things) and *mizan* (balance), which are the laws of creation. Repetition, symmetry and variation are important aspects of Islamic design and are also the principles of all textile designs. Patterns formed by straight lines and angles are loved by textile designers because their bold lines and simple forms can have a strong visual impact. Two colours are sufficient to create a powerful effect; more can be used but a large palette is not as essential for geometric patterns as it is when working with floral patterns, where nuances of tone and shades of light and dark are essential to create a realistic form.

It is sometimes said that geometric patterns are masculine and floral ones are feminine, but the two are frequently combined in the form of stripes. Striped fabrics are simple to weave and require only the use of different colours in the warp for vertical stripes, different colours in the weft for horizontal bands, and in both for a checked pattern. Although they can be varied by changing the colour combinations, stripes by themselves can be monotonous. They become far more complex and interesting, however, if the intricate details of floral motifs are inserted between their lines. It is not difficult to set up a loom in such a way that diagonal stripes can be woven and their direction can be varied to produce a zigzag or chevron pattern. Using the same principles, diamond-shaped lattices or grids can be made by crossing diagonal lines, and this proved to be a very popular format for woven and printed textiles because the spaces within the grid could be filled with different motifs and therefore the possibilities were almost endless. Exactly the same patterns of stripes and grids can be achieved with embroidery but the effort required for this was far greater than that exercised by the weaver, so geometric designs were usually woven.

Crescent moons and stars, the *khamsa*, also known as the Hand of Fatima, and short inscriptions contained within oblong cartouches were sometimes used as decorative motifs; calligraphy, which will be considered in the following section, is a form of geometric ornamentation. Representational forms are not used as decoration in Islamic religious contexts so designers concentrated their talents on the development of intricate geometric patterns based on their advanced understanding of geometry and mathematics. This is most often seen in tile work and woodwork, but the same principles were used by textile designers in medieval Islamic Spain and in North Africa, where they combined octagons and eight-pointed stars with roundels and interlaced lines. Not all geometric patterns are based on sharp angles and straight lines, however, and a surprising number have sweeping, swirling lines forming waves, spirals, arabesques and delicate tracery. These curvilinear designs are most easily embroidered, rather than woven, on to fabric and are usually found decorating various outer garments, where they would be seen and admired for their ingenuity and beauty.

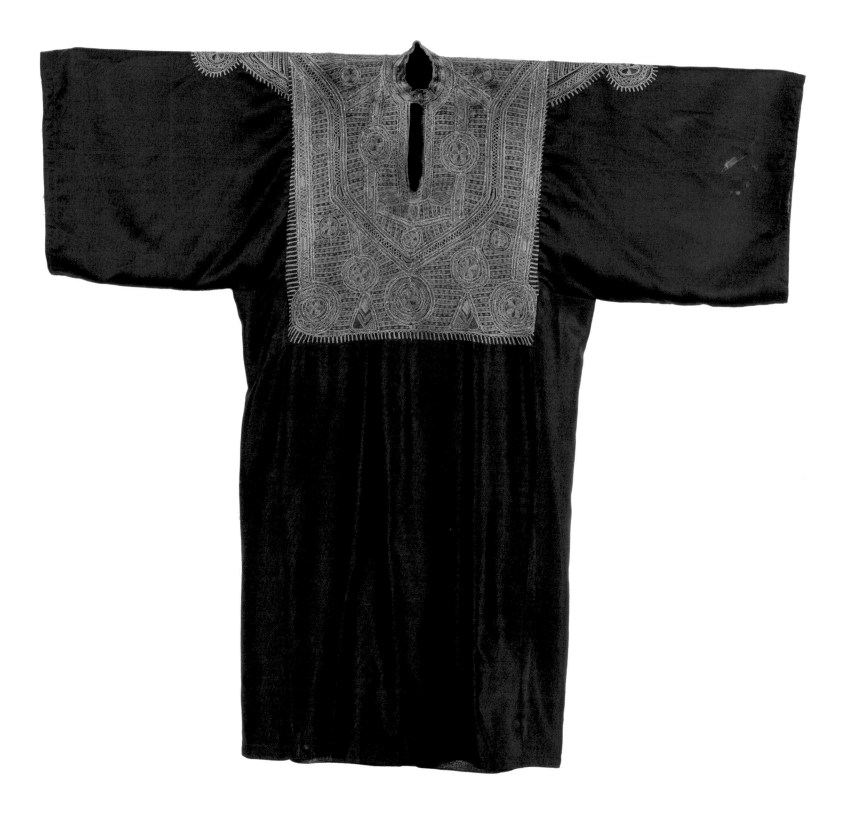

28
Woman's dress

Cotton twill embroidered with cotton
Yemen, mid 20th century
L: 133 cm × W: max. 141 cm

The dress is made from cotton twill, on
to which the embroidery on the upper part
of the sleeves was directly worked. The
embroidery on the bodice, however, was
worked on a piece of plain weave cotton
and was then sewn on to the dress, and
some of the pattern around its edges has
been lost in the seams. The patterns and
the quality of workmanship are the same
in both places, but the embroidery on the
sleeves contains no metal thread and
the colours are slightly brighter, which
suggests that the chest panel was taken
from an older dress. Further alterations
were made when a band of velvet was
added to make a stand-up collar and a zip
was sewn into the front slit. The exquisite
embroidery over the chest has incredibly
fine details, combinations of different
textures and a subtle, restful palette. With
its broad lines and prominent circles it
looks as if the embroiderer was replicating
in thread the magnificent silver and
jewelled medallions and triangular amulets
a woman might wear to express her wealth
and status. Perhaps the embroidery was a
substitute for what the wearer desired but
did not possess. So it is not only a panel of
beautiful patterns but also an expression
of a woman's dreams. *Inv.52*

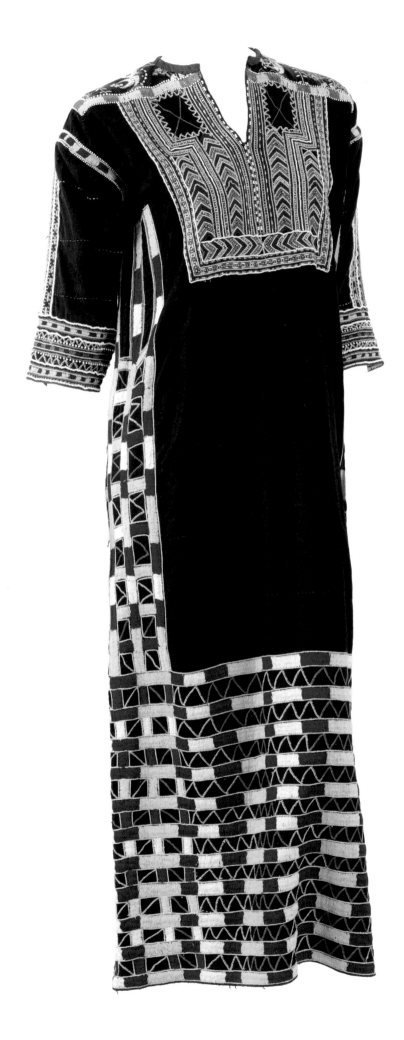

29
Woman's dress

Cotton twill embroidered with cotton
Saudi Arabia, southern Hijaz, Bani Malik
tribe, 2nd half 20th century
L: 131 cm × W: max. 123 cm

The dense embroidery down the sides
and on the lower part of this dress, on
the sleeves and across the chest has been
worked through an additional layer of
fabric, an inter-lining which ensured the
dress retained its shape. The stitches which
secured it to the main fabric can be seen
as a series of widely spaced horizontal lines.
The embroidery may be divided into two
types: there are broad and very dramatic
yellow, red and white lines, and on the
sleeves and the chest panel there are less
obvious, more restrained lines and chevrons
with beads. This is the most practical way
to divide decoration, to have the simplest
and most obvious pattern in the lower part,
where it is clearly seen from a distance,
and to have the finer, detailed patterns
near the face, where they can be admired
on closer acquaintance with the wearer.
A panel of roller- or screen-printed fabric
with additional embroidery of a completely
different character to that on the dress has
been applied across the back and over the
shoulders. At one time in the past this may
have been done to add a contemporary
detail to an otherwise traditional garment,
but over the years it has become an integral
part of the tradition itself. *Inv.47*

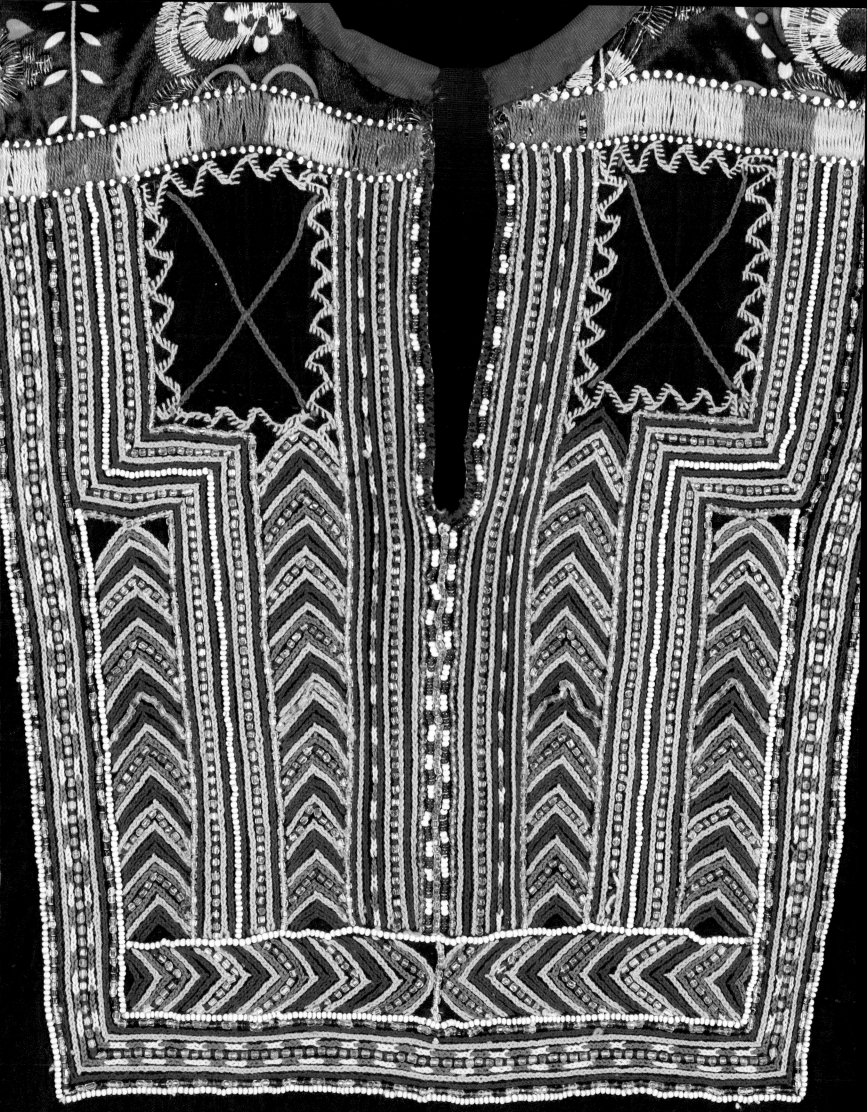

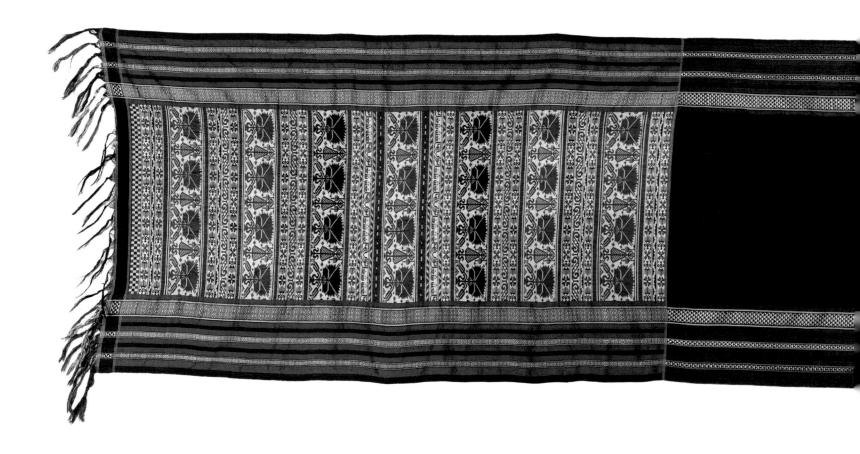

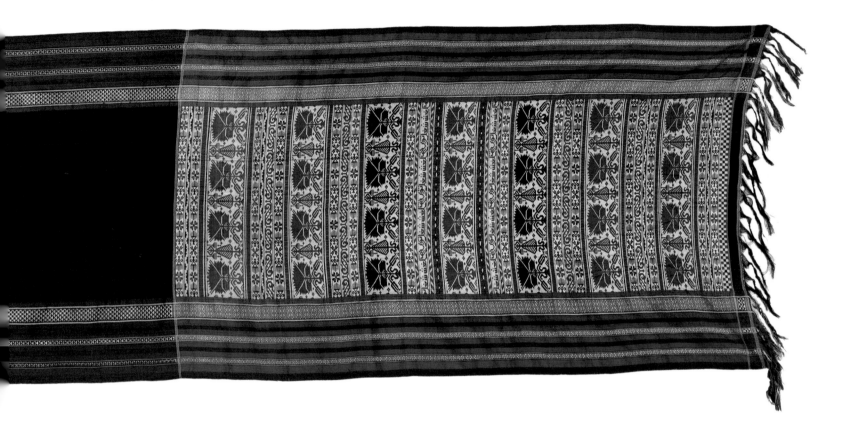

30

Ajar

Tunisia, Tunis; 1st half 20th century
L: 270 cm × W: 58 cm

In the 19th and 20th centuries these veils
were woven in workshops in Tunis and were
worn by affluent city- and town-dwelling
women to cover themselves while out in
public. The elaborately decorated stripes
and bands would have covered their head
and shoulders, while the translucent black
rectangle in the centre concealed their
face, allowing the wearer to see through it
without exposing her face to strangers.

This style of veil, or *ajar*, is said to have
evolved in the small northern hill-town
of Testour, in which many Muslim refugees
from Andalusia in Spain settled at the
beginning of the 16th century. As Tunisia
was part of the Ottoman Empire until 1884,
it is not surprising that the designs are
often a combination of motifs from both
Andalusia and the Ottoman world. The
fan-like carnation came from the east and
the purely geometric motifs came from a
long tradition of Hispano-Moresque art.
Inv.148

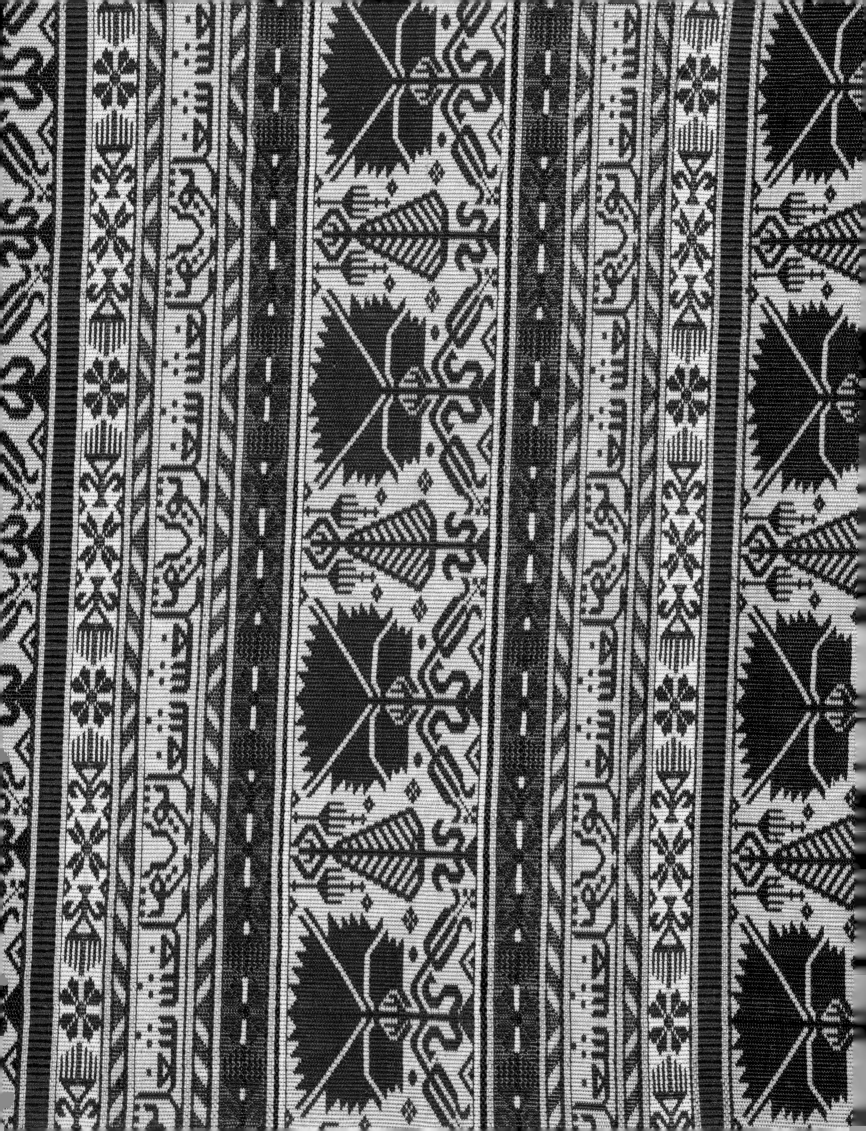

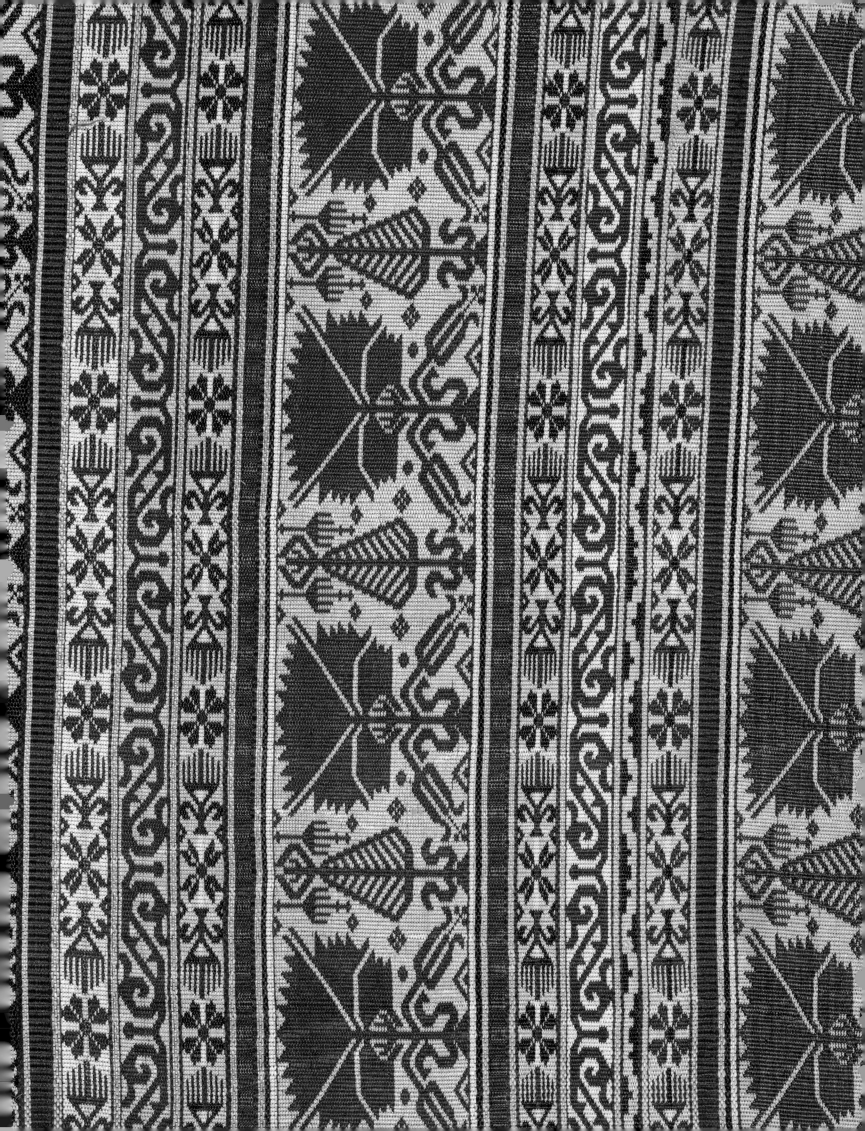

31
Chador

Net embroidered with metal thread
Iran, 19th/20th century
L: max. 158 cm × w: max. 301 cm

Iranian *chador*s are draped over the head, they are full length and the edges are held or pinned under the chin. This delicate bridal *chador* would have been secured with pieces of jewellery and, as it is very lightweight, would have been worn over another, less transparent one. It is embroidered with narrow strips of silver-gilt plate, each approximately 3 mm wide, that have been threaded through the holes in the net, criss-crossed, pinched off with the fingernails and pressed flat between the fingers. This technique may have a long history but it became very popular in the late 19th century, especially in Egypt and in parts of Anatolia, where it is known as *tel kirma*, or 'broken wire'. There is a border of linked trefoils around the edges of the *chador* and a diagonal sprig of leaves, flowers and birds in the two corners, but the main decoration is a small six-pointed star alternating with an even smaller diamond. These are embroidered at regular intervals and when viewed from a distance it can be seen that they form a zigzag pattern across the net. The hexagonal net ground of this semi-circular *chador* is machine-made and four pieces were required to give the correct shape. *Inv.121*

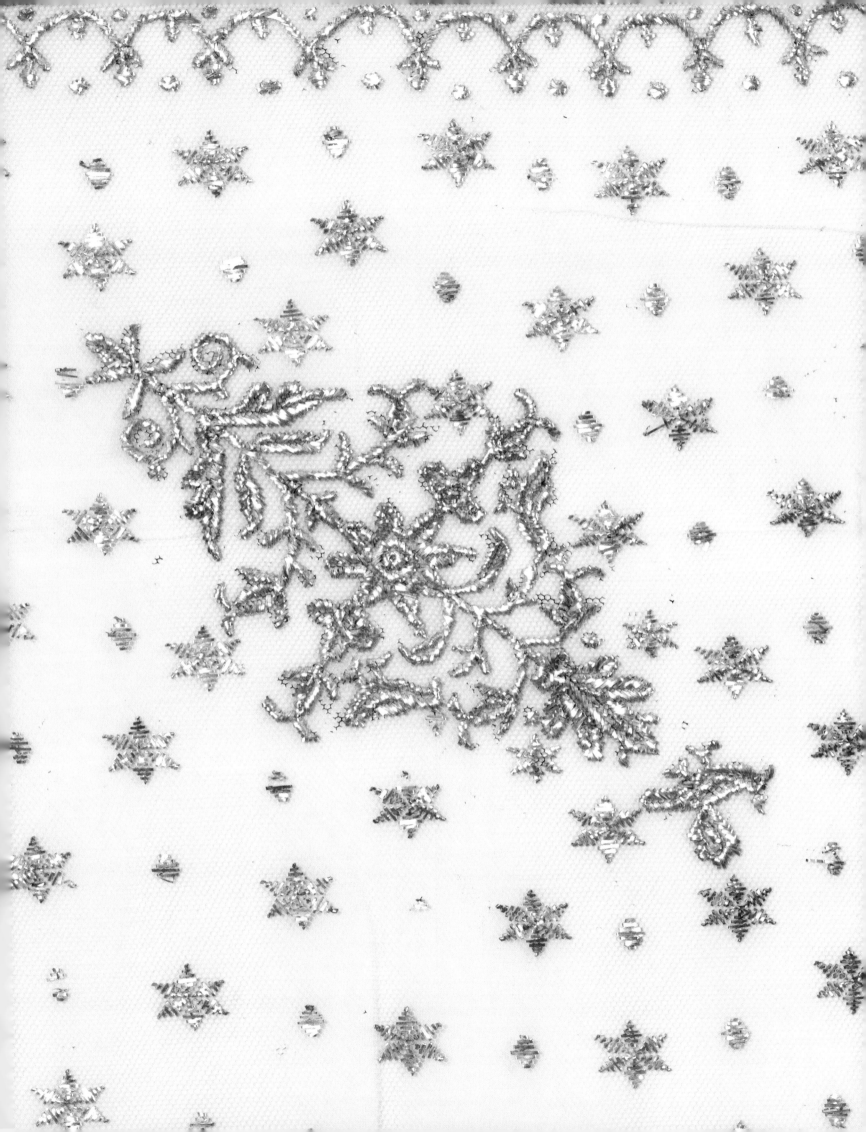

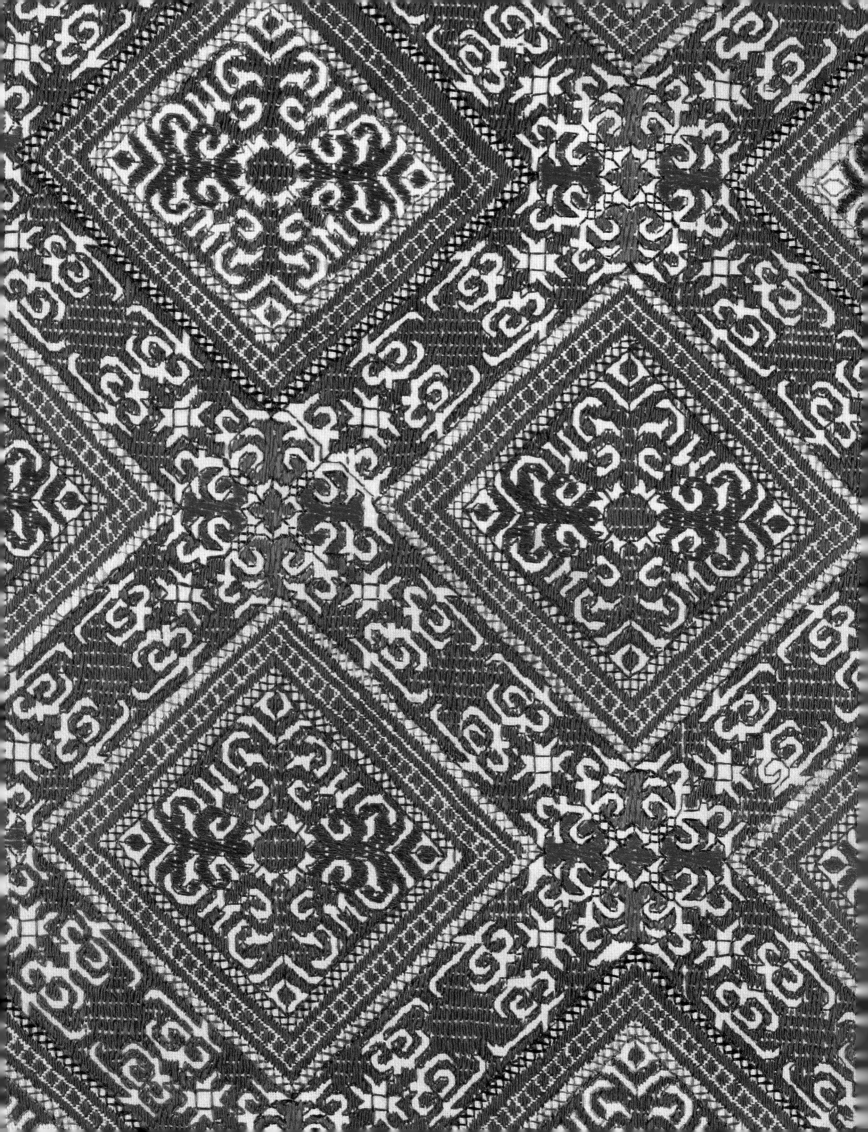

32
Woman's shawl (part)

Cotton embroidered with floss silk
North West Frontier, Hazara region,
20th century
L: 253 cm × W: 45 cm

The complex pattern covering this cloth –
so dense that hardly any of the ground
fabric is visible – was worked by counting
the number of threads over which the
stitches were made. The surface darning
stitch chosen for this piece means that
precious thread was not wasted on the
reverse, where it was not essential, but no
economy was made when it came to the
effort required to count threads. This is half
of a woman's shawl or head cloth. It would
have been joined to an identical piece to
complete the large covering. The pattern is
typical for Hazara, using shades of pink
and red to create stars and curling horns
within diamond-shaped blocks. Clever use
of small amounts of other colours breaks
up what might have been a monotonous
pattern by varying the colour of silk that
outlines the inner and outer edges of the
diamonds. The design is not symmetrical:
in one half the second deepest border
contains dark outlining stitches that are
absent from the corresponding border in
the other half, and yet this is satisfactorily
balanced by the fact that the main pattern
closest to the simpler border contains more
variation in colour. *Inv.66*

33
Man's *abba*

Silk and metal thread with tapestry
woven decoration
Syria or Iran, late 19th/ early 20th century
L: 140 cm × W: 140 cm

There is nothing subtle about the colour
combination in this *abba*. Royal purple
and bright gold thread send out a clear
message of wealth and power, they attract
attention, they say 'look at me'. The man
wearing this robe could not fade into the
background. As with many garments,
the decoration comes alive when draped
around a moving body. The large gold
triangular panels across the back of each
shoulder slip forward along the upper arms,
contrasting with the broad purple stripes
down the front; the zigzag band of gold
along the horizontal seam forms glittering
blocks at hip level; what the mind knows
are straight vertical stripes become diagonal
ones sweeping up and out from the hem,
changing the overall pattern with every
step of the wearer. This *abba* belonged to
Major-General Sir Percy Zachariah Cox
(1864–1937), who was a British Indian Army
officer, administrator and diplomat and one
of the major figures in the creation of Iraq
(see no. 46). *Inv.145*

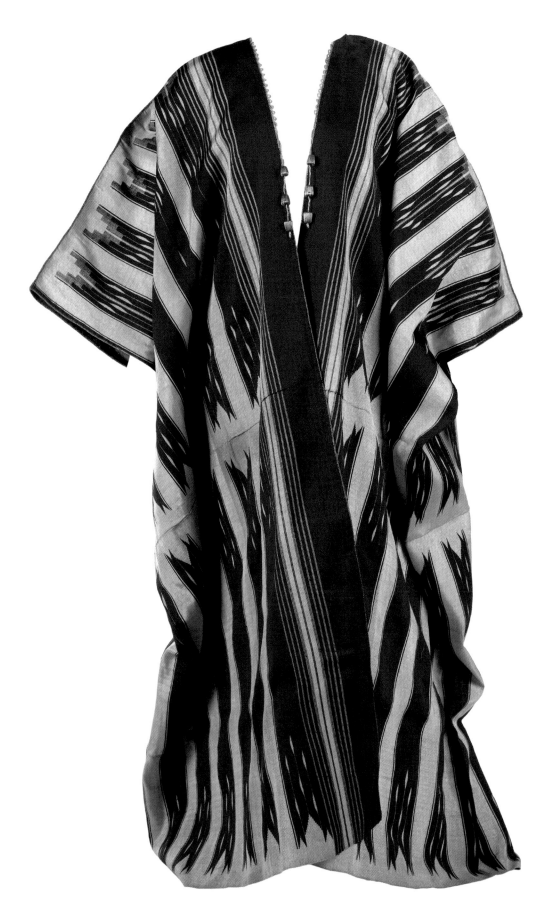

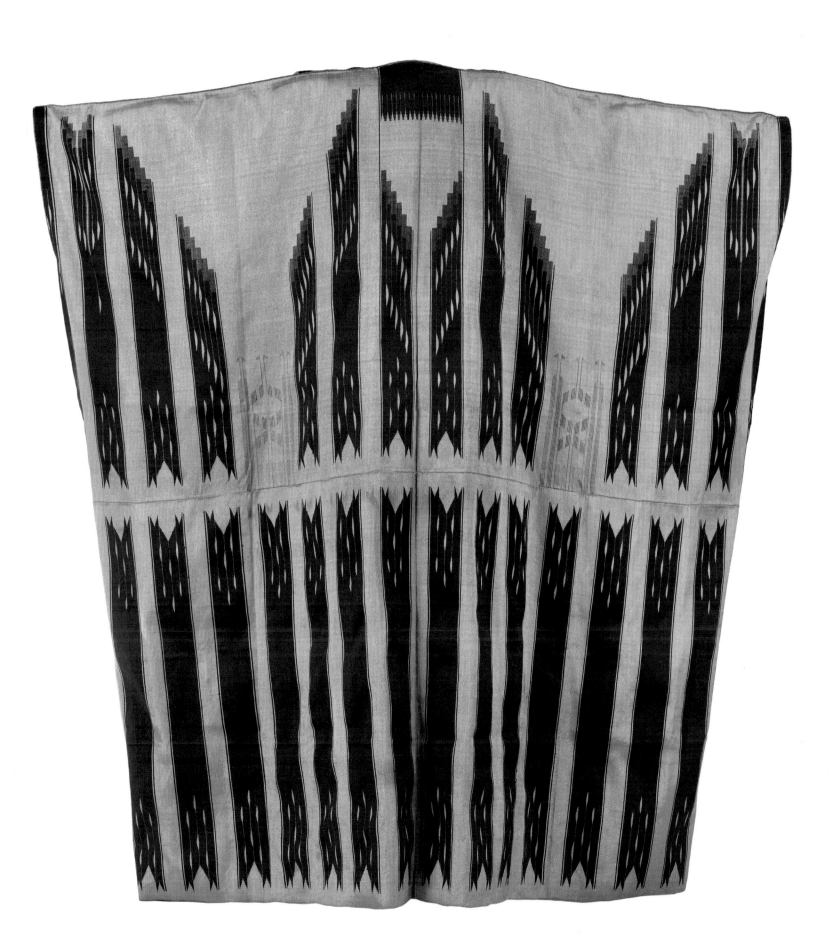

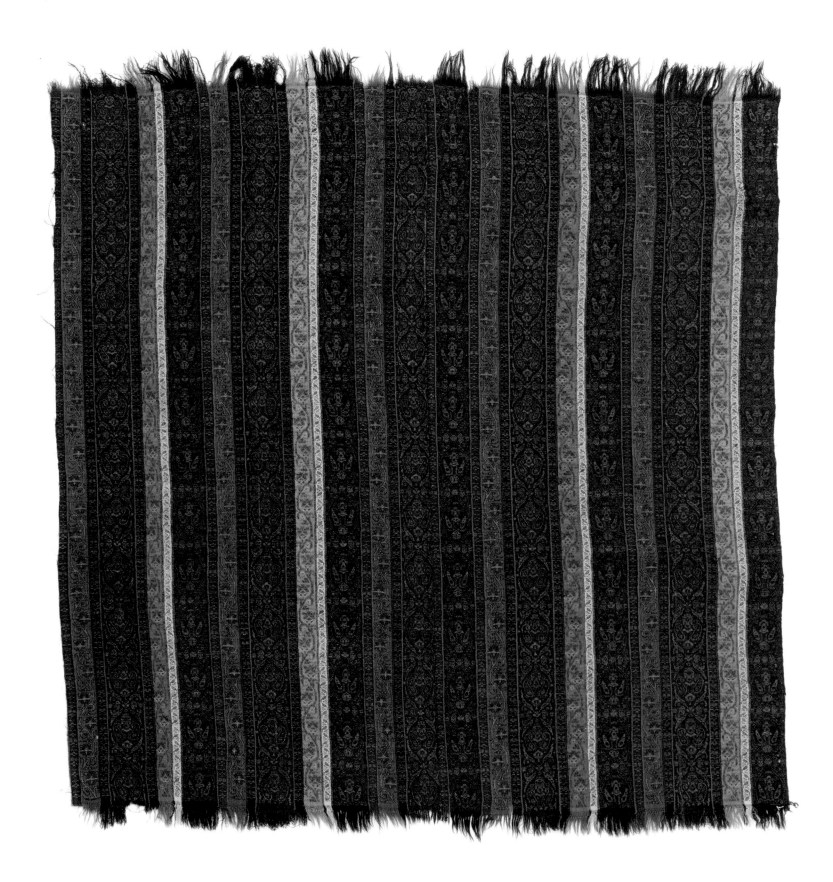

34
Shawl

Wool twill brocaded with wool
Iran, probably Kerman, mid or
late 19th century
L: 120 cm × W: 117 cm

The simpler the basic design structure, the greater the effort required by the designer to disguise it, and what could be simpler than a shawl decorated with stripes? Yet the pattern on this soft and warm fabric is far from monotonous. The designer has used three different widths of stripe and four different patterns. The narrowest stripes have either a dark blue or a red ground with a tiny pattern which might be a flowerhead. There is also a white ground stripe with a soft zigzagged line of pointed leaves. The widest stripes, also dark blue or red, contain a series of oval medallions, which are formed by four pairs of split leaves and include a pair of small *boteh*s within them. The medium stripes, orange, pale blue or green, have an undulating floral stem running along them. After varying the width and the patterning of the stripes the designer added another layer of elaboration by choosing to use a large number of colours, contrasting the majority darker ones with a few lighter, brighter ones. There is a seam down the centre of the shawl, perhaps repairing a worn area, and it has disrupted the regular repeat of the colours, but by doing so it has actually added further visual interest. *Inv.75*

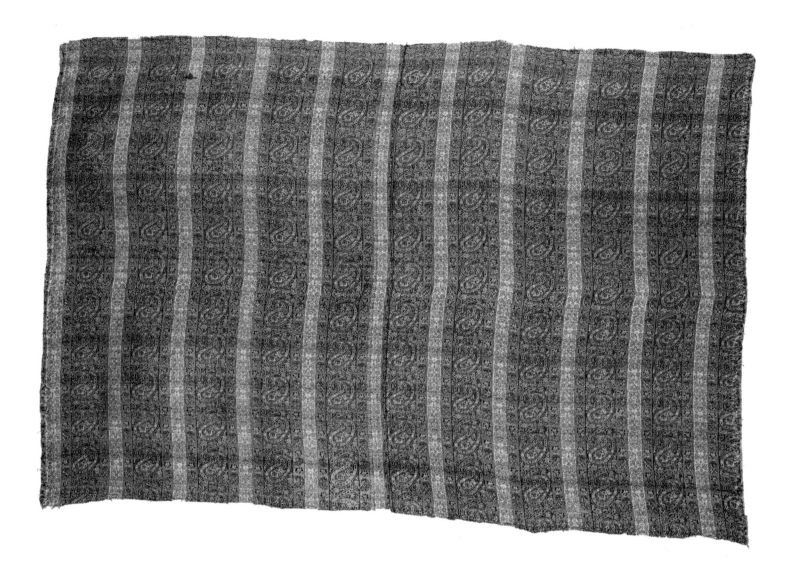

35
Dress fabric

Woven silk twill
Iran, Yazd, 2nd half 19th century
L: 62.5 cm x W: 94 cm

The demand for dress fabrics in ever-changing patterns was great in Iran in the 19th century and textile designers were under pressure to produce novel combinations of the most popular motifs. This type of woven silk is known as Husein Quli Khan and was probably named after a merchant who developed the style in the 1860s or early 1870s. It combines the fashionable *boteh* designs, which were used in expensive hand-woven Kashmir and Kerman woollen shawls, with a machine-woven technique in which the coloured wefts are taken from side to side across the back when not required for the pattern. This type of fabric would have been used to make jackets and longer robes, for which stripes were exceptionally popular. There is a broad stripe and a group of three narrower stripes. The broad stripe contains the *boteh*, leaning to one side and creating a sense of diagonal movement to balance the strong verticals. The white stripe at the centre of the narrower group lightens the overall palette and the tiny *boteh*s in the pink stripes to either side of it lean in towards it, adding balance to the group. The colour pink unites the different elements of the pattern. *Inv.19*

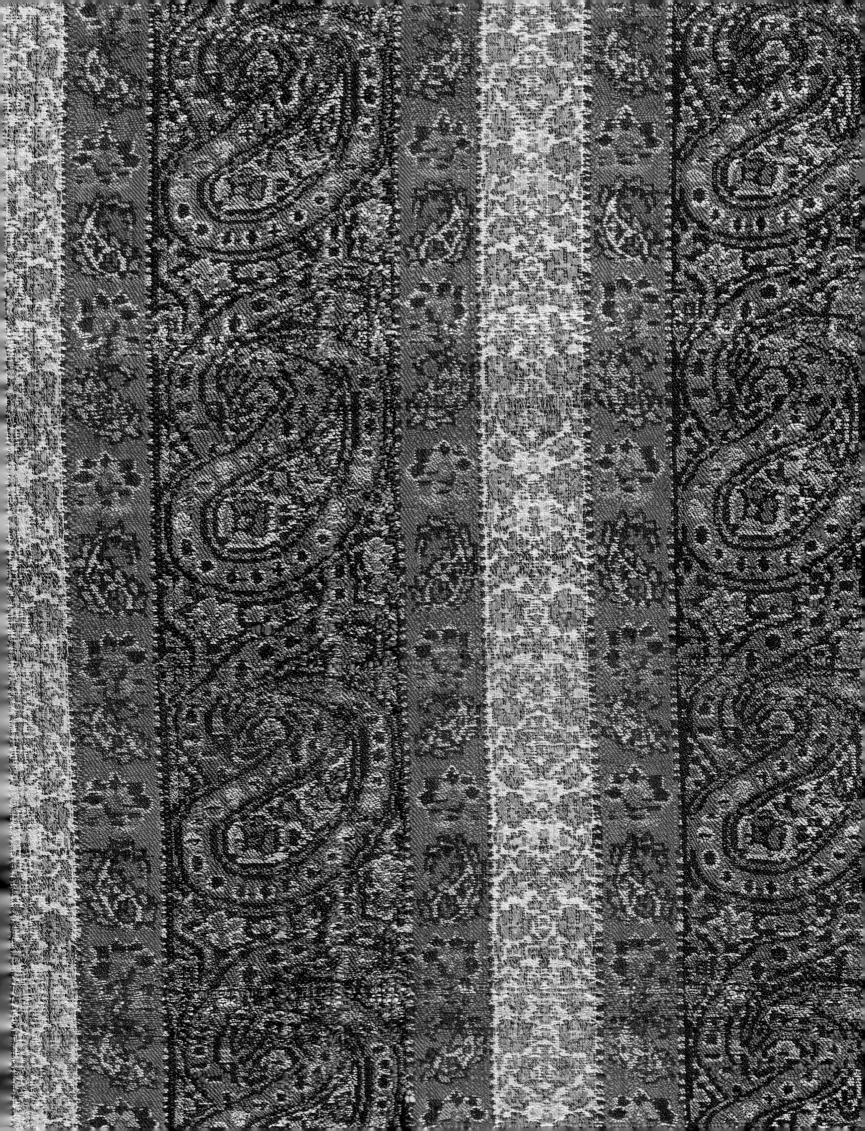

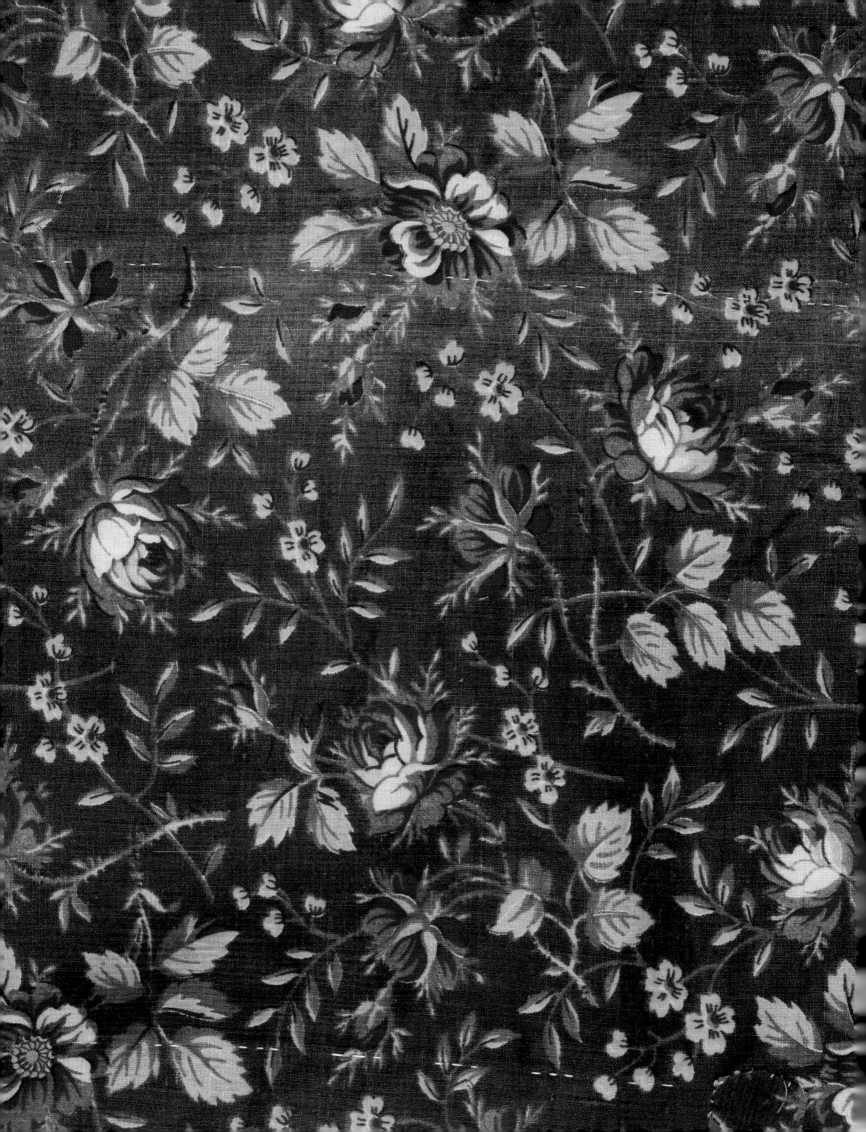

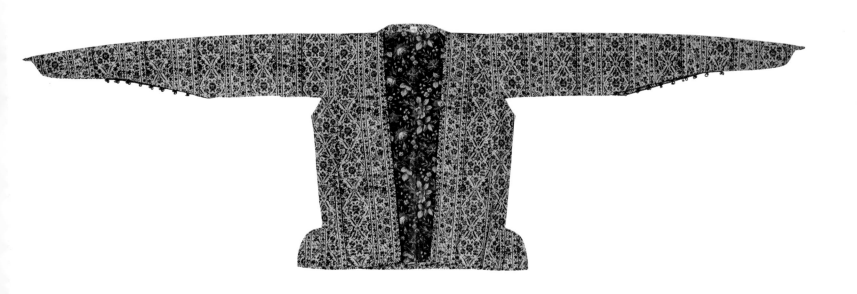

36
Jacket

Block-printed cotton lined with
roller-printed cotton
Iran, 19th century
L: 55 cm × w: max. 181.5 cm

Striped cotton jackets were worn by both
men and women in Iran in the 19th century
and there is evidence from painted portraits
that two or sometimes three were worn
together, one on top of the other, so the
demand for new designs must have been
constant. Designers often began with two
stripes of equal width and then divided
one of them by drawing a narrow stripe
down either side. In this piece the wide
stripe contains pointed medallions around
a circle of flowers and a central blossom;
the other stripe contains an undulating
floral stem between two very narrow
stripes in which the designer has drawn
a tiny, stylized pattern of flowerheads.
To get the correct shape of garment
and to avoid unnecessary wastage,
pieces have been added at the sides and
these interrupt the flow of the patterns.
Linings fulfil a function by maintaining
the structure of the garment and making
the wearer more comfortable; they are
generally not intended to be seen and
so are often plain, undecorated fabrics.
The roller-printed cotton, with blossoms
on a mauve ground, used to line this jacket
was an expensive import from one of
the many printing mills near Moscow
and a secret pleasure for the wearer alone.
Inv.17

37
Woman's trouser panel

Woven silk
Iran, 1st half 19th century
L: 53 cm × W: 45 cm

The fashion for diagonally striped trousers among wealthy women in Iran spanned at least three centuries, from the middle of the 16th until the middle of the 19th. The most expensive panels would have been woven; embroidered ones would have been a cheaper option. The narrow horizontal border on these pieces always formed the lower part of the trouser leg, at the ankle; this meant that the pattern of floral sprays would have been upside down to an observer but the right way round for the woman wearing the trousers and looking down at her feet. There are three different floral sprays in the widest stripes, each one forming a large diamond, although there are no lines dividing one diamond from the other. Because, unlike weavers, embroiderers work with few technical limitations, the patterns in embroidered panels are frequently more complex, with wider and narrower stripes but still with the same diamond-shaped floral arrangements. *Inv.156*

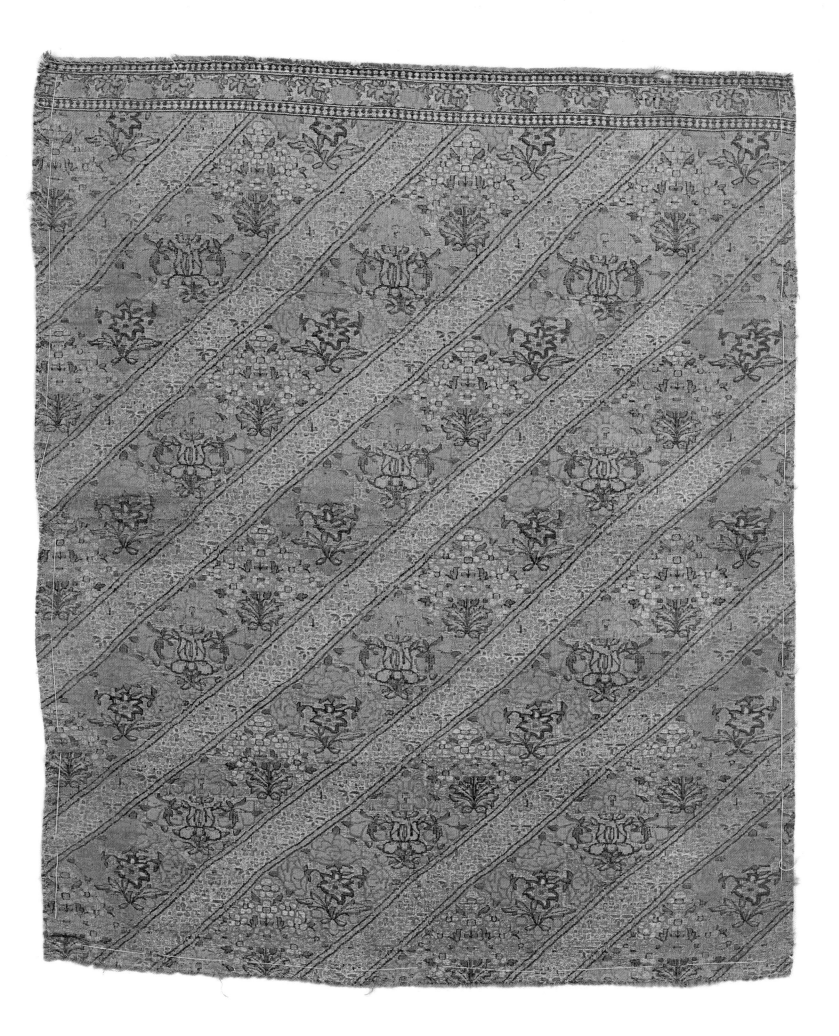

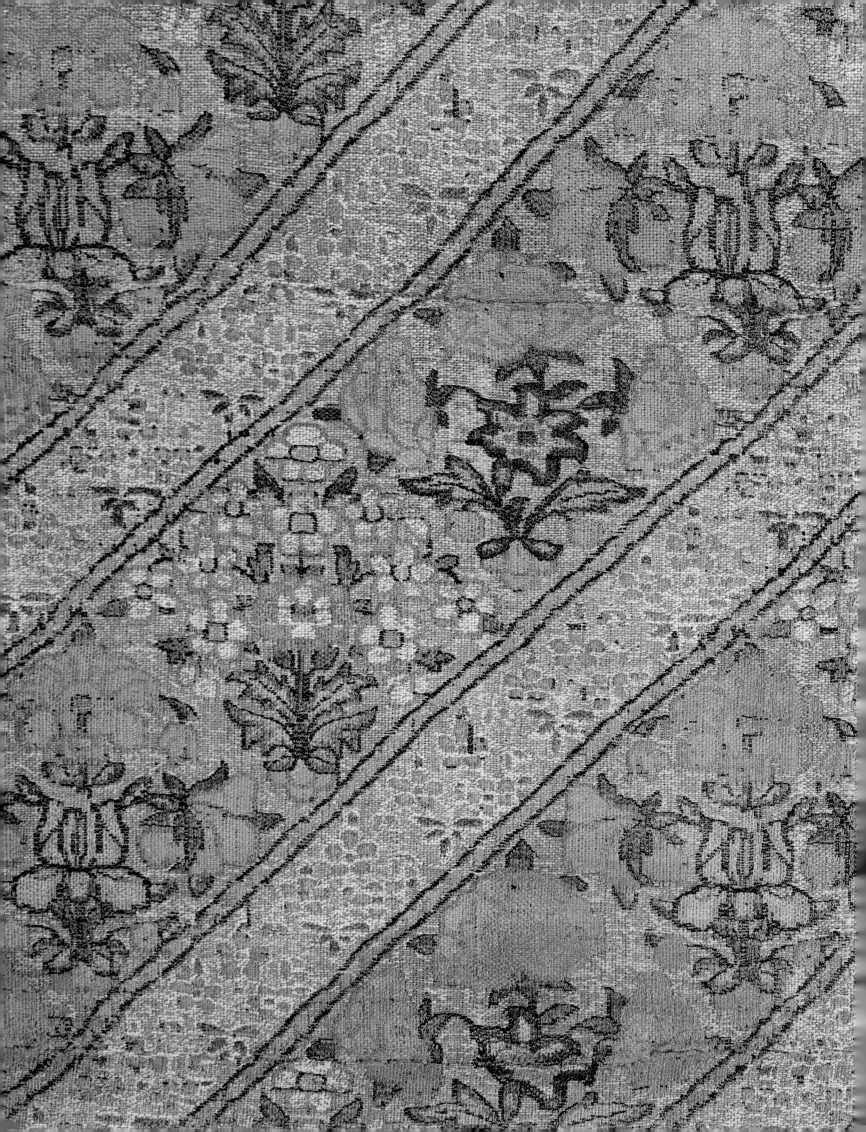

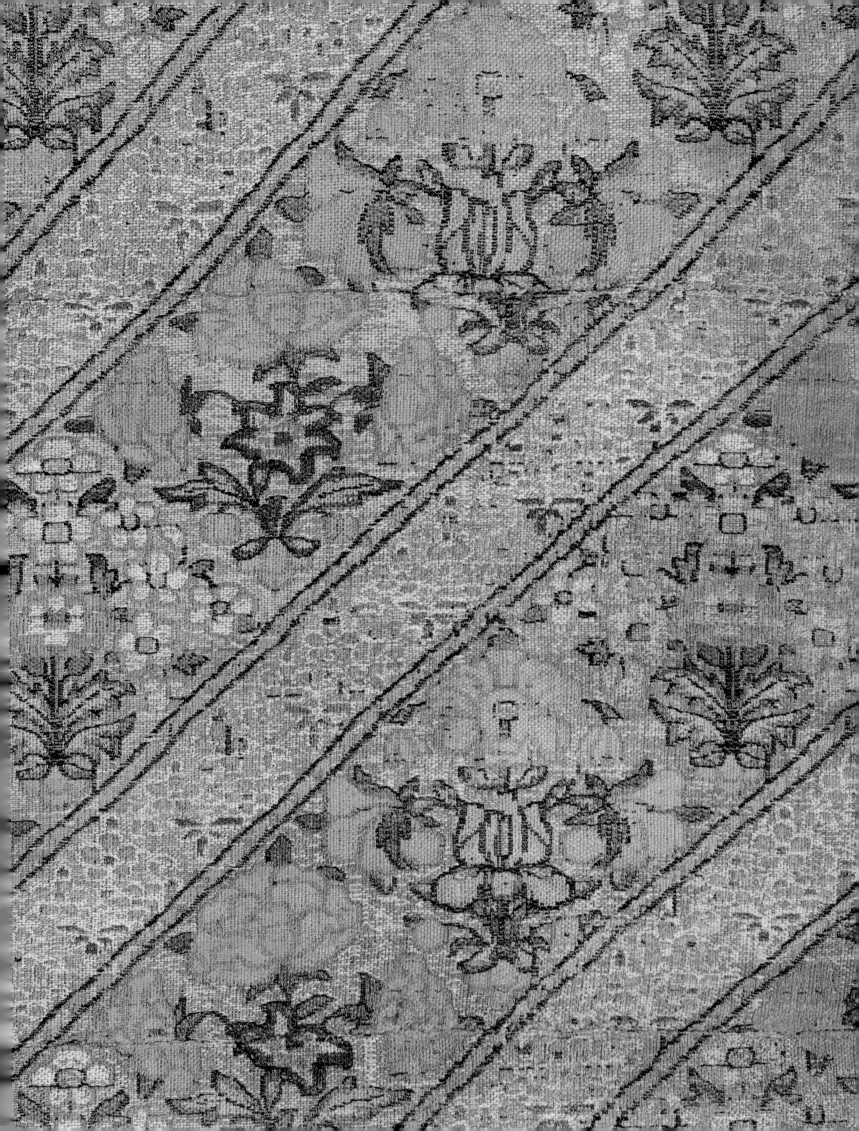

38
Nakshe (pieced fragment)

Cotton embroidered with silk
Iran, 1st half 19th century
L: 45 cm × W: 37.5 cm

Called *nakshe*s from '*naqqash*', meaning 'design', a pair of these panels would have formed the lower part of the wide trousers worn by Iranian women until they went out of fashion in the 1870s. Any fabric which came to hand would have been used to make the upper part of the trousers, which would have been concealed under other clothing. Only the part that showed was decorated with embroidery. Although this *nakshe* has been heavily repaired with pieces from a similar panel, the overall effect of the dense stitches in diagonal lines is not diminished. There are four separate patterns, each composed of two alternating motifs: in the lower border there is a red tulip-like flower and a group of three or four leaves; in the broad stripe there is a sprig of three red flowers and a stylized arrangement of small, pale flowerheads, although this has been disrupted by the repairs; a variation of this pattern is used in the slightly narrower stripe; and there is a very simple pattern of flowerheads in the narrowest stripe. In old European inventories such panels were sometimes called *gilet*s (French for 'waistcoat') because, when they went out of fashion in Iran, large quantities were shipped to Europe, where they were made into waistcoats, slippers and bonnets. *Inv.9*

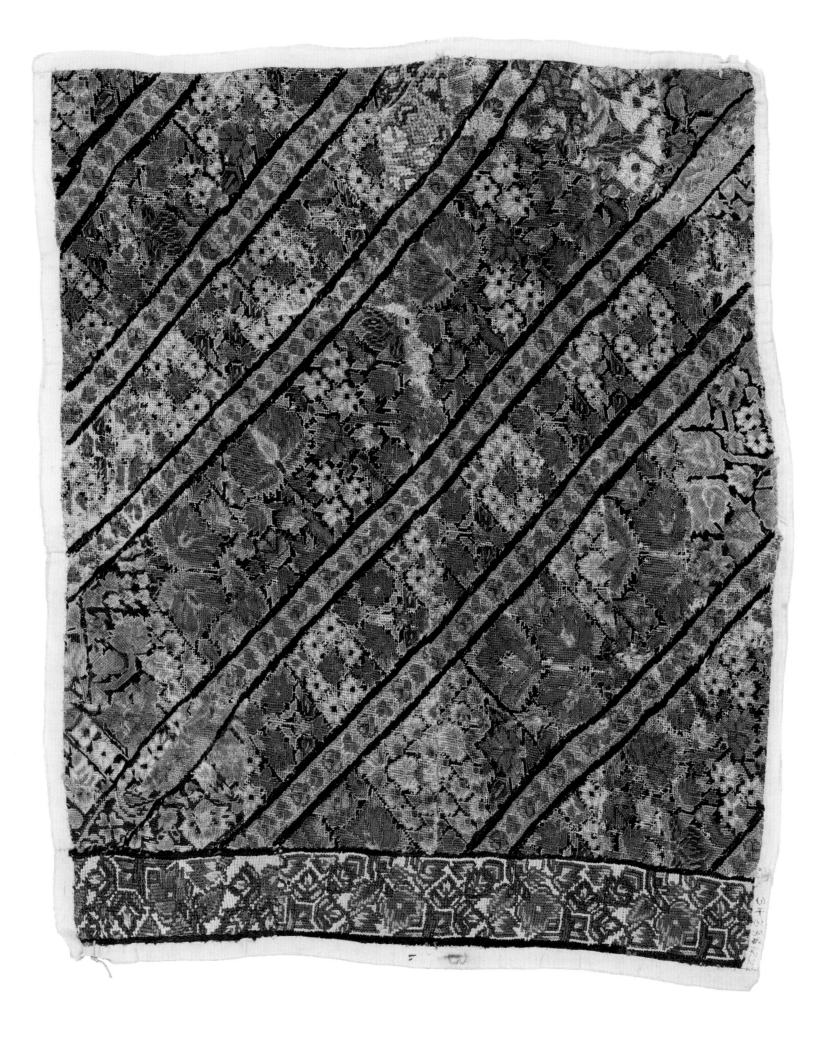

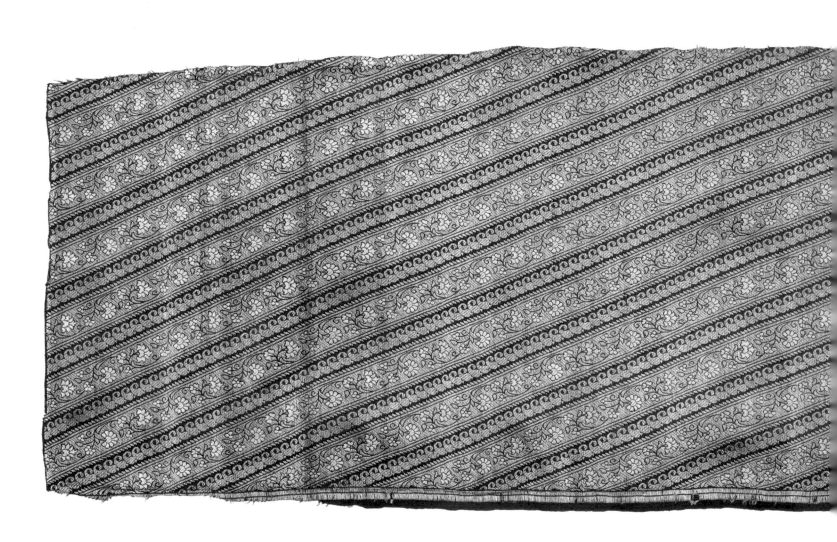

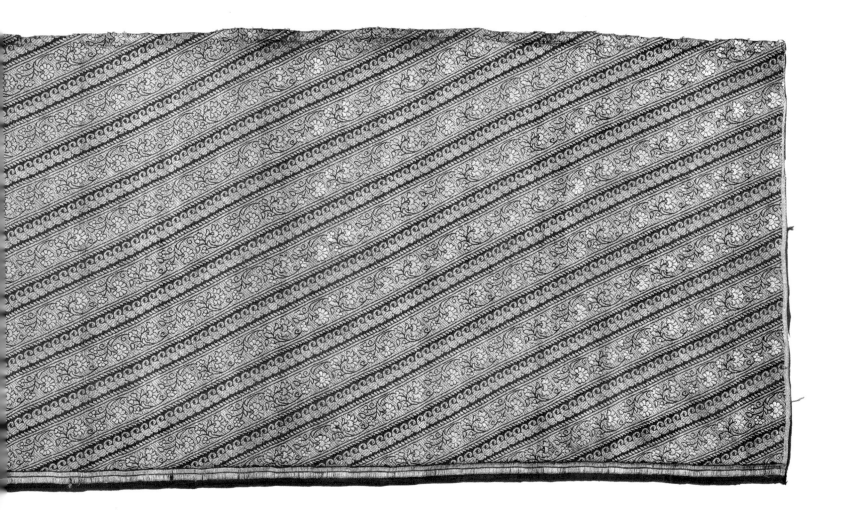

39
Kincob dress fabric

Woven silk satin brocaded with silk and metal thread
India, Benares (present Varanasi), mid 19th century
L: 143 cm × W: 36.5 cm

This textile is an example of *kincob*, an anglicized word of uncertain origin which refers to a rich, silk fabric patterned with metal weft threads made by wrapping gold or silver strips around an orange silk core. Because of the high metal content, *kincob* was usually sold by weight. It was used for making tailored garments such as robes and trousers. This piece is decorated with diagonal stripes of small golden *boteh*s on a crimson ground alternating with white flowers and a fine undulating stem on a gold ground. The effect is similar to that achieved by enamelling in metalwork and the same word, '*meenakari*', is often attached to both jewellery and textiles. Tiny pointed leaves edge the floral stripe, pointing up along one edge and down along the other, giving the effect of carved wooden beading. There is a plain band along the lower edge of the textile which marks the beginning of the pattern. Such bands (which may be called 'loom ends' or 'piece ends') are often found marking the beginning and the end of a set length of fabric, usually the length required for a specific garment. Several such lengths would be woven from one long warp and when the weaving was finished each panel would be cut and separated. *Inv.5*

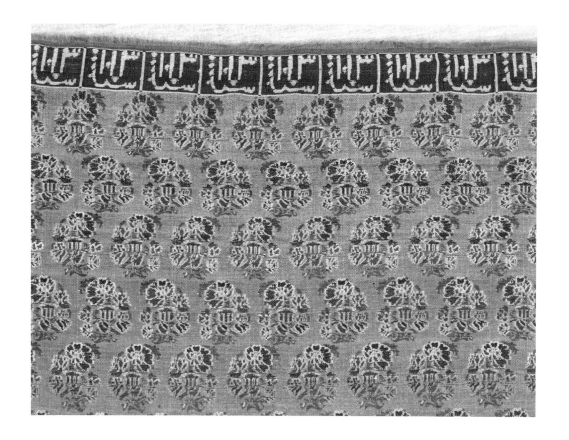

40
Dress fabric

Woven silk
Iran, 19th century, but woven with
the date AH 1013/ AD 1603
L: 135.5 cm × W: 51 cm

This is an ingenious and unusual design
using *boteh*s bending to the left in one row
and to the right in the next and offset in
such a way that they form zigzagged stripes
running the length of the fabric. It is also
a puzzling piece. The scale and proportions
of the pattern are 19th-century: this
particular shape of the *boteh* did not
evolve until the 19th century and the silver
thread woven into the fabric is loosely
wound around an orange silk core, which
is another feature of 19th-century textiles.
Yet there is a woven inscription across
the top of the textile with the date AH 1013/

AD 1603. A band at the end of a piece of
woven cloth was not uncommon in 19th-
century Iran to indicate the completion
of a particular length of fabric, probably
the length required to make a garment.
It often included a maker's name or mark
or a short inscription and may have been
a way for the weaver to identify his work
when it was passed to a middleman or
merchant for payment. However, it is
possible that this is not a weaver's mark
but an inscription to indicate that the
textile was woven to commemorate an
event which took place in AH 1013, perhaps
the completion of an important mosque
like the Masjed-e-Imam in Isfahan,
which had become the Safavid capital in
AD 1597. For the moment, it remains a
puzzle. *Inv.6*

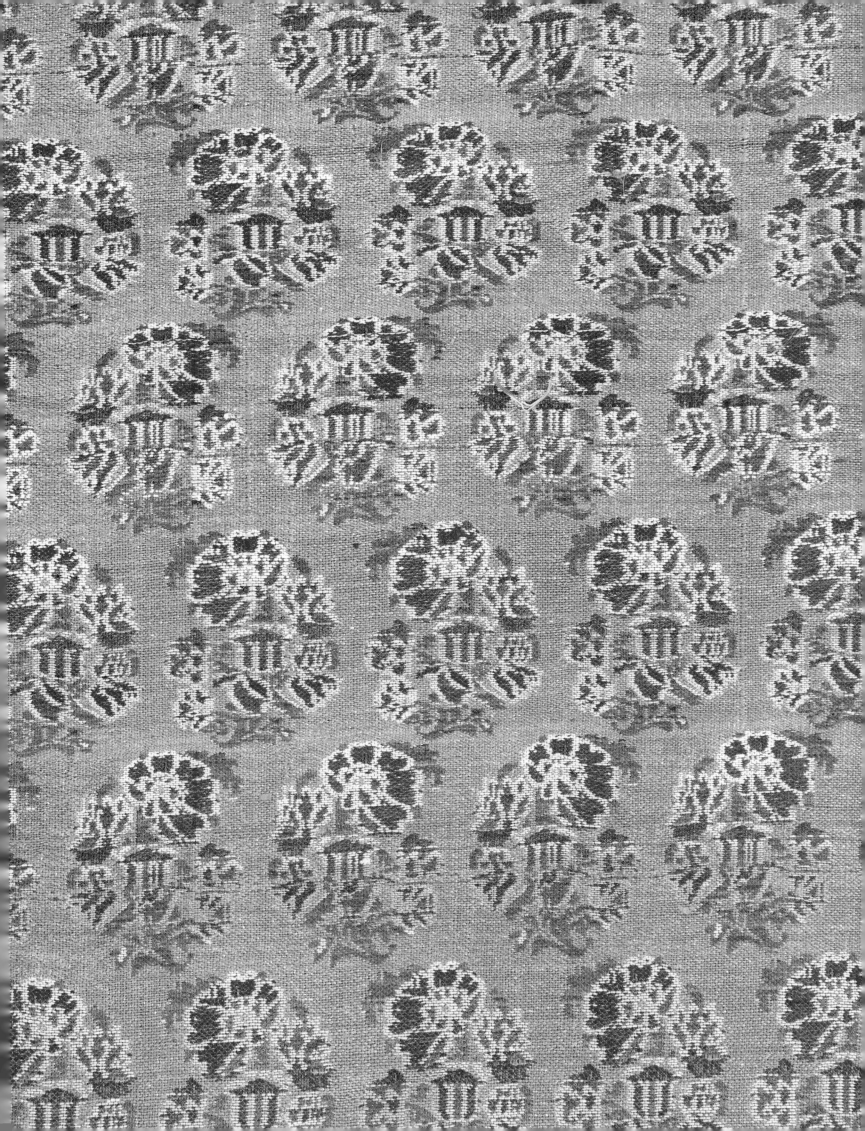

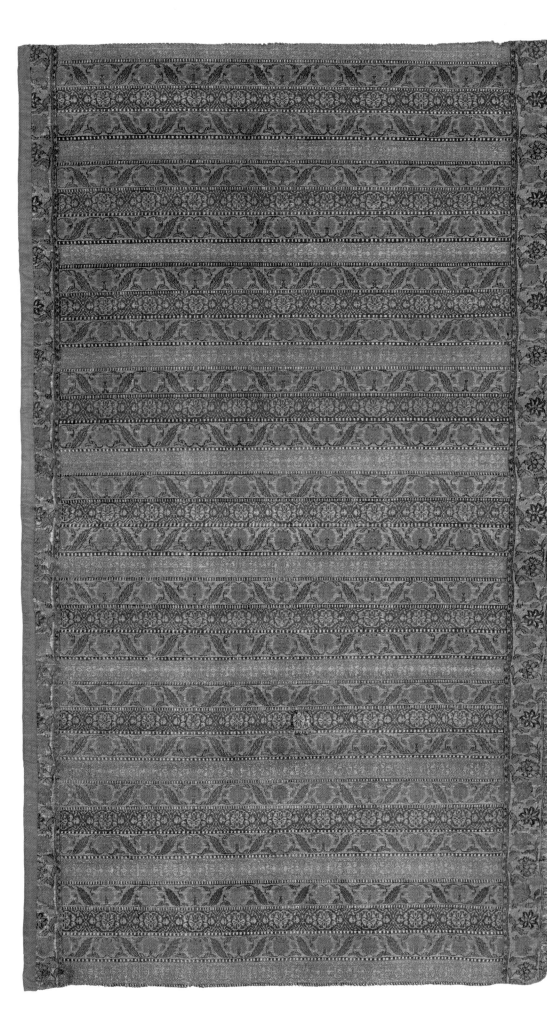

41
Man's waist sash (part)

Woven silk and metal thread
Iran, possibly Kashan, 18th century
L: 102 cm × W: 59 cm

Kashan on the eastern edge of the Zagros
Mountains in Iran was famous for its woven
textiles, which included waist sashes of
up to five metres in length that combined
gold and silver with lustrous coloured silk
threads. Their popularity was so great,
especially in Eastern Europe, that when
demand exceeded production in the later
18th century these sashes were copied in
workshops in Turkey, Poland and Russia.
Typically there would be a deep border at
either end with isolated flowering plants or
trees but the rest of the fabric was decorated
with narrow bands (horizontal) or stripes
(vertical). These patterns were arranged so
that when the sash was folded and wound
around and around the man's waist it would
reveal what seemed to be two different
textiles – one floral and one striped.

This is part of the main, striped section
of the sash and there are two designs:
one is woven with gold thread on a blue
and on a pink ground and the other is
woven with pink and green silk on a gold
ground. Similar motifs are used in both
designs: there is a fan-like carnation, a
round blossom and a pair of buds. In the
blue and pink stripes these are formed
into medallions – they show clearly on
the blue but the pink has faded making
the pattern indistinct. In contrast, the
coloured flowers and leaves in the other
stripes form a sinuous pattern, adding
movement and grace. To add a lighter
colour, tiny blocks of dark brown and
white silk separate the stripes, and it should
be noted that the designer has cleverly
off-set the flowers in the coloured stripes
so that a carnation in one is opposite a
blossom in the other. Such attention to
detail is the hallmark of excellent design.
Inv.4

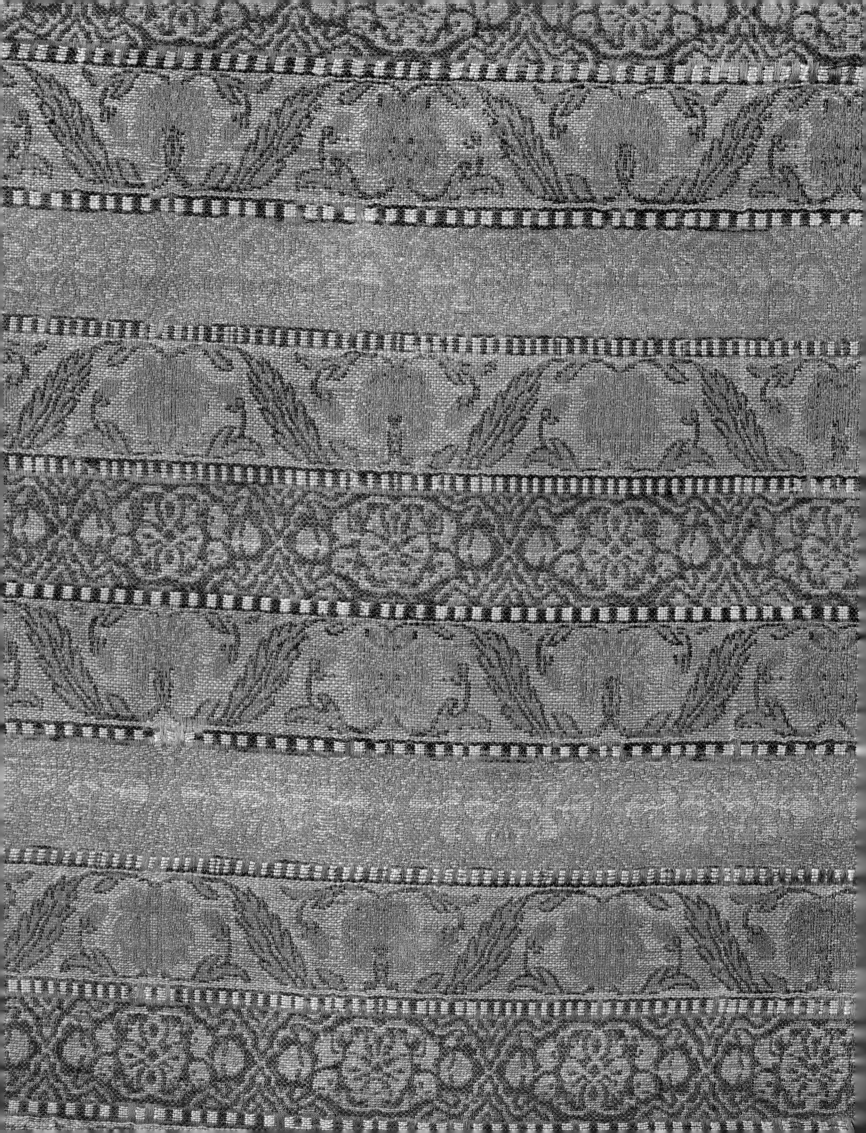

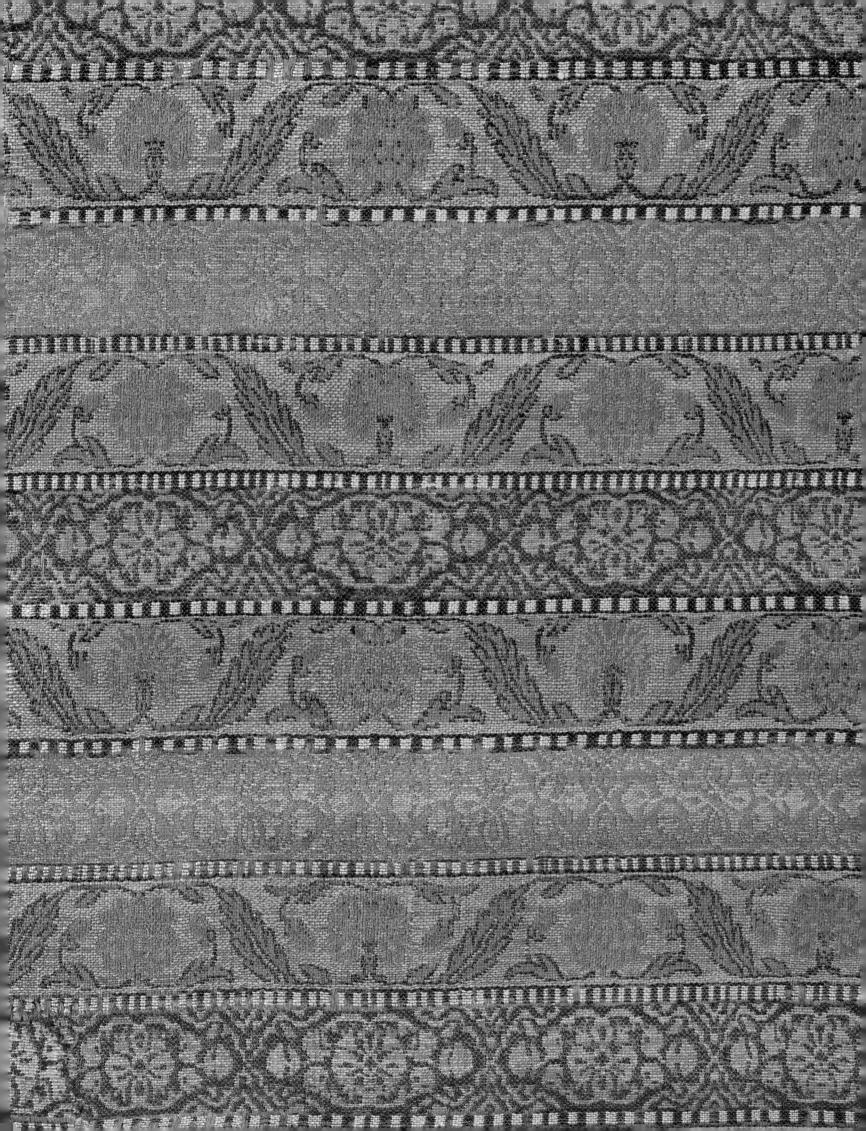

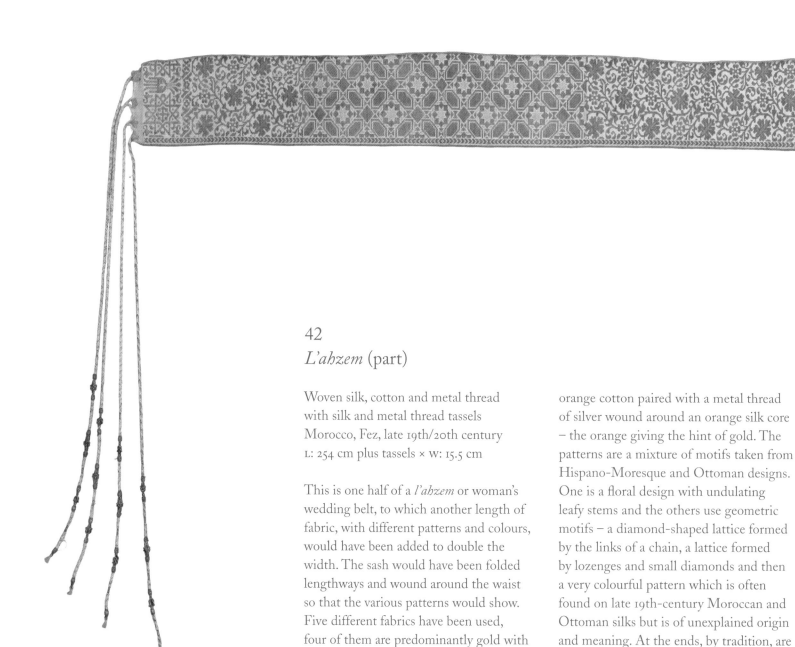

42
L'ahzem (part)

Woven silk, cotton and metal thread
with silk and metal thread tassels
Morocco, Fez, late 19th/20th century
L: 254 cm plus tassels × w: 15.5 cm

This is one half of a *l'ahzem* or woman's
wedding belt, to which another length of
fabric, with different patterns and colours,
would have been added to double the
width. The sash would have been folded
lengthways and wound around the waist
so that the various patterns would show.
Five different fabrics have been used,
four of them are predominantly gold with
blue highlights while the fifth is strongly
coloured with dark red and yellow. The
gold is achieved by using a thread of

orange cotton paired with a metal thread
of silver wound around an orange silk core
– the orange giving the hint of gold. The
patterns are a mixture of motifs taken from
Hispano-Moresque and Ottoman designs.
One is a floral design with undulating
leafy stems and the others use geometric
motifs – a diamond-shaped lattice formed
by the links of a chain, a lattice formed
by lozenges and small diamonds and then
a very colourful pattern which is often
found on late 19th-century Moroccan and
Ottoman silks but is of unexplained origin
and meaning. At the ends, by tradition, are
the Hand of Fatima and a star. Beautifully
made tassels have been added to this wealth
of pattern. *Inv.102*

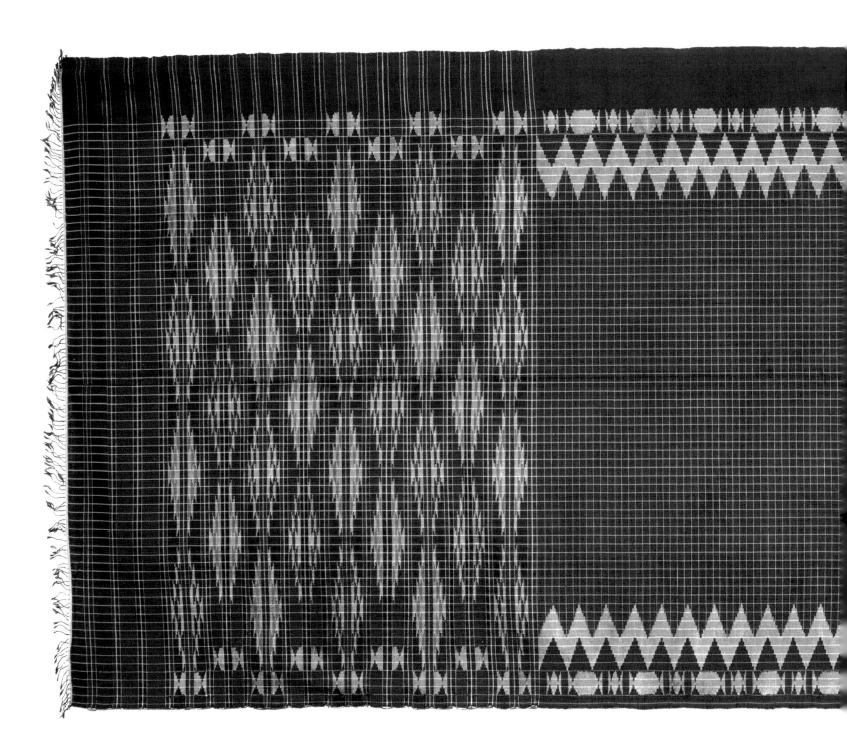

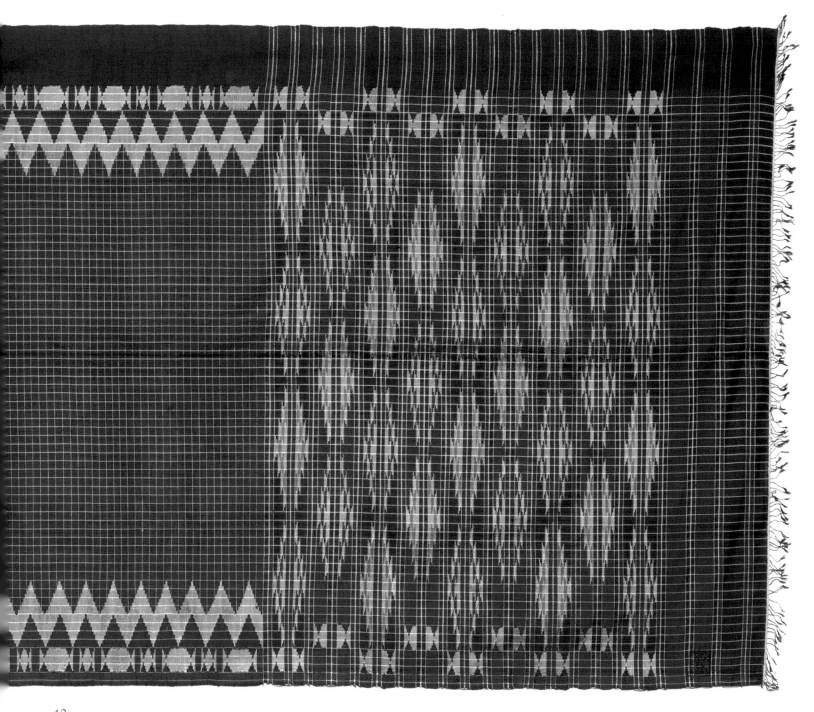

43

Mi'zar al-hammam

Woven silk and metal thread with resist-dyed warp threads (ikat) and brocaded and tapestry-woven decoration
Syria, mid 20th century
L: 250 cm × w: 98.5 cm

Sometimes incorrectly called a shawl or a towel, this type of wrap was worn by men and women relaxing in one of the outer rooms of the *hammam*, hence the name used locally, '*mi'zar al-hammam*'. Multiple weaving techniques have been used in this piece, from the subtle, almost invisible resist-dyed (ikat) thread making the check pattern on the red ground to the bold brocaded zigzags either side of the central panel. Black and red weft form bands across the width and together with white are the colours most frequently associated with bath wraps. In addition, a silver strip loosely spun around a pale cream core was used with the white silk and was also used in the tapestry-woven blocks that form slim blue and green lozenges within the coloured bands. The central part of the wrap has been left relatively undecorated – this would be across the user's back and the patterned ends would wrap around to the front of the body. There is a black border along one edge but not the other; as the textile is complete, with nothing missing, this asymmetry was deliberate but the reason for it is unclear. *Inv.7*

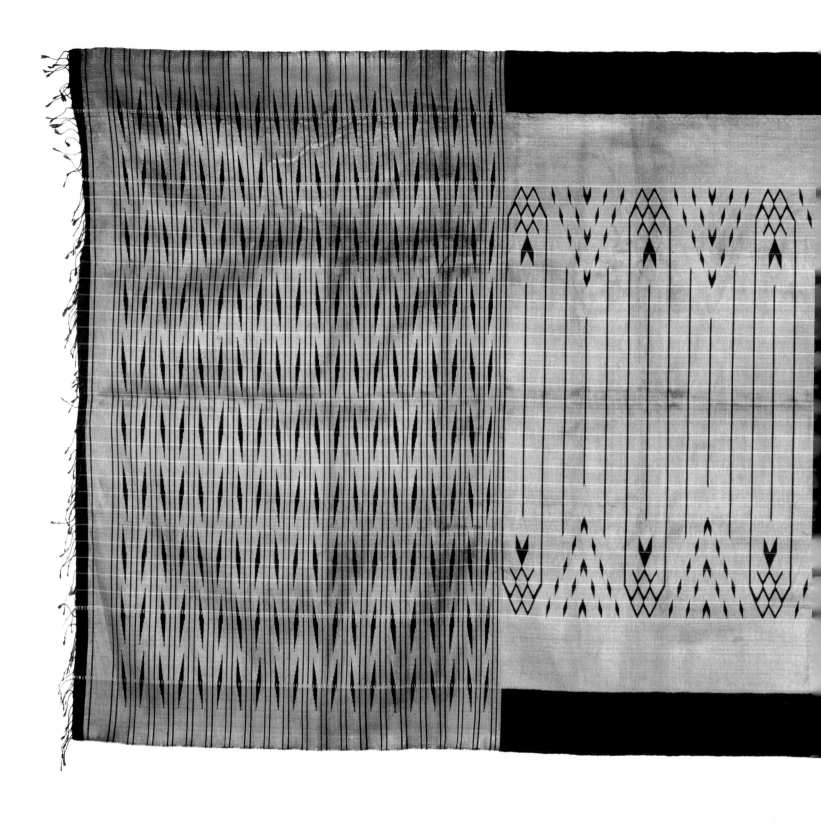

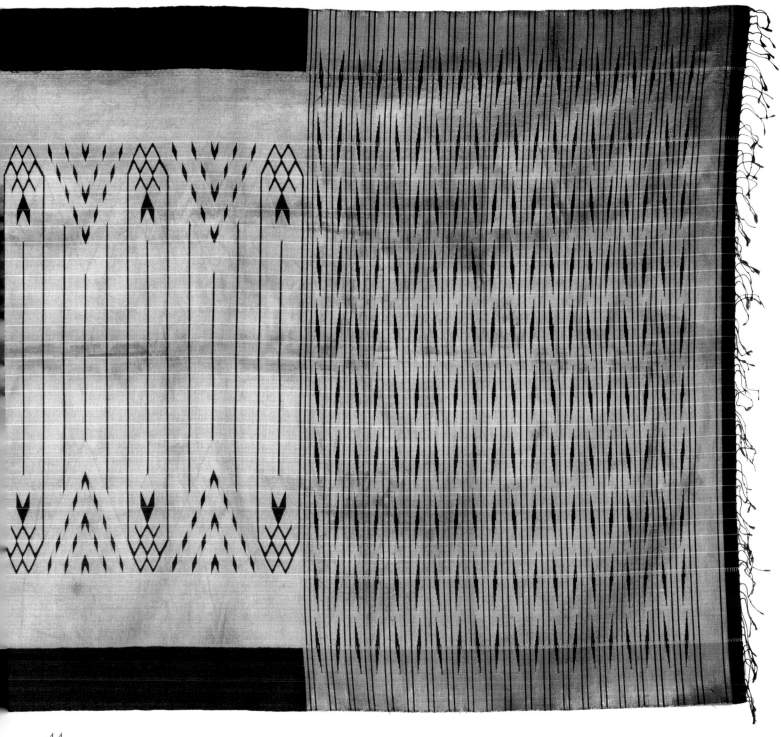

44

Mi'zar al-hammam

Woven silk and metal thread with brocaded and tapestry-woven decoration
Syria, mid to late 20th century
L: 224 cm × W: 99 cm

Coloured silk warp threads form faint stripes along the length of this *mi'zar al-hammam* or bath wrap but the dominant patterns are created by the silk and metal thread wefts. The main weft consists of three separate metal threads: two of them are thin and one is thicker and all have a silver strip loosely wound around a white silk core, which enhances the cool shimmer of the white metal. Because it has this silk core, the metal is flexible and so the fabric can be easily folded and draped. The layout of the design is typical, with a relatively undecorated central part and heavily patterned ends. A comparison of this and the previous *mi'zar* (see no. 43) illustrates how varied the designs can be. In both pieces the designs are based on the meeting of two diagonal lines, making zigzags or chevrons and lozenges and V-shapes; this is a simple concept with infinite possibilities. *Inv.8*

45

Mi'zar al-hammam

Silk and cotton twill brocaded with silk
and metal thread
Syria, Homs, 20th century
L: 195 cm × w: 115 cm

This is probably a *mi'zar al-hammam*,
or bath wrap, deliberately woven in twill
because this weave is especially suitable for
fabrics which will be folded, gathered or
draped: it has a diagonal structure, creating
greater flexibility than either plain weave
or satin weave. The pattern is bold and
rather stark, with the focus on three large
elongated diamonds, but the inclusion of
silver thread would ensure it shimmered
in the pale light of the outer rooms of the
hammam. A long warp, sufficient for several
wraps, would have been on the loom. After
the completion of each wrap the weaver
would leave one or more narrow bands with
no weft, and one of these bands, usually
called a 'piece end' (see no. 39), can be seen
along one end of this wrap. When the
finished fabric was taken from the loom,
the individual wraps were separated by
cutting along these bands. *Inv.87*

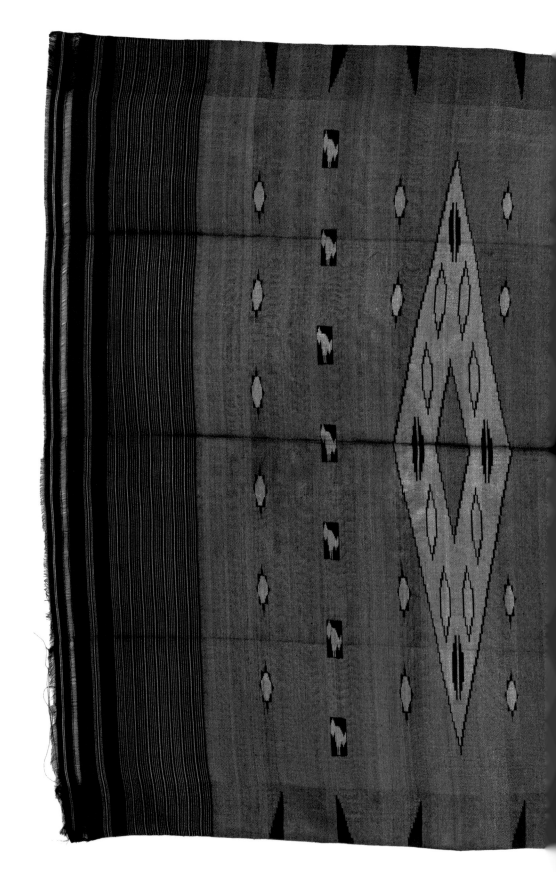

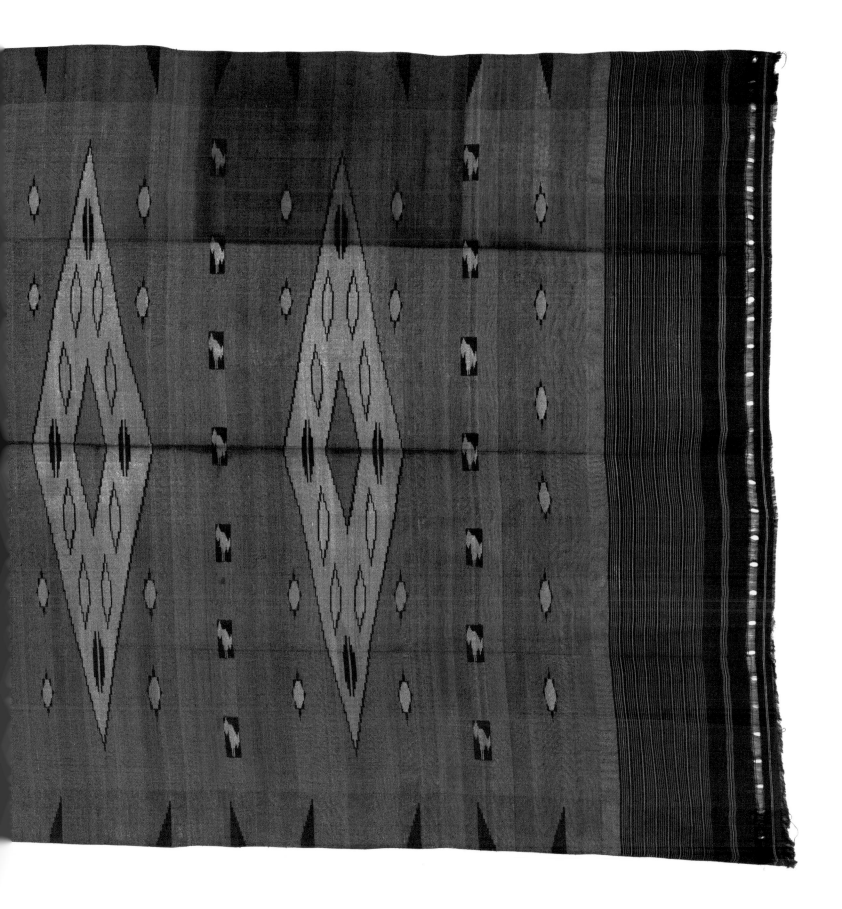

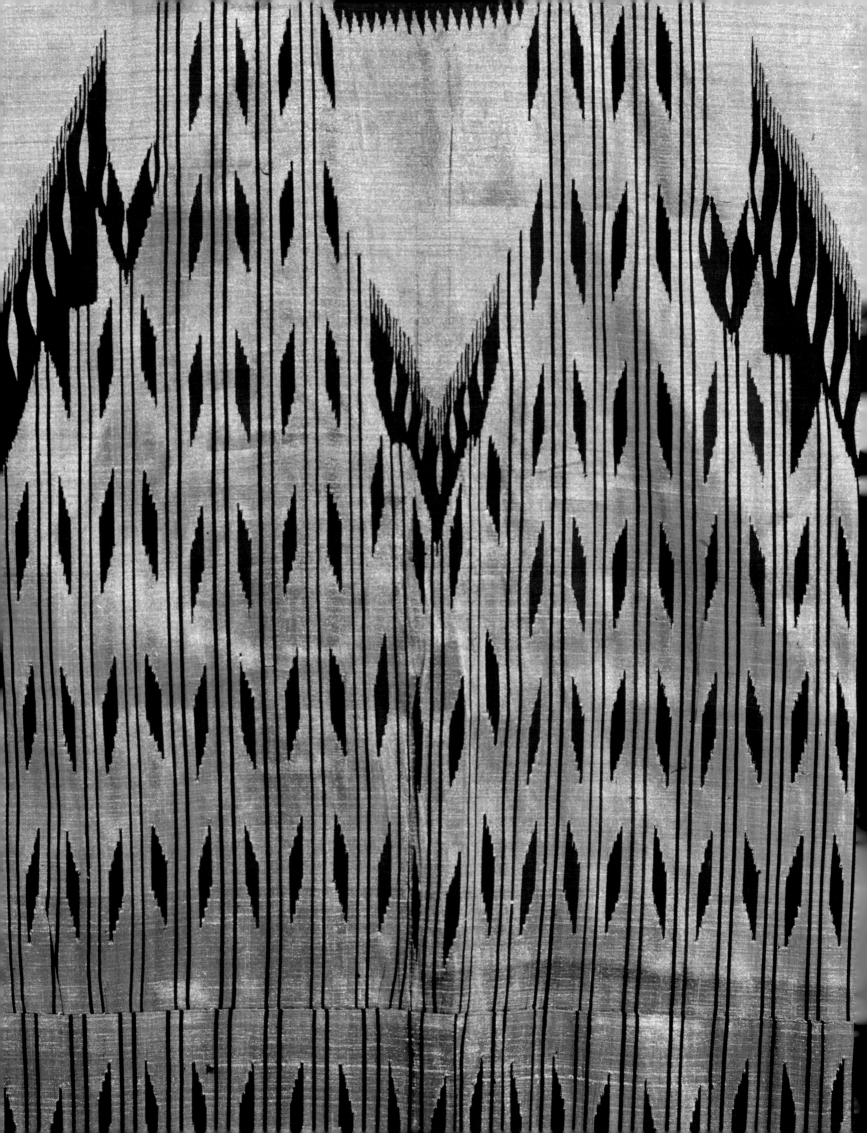

46
Man's *abba*

Silk and metal thread with tapestry
woven decoration
Probably Syria, late 19th/ early 20th century
L: 140 cm × W: 132 cm

These elegant garments were worn with
honour and pride and one decorated
with pleasing patterns and colours would
have added to the wearer's dignity. This
abba once belonged to Major-General
Sir Percy Zachariah Cox and may have
been presented to him as a diplomatic gift
(see also no. 33). It is certainly a particularly
fine example of weaving. The lines of small
lozenges are similar to those woven into
the Syrian *mi'zar al-hammam* that is
no. 44 and demonstrate that designers were
working with a tried and tested repertoire
of patterns which could be easily adapted
for a range of products. It was common
for the designer to leave three undecorated
triangular areas across the upper back of an
abba, and in this example these plain areas
perfectly balance the expanse of densely
packed lozenges and lines surrounding
them. *Inv.144*

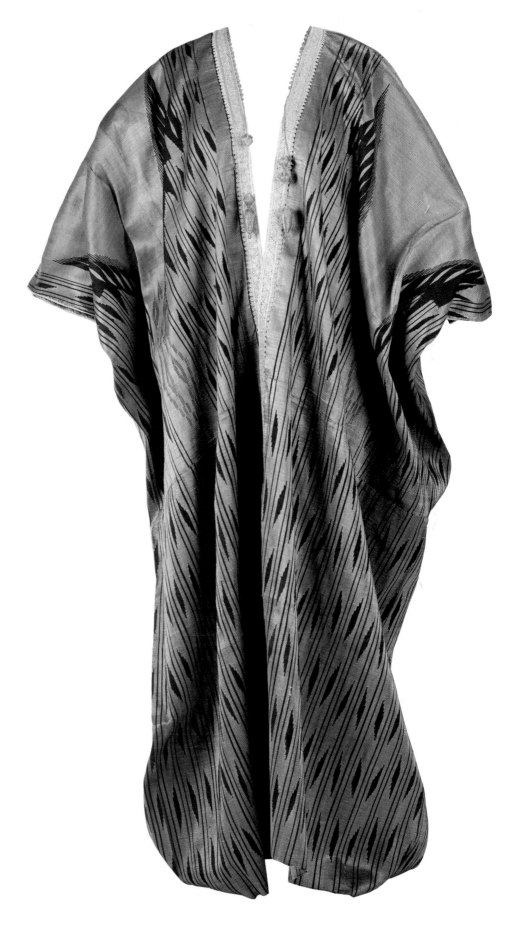

133

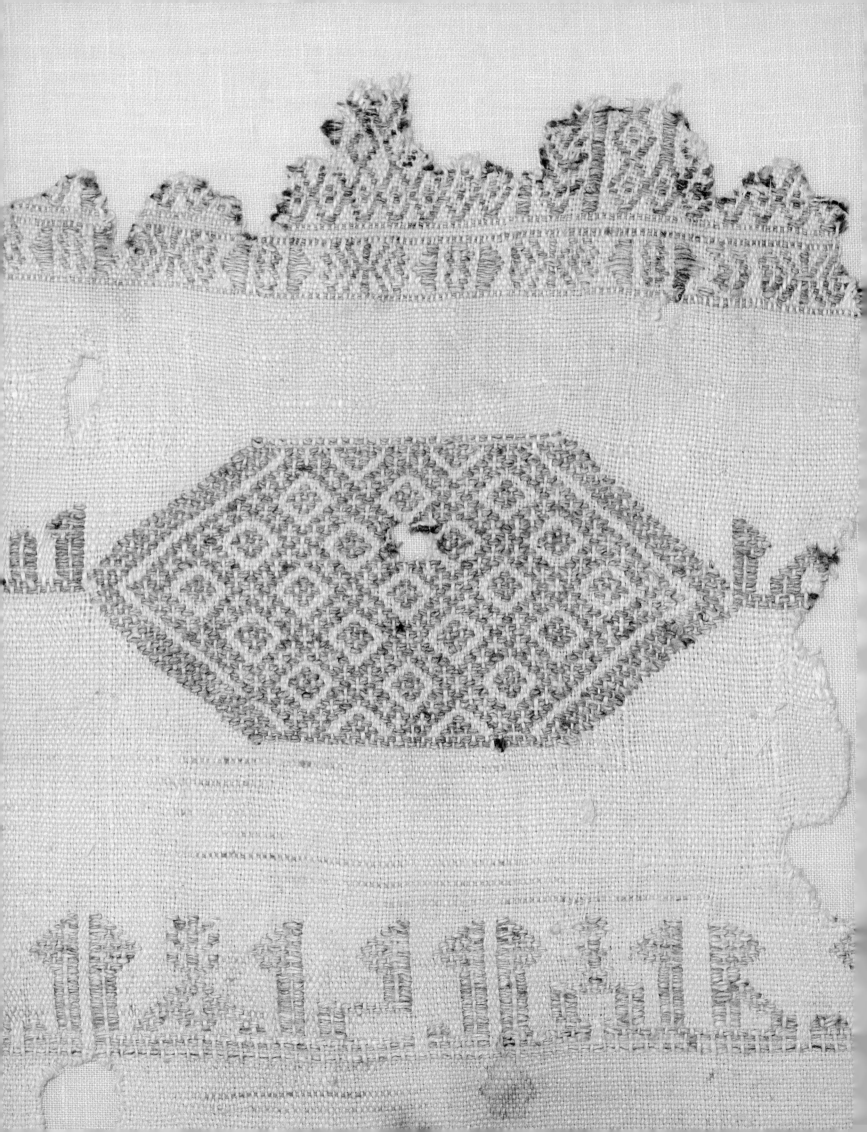

The Written Word

The art of calligraphy, *Khatt ul-Yad*, is the practice of hand-writing based on the Arabic script and for many Muslims is the most admired and esteemed form of Islamic art, because it links the people with the language of the Qur'an and through that with the spiritual world. Calligraphy, from the Greek for 'beautiful writing', is a discipline in which the craftsman modifies existing letters to create pleasing patterns and, in its highest form, to enhance the meaning of the text. In Islamic cultures calligraphy has been used in highly creative and imaginative ways and has not been confined to pen or brush, parchment or paper, but has spilled over to decorate almost every form of artistic endeavour, and for this reason is often considered to be a uniquely original feature of Islamic art and is sometimes called 'the speaking art'.

The flowing nature of Arabic letters, formed by lines, dots and many curves, enables the artist to create harmonious as well as functional patterns, which even if they cannot be read as texts can be enjoyed as graphic art. Their translation into textile designs is most often confined to short mottoes or phrases expressing a particular sentiment, usually one wishing health, happiness or blessing to the person wearing or using the textile. For legibility, clarity of line and precision of diacritical marks, the most satisfactory way to incorporate words into textiles is to write or draw the letters with a pen or a brush, using a closely woven fabric as if it were a sheet of paper. Sometimes a mixture of chalk and gum was rubbed into the cloth to produce a smooth surface for the artist. As neither this paste nor the inks nor paints were waterproof, such textiles could never be washed. Less fugitive dyes were used for block-printing textiles, and an inscription could be carved into a wood block and used over and over again in the mass production of printed cottons. Lengthy inscriptions either from the Qur'an or from works of literature are, therefore, usually printed.

The most difficult way to incorporate words into textiles is to weave the letters into the fabric rather than add them to the finished cloth. The ability of the weaver to do this depended on the available technology. Using a simple loom the weaver could employ a tapestry technique to include letters in the design, but without considerable skill the lettering is often highly stylized. However, using a draw-loom, requiring two operatives and generally found only in highly professional workshops, a weaver would be capable of reproducing complex inscriptions. Such textiles are comparatively rare because of the costs involved in setting up the loom for a pattern which did not repeat at regular intervals. Shorter inscriptions repeated across the width of the textile were more common. The most beautiful inscriptions are embroidered. All are evidence of an overwhelming desire to use the written word on a garment or a furnishing in order to give the textile greater meaning and significance.

47

Tiraz fragment

Tapestry-woven linen and silk
Egypt, Fatimid Dynasty, 12th century
L: 14 cm × W: 12 cm

The earliest and most common textiles
decorated with the written word are called
'*tiraz*' from a Persian word, '*tarazidan*',
meaning to embroider. *Tiraz* refers to
bands of calligraphy which decorated
garments – usually around the top of the
sleeves – and which included the name
of the ruler. The garments were given to
those officials and nobles whom the ruler
wished to honour, and the acceptance of
such a garment implied that the recipient
was acknowledging the authority of
that ruler. A similar system was used by
the Sassanians and the Byzantines. The
earliest known Islamic *tiraz* workshop was
established by the 10th Umayyad Caliph
Hisham (AD 724–43) in Damascus, but
very quickly all the major textile centres
included one. The Fatimid dynasty, more
than any other, used *tiraz* to proclaim
their political and religious beliefs. This
fragile piece is completely covered with
woven inscriptions: the most easily read
is the *Bismillah* across the central blue
band, 'In the Name of God, Most
Gracious, Most Merciful'. Above it, in
the palest band may be the words *Nasr
min Allah*, 'Victory from God'. By this date
the flowing, cursive letters of the *naskh*
script, which had developed from a system
of writing used for business and general
correspondence, had largely replaced the
angular kufic script (see nos. 48 and 59).
Even the most skilful tapestry weavers were
challenged by *naskh*'s rhythms and grace,
but the words and their meaning were
important enough to justify their efforts.
Inv.170

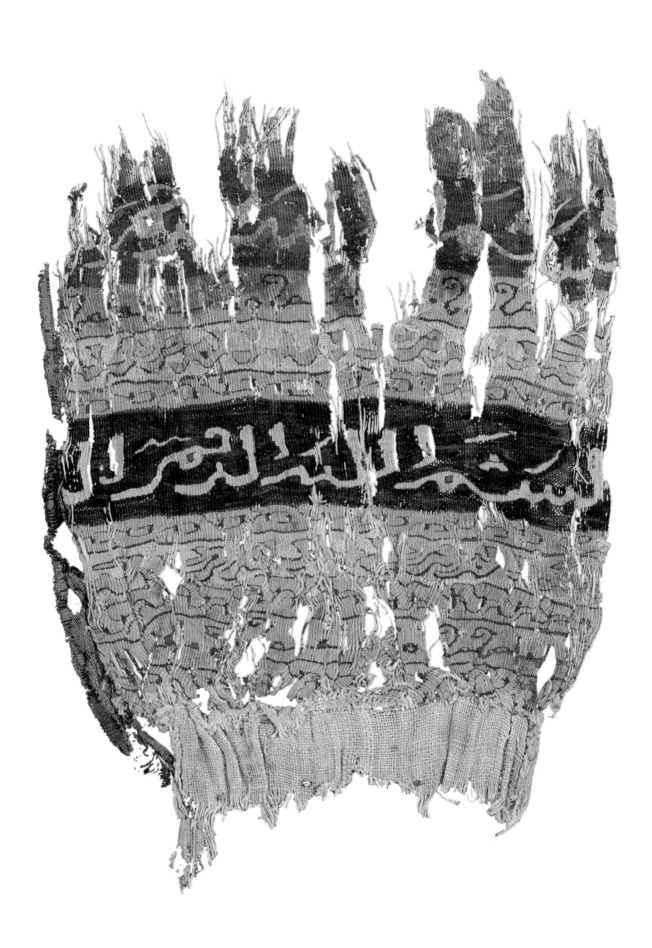

48
Tiraz fragment

Woven linen
Egypt, Mamluk Dynasty, 14th/15th century
L: 36 cm × W: 144.5 cm

Over the centuries *tiraz* became so fashionable that they were widely imitated in 'unofficial' workshops, and short inscriptions such as 'good fortune' or 'health and happiness' replaced the name of the local ruler. This *tiraz* is a good and rare example of one of these. The long inscription on this piece is a repetition of the word 'dominion'. The letters which link the lozenges in the band above appear in slightly different forms on several Mamluk *tiraz* fragments and it is thought that they were derived from the word

'Allah' written in the angular and rather majestic kufic script (see no. 59). Until it was replaced by *naskh*, kufic had been used for formal texts. Its decorative potential was cleverly exploited in all manner of art, sometimes, however, to the point that it became quite difficult to read the actual words. The original clarity of a beautifully constructed and drawn 'Allah' was lost with repetition over time and it eventually became the protective or good-fortune symbol seen here. Unfortunately, in the past some excavators and dealers were accustomed to cutting the decorative bits from the plain parts of textiles, so it is difficult to identify what sort of garment this fragment came from. *Inv.162*

49
Cenotaph cover (part)

Woven silk
Iran, early 18th century
L: 106 cm × W: 90 cm

This is a rare example of a cenotaph, or tomb cover, from the late Safavid period in Iran. The Safavid dynasty ruled from 1501 until 1736, at a time when Iran was noted for the design of exceptionally beautiful textiles decorated with flowers, animals and even human figures. Textiles for use in a religious context, however, were decorated only with geometric motifs or with inscriptions. The two prominent inscriptions here are: 'In the name of Allah, the Entirely Merciful, the Especially Merciful' and 'Indeed, We have given you [O Mohammed] a clear conquest'. Rows of small cartouches form panels across the cover and alternate with panels of rose-coloured silk. There are inscriptions woven within these apparently blank panels using a slighter darker shade of rose. When complete this cover would have included at least three repetitions of these panels, and one known example has an end border decorated with the *khamsa* or Hand of Fatima. Weaving legible inscriptions is difficult, so the verses chosen are short and are repeated over and over again, but by varying the colours – by having a green stripe down the sides and by including those large rose-coloured panels – the designer has avoided any sense of monotony and has created a refined and elegant pattern. *Inv.159*

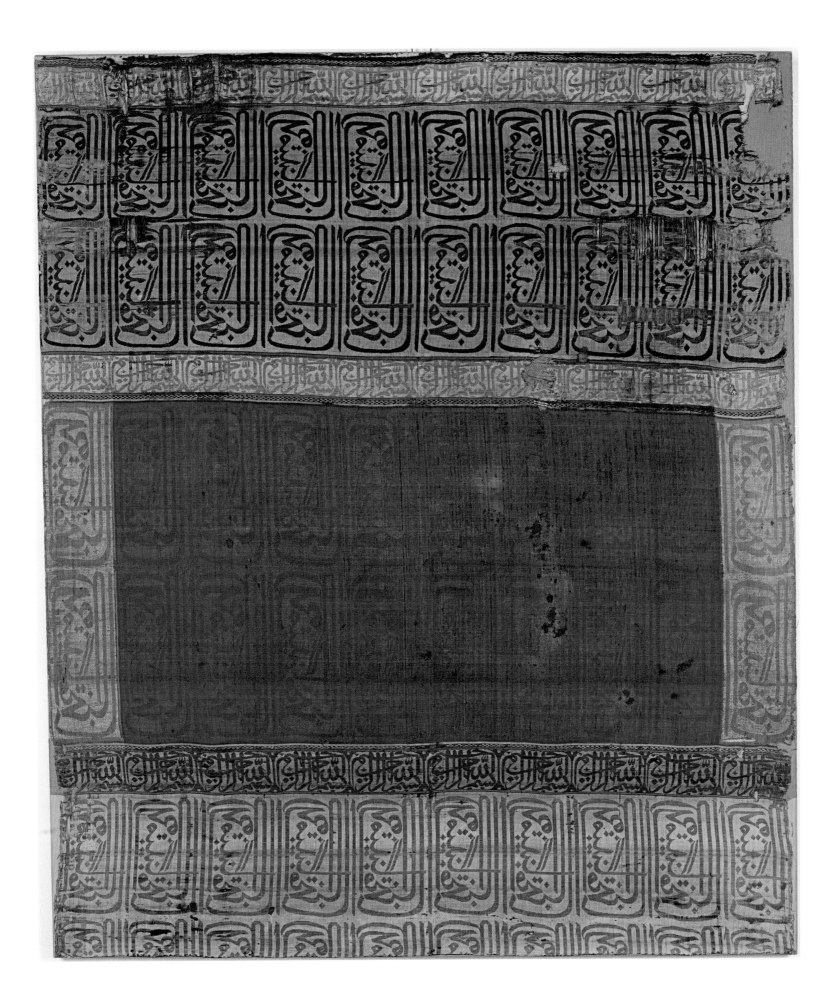

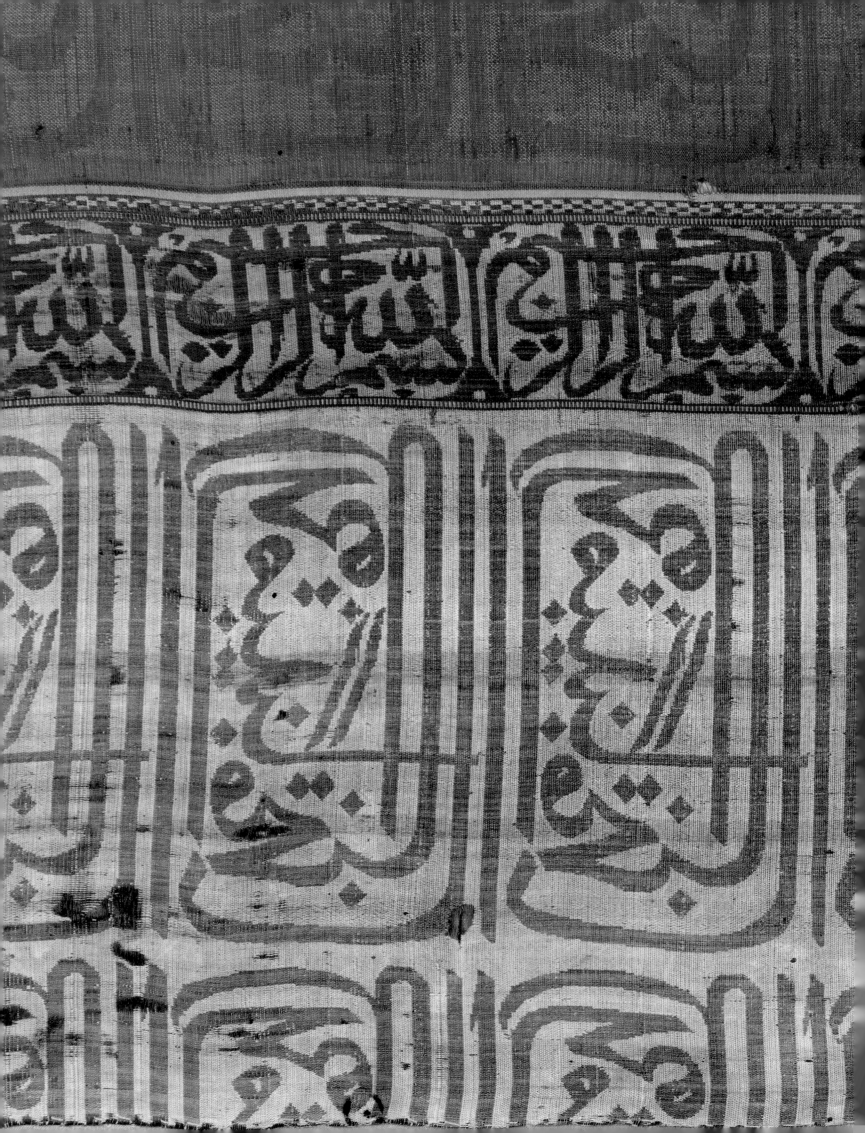

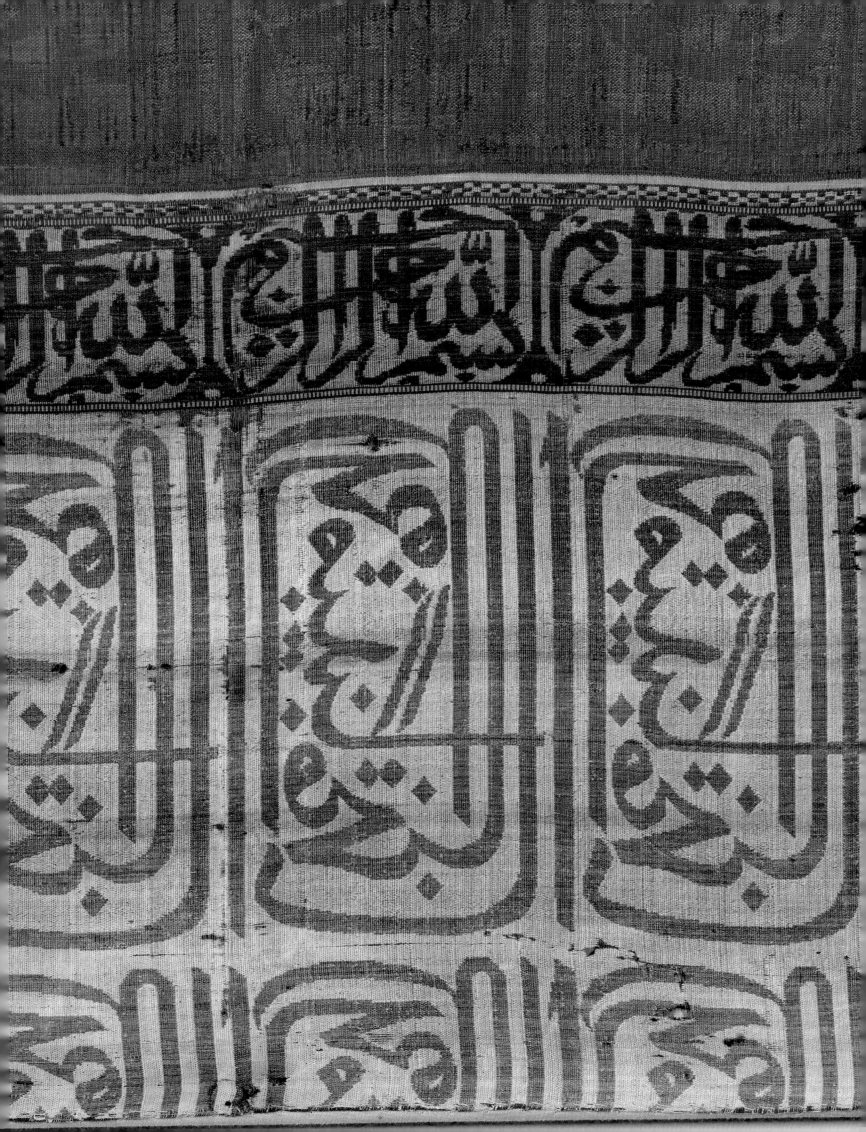

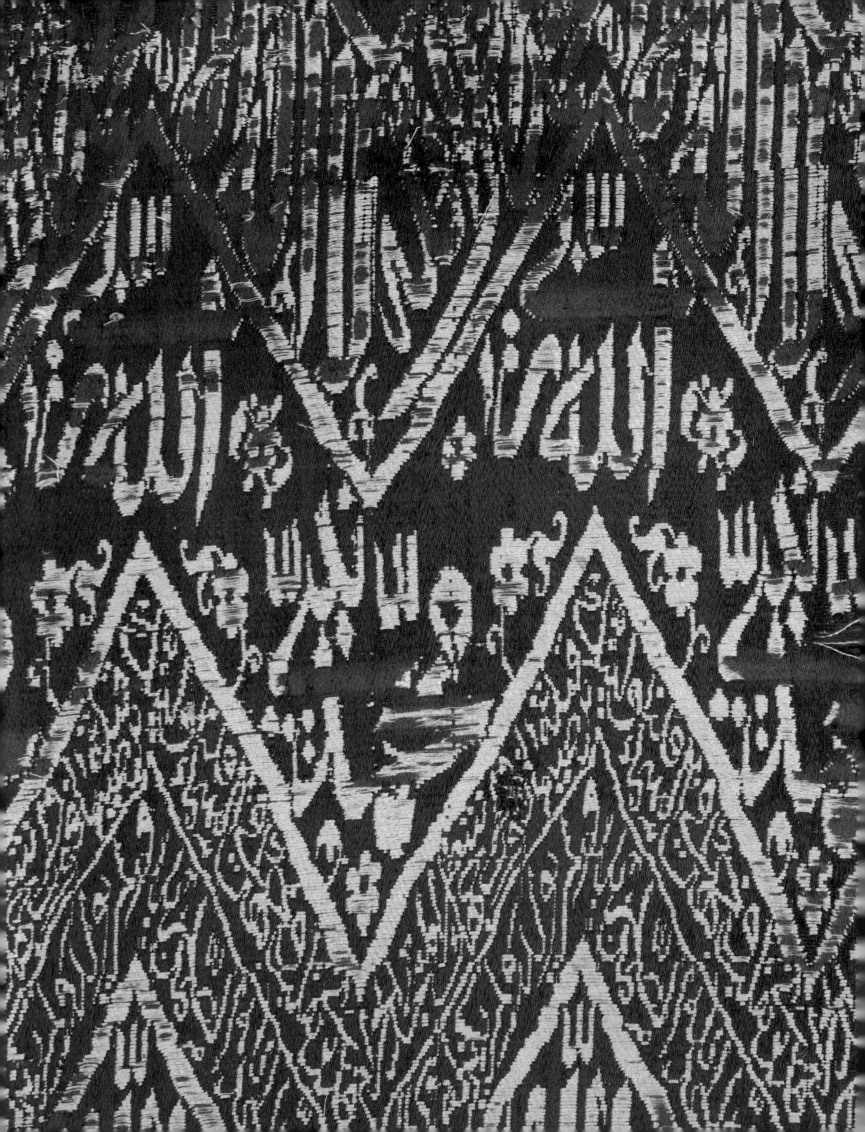

50
Curtain (part) for inside the Ka'aba or for the Tomb of the Prophet

Woven silk
Ottoman, 18th century
L: 126 cm × W: 72 cm

Silks woven with inscriptions within this distinctive chevron pattern were used for covering *sandukas*, the stone sarcophagi found in Ottoman shrines, but some were woven specifically as curtains to line the inner room of the Ka'aba in Mecca. Whereas cenotaph or tomb covers might be red, green or blue or combinations of these colours, the curtain for the Ka'aba room and for the Prophet's Tomb in Medina were white on red. The largest inscription on this piece is the *Shahada*, the Profession of Faith, and the narrower band contains a quotation from the Qur'an in which God instructs Muslims to pray towards the Ka'aba; the other inscriptions include the name 'Allah' and 'Mohammed' and the entreaty 'Say "He is Allah, Who is one"'. Working within the strict limits defined by the steeply angled chevrons and the need to use only legible calligraphy, the designer has balanced the bands densely packed with text by separating them with the slightly larger *Shahada*. The eye is therefore drawn immediately to the Profession of Faith, then to the names and then, with more effort, to the remaining inscriptions. When the curtains were periodically replaced, the old ones were usually preserved and honoured because they had become permeated with *barakah*, or divine grace, through contact with such holy places.
Inv.158

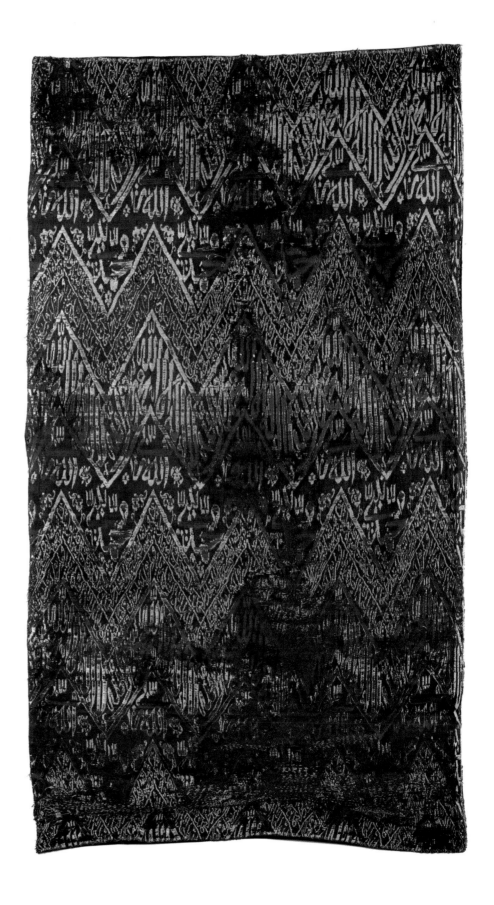

51
Shawl

Silk twill woven and brocaded with silk
and metal thread
Syria, Damascus, dated AD 1855
L: 272 cm × W: 63.5 cm

As the *hammam* was an important part of
Ottoman life, allowing women to enjoy
degrees of ostentatious display not normally
permitted outside the home, textiles
associated with it – towels, wrappers and
covers – were carefully chosen for their
decorative qualities. A shawl such as this
would be used after bathing, while the
woman was relaxing or while her hair
was being dressed or perfumes and oils
were being applied. A twill weave has
been used to produce a supple fabric and
the central part of the shawl is relatively
undecorated to preserve this flexibility.
The greater part of the pattern is in a
series of coloured bands at the ends, the
wider ones containing the following woven
inscription: 'Blessed shawl made by Hanna
Malouk in flourishing Damascus. Health,
prosperity and well-being to the wearer;
1855'. The narrower bands are patterned
with coloured blocks or chevrons or with a
small cross, and serve to separate and space
out the inscribed bands so that the pattern
is not monotonous. Instead, each border
has a wide group of blue, black and white
bands either side of a more condensed
group of red, green and multi-coloured
ones. The green bands at each end balance
the three green bands in the centre. At
one end there is a black instamp, which is
common on Ottoman textiles and indicates
that a local tax or duty has been paid. *Inv.35*

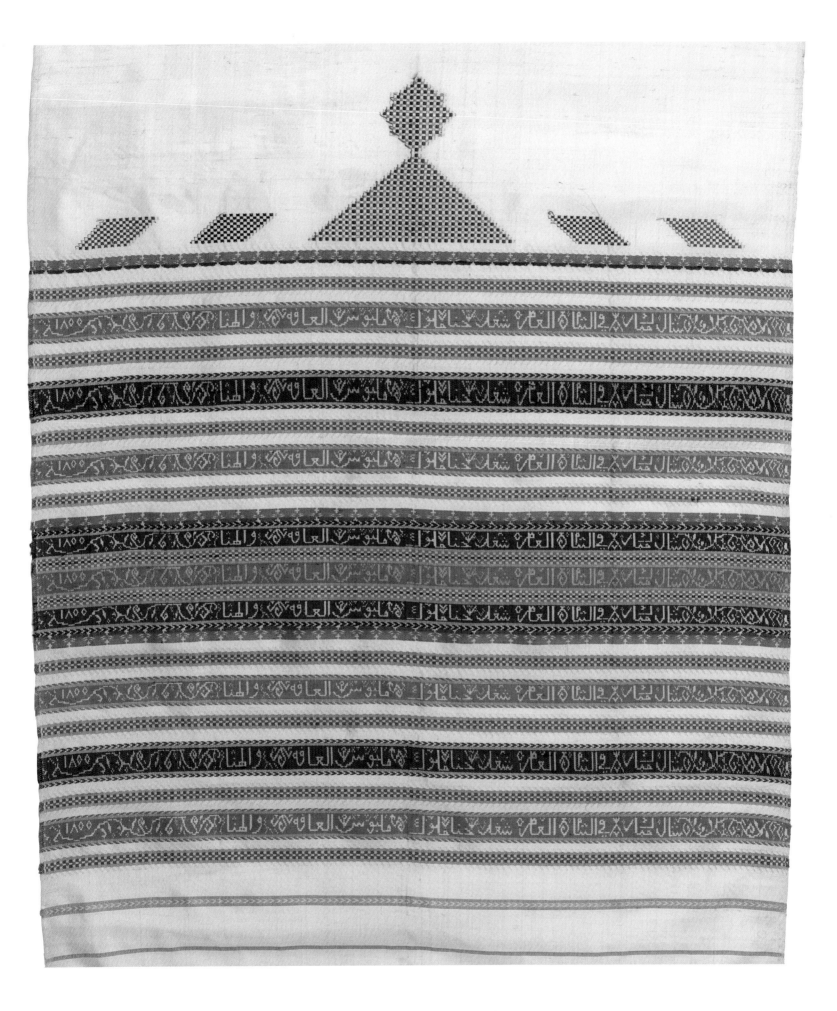

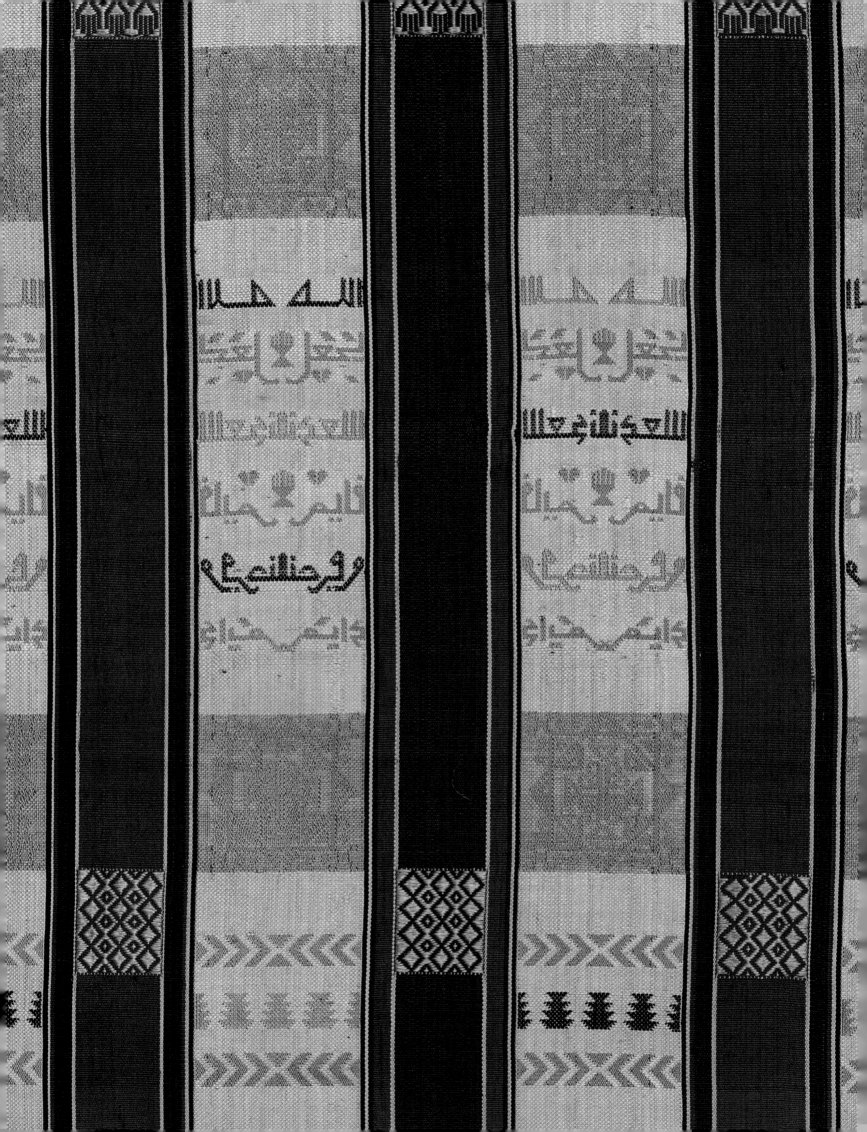

52
Wedding veil (part)

Woven silk
Tunisia, 2nd half 19th century
L: 203 cm × W: 54 cm

When inscriptions are included within
the patterns on textiles, the meaning of
the words and the sentiment behind them
are of great importance. This inscription
reads: 'God makes our good fortune rising
and our happiness lasting'. These two
joined panels of striped silk were probably
first used as part of a wedding veil and
the words suggest that it was a gift from
the man to his bride. The silk may have
been used later as a wall hanging or as a
decorative cover. The choice of colour and
the small motifs are similar to those used
in the veils (*ajar*s) worn by wealthy women
in the main towns and cities of Tunisia (see
no. 30). Some of the patterns were used
as tattoos on the faces of Berber women,
usually between the eyebrows and on the
chin, to protect them from the evil eye, and
the inscription and tiny representations
of the *khamsa*, the Hand of Fatima, were
deliberate features to bless and defend the
beloved wearer. *Inv.161*

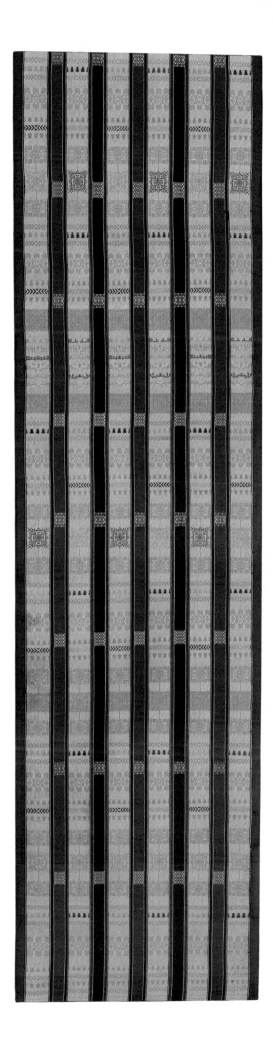

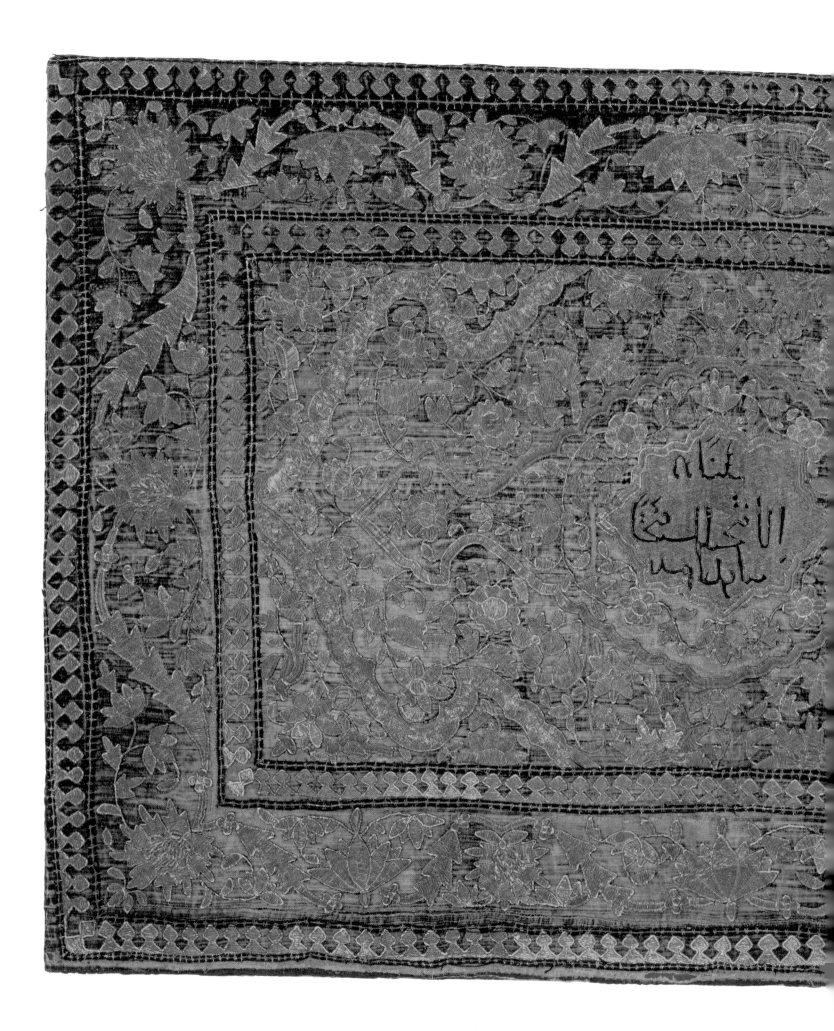

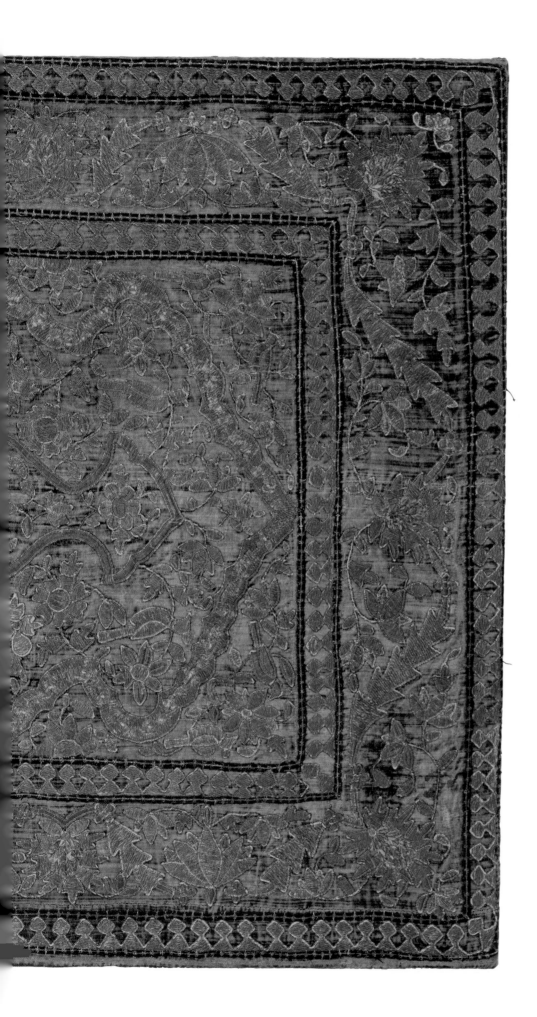

53
Hanging or cover

Silk velvet embroidered with metal thread
Iran, 19th century
L: 93 cm × W: 140.5 cm

The combination of shimmering metal
thread against a ground of richly coloured
velvet has always been admired and,
although this velvet has faded, it is easy
to see how magnificent it once was. To
add some texture to the otherwise flat
embroidery, the metal thread used for the
stems and for the outlines of the motifs
was couched over a cotton cord and over
layers of stitching to give roundness to the
birds, the feathery centre of the large leaves
and the border of the central medallion
with pendants. In contrast to this well-
drawn and well-balanced design, there is
an irregular lozenge almost, but not quite,
in the centre; because of its position a petal
is missing from one flower. The ground
of the lozenge has been embroidered with
metal thread, leaving unworked velvet
to form an inscription, a verse from the
Qur'an. The inscription itself is not well
placed within the lozenge. It is evidence
that the inscription was far more important
than the decorative qualities of the textile.
Inv.25

54
Tensifa

Cotton embroidered with silk and
metal thread
Ottoman, 19th century
L: 120 cm × W: 45 cm, folded and secured
with ribbon to show the corner motifs

This cover is similar in format to no. 6,
but it is rectangular and in place of
flowers and stars it is decorated with
inscriptions embroidered with black silk.
The inscriptions are blessings written in
Ottoman Turkish. Until 1928 and the
fall of the Ottoman Empire there were
at least three variants of the language,
that of the government and poetry, that
of the upper classes and trade and that
of the lower classes; all were written
in a variant of the Arabic script. Although
as part of Mustafa Kemal Atatük's
modernization the language was reformed
and the Latin script was introduced,
Ottoman Turkish was still partially
understood by some people up to the 1960s.
Long, narrow embroideries such as this are
usually called mirror covers (*tensifa*s) and
would have been hung over the reflective
glass to ward off the evil eye. As with all
blessings, these painstakingly embroidered
words would have protected the user from
ill influences and from the mishaps and
misfortunes of life. *Inv.143*

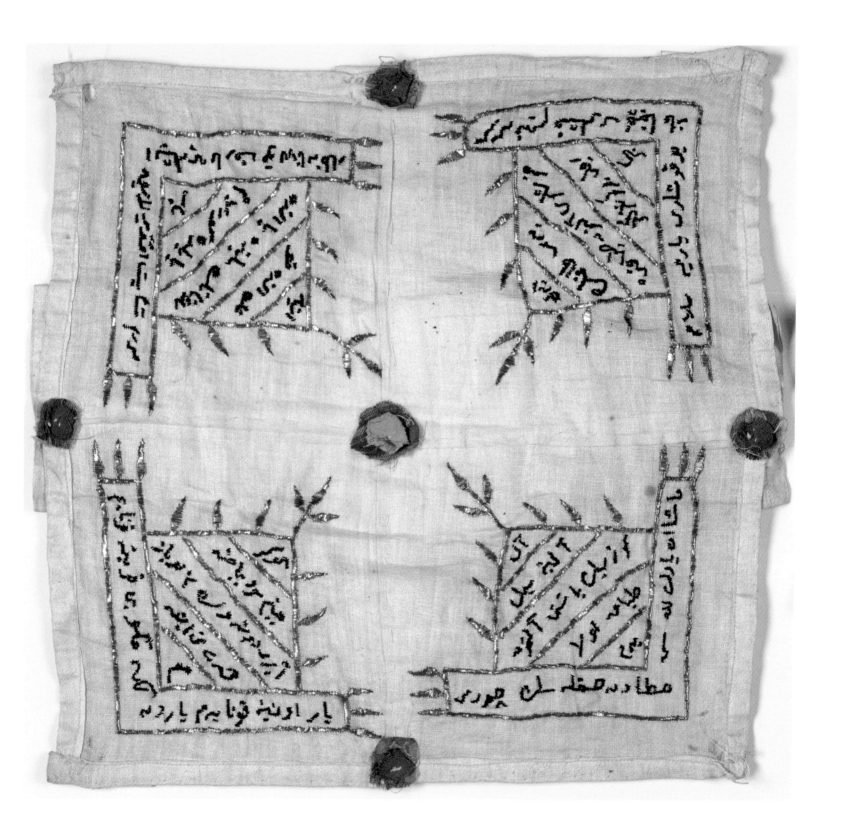

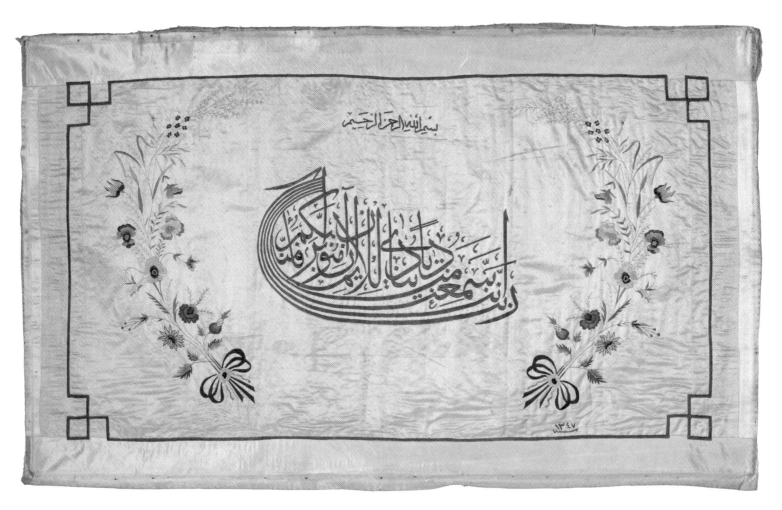

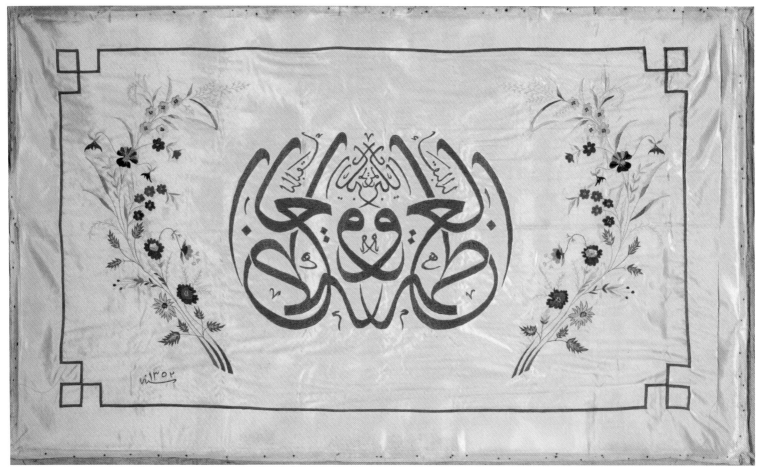

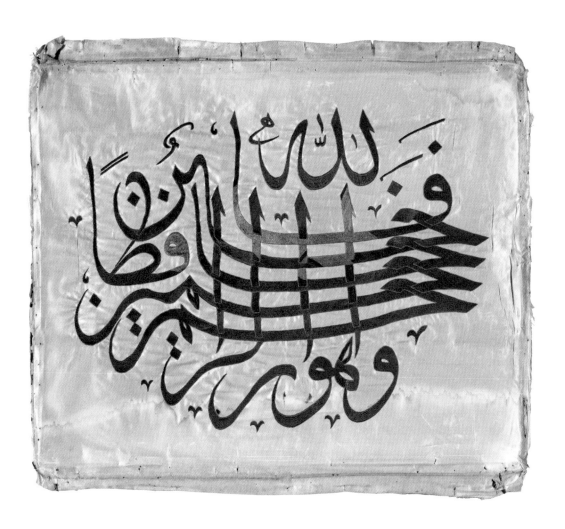

55, 56 and 57
Three panels

Silk and cotton satin embroidered with silk
Possibly Syria, 59 dated AH 1347/ AD 1928;
60 dated AH 1352/ AD 1933
59 (TOP LEFT) L: 74.5 cm × W: 122.5 cm
60 (BOTTOM LEFT) L: 74 cm × W: 124 cm
61 (ABOVE) L: 60 cm × W: 64.5 cm

These panels were made in the same workshop but two are dated four years apart and one has been reduced in size and no longer includes its date. Despite the difference in date, the basic format remained unchanged, with a narrow line framing two curving floral sprays and a central inscription, all embroidered with silk. The flowers and the stitches used to work them – satin, long and short, split, running and straight stitches and French knots – are from a European tradition; the calligraphy, however, is not. It is a feature of Islamic art used both for the message it conveys and for the beauty of its flowing lines. The inscriptions read – no. 55: 'Greatness and Pride to that […] who survives'; no. 56: 'Our Lord, indeed we have heard a caller calling to faith [saying] "Believe in your Lord" and we have believed. Our Lord, so forgive us our sins and remove from us our misdeeds and cause us to die with the righteous'; no. 57: 'But Allah is the best guardian, and He is the most merciful of the merciful'. In no. 57 the vertical strokes are not well embroidered: there is no sense of interlacing, and instead the embroiderer has broken the strokes into short blocks. Embroiderers were not always literate and in this case they may not have been able to follow the letters correctly, or they may simply have been careless; either way, when seen from a distance everything seems perfect. *Inv. 90, 91, 92*

58
Talismanic shirt

Parchment decorated with ink and paint
North India, 19th century
L: max. 64 cm × w: max. 117 cm

A talisman is any object that is given
protective powers by inscribing it with
words, signs or numbers, and all cultures
have their talismans. In the Muslim
world talismans bear Qur'anic inscriptions,
religious narratives, numbers and
sometimes astrological signs. Many believe
that a talisman can protect the person who
sees, reads or wears it. Talismanic shirts,
known as *jama* or *cam'e yi'feth*, are thought
to have been worn under armour and are
known in versions from Iran, Turkey and
India. They are usually made from cotton
cloth and are seamed under the arms
and down the sides. This shirt is different
– it is made from parchment, which is
calf, sheep or goatskin. Unlike leather,
which is tanned, parchment is limed –
soaked in a solution of calcium oxide or
calcium hydroxide to preserve it. The shirt
is decorated entirely with calligraphic
inscriptions, which include the ninety-nine
Names of God, the *Shahada*, the phrase
'Allah is Great' and part of Surat Aş-şaf:
'Victory from Allah and an imminent
conquest'. The parchment is very rigid
and it would have been difficult to wear,
although the fact that the sides are not
sewn together would have made it more
comfortable. *Inv.136*

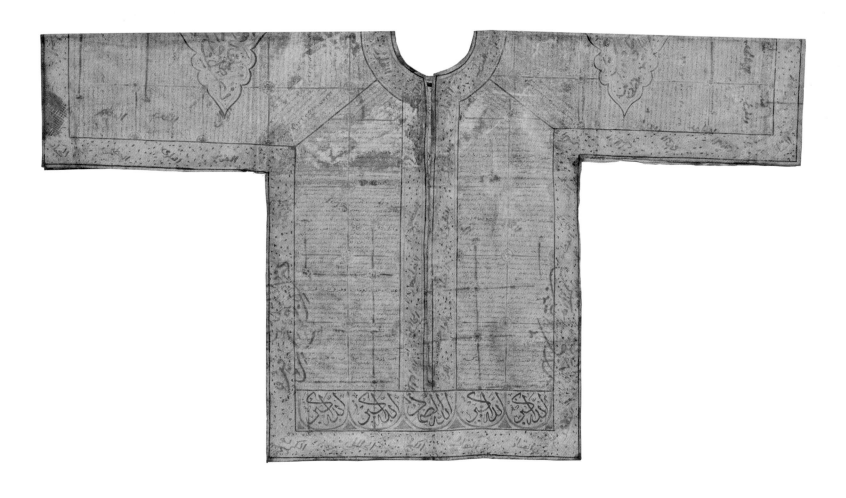

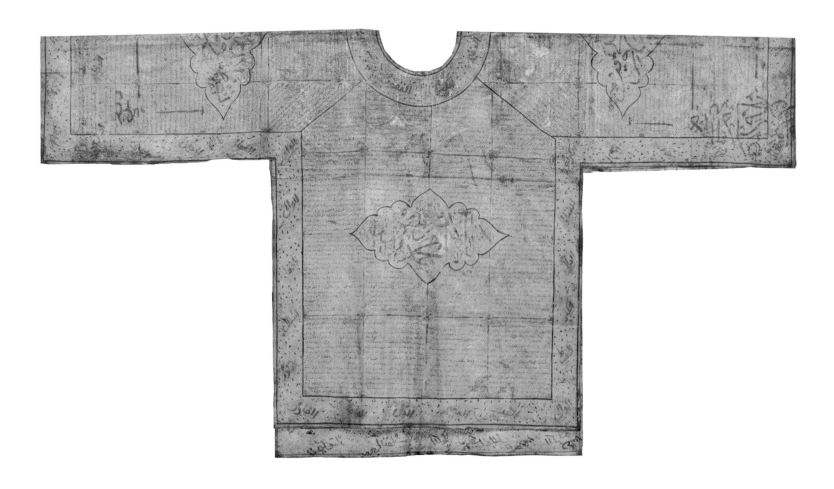

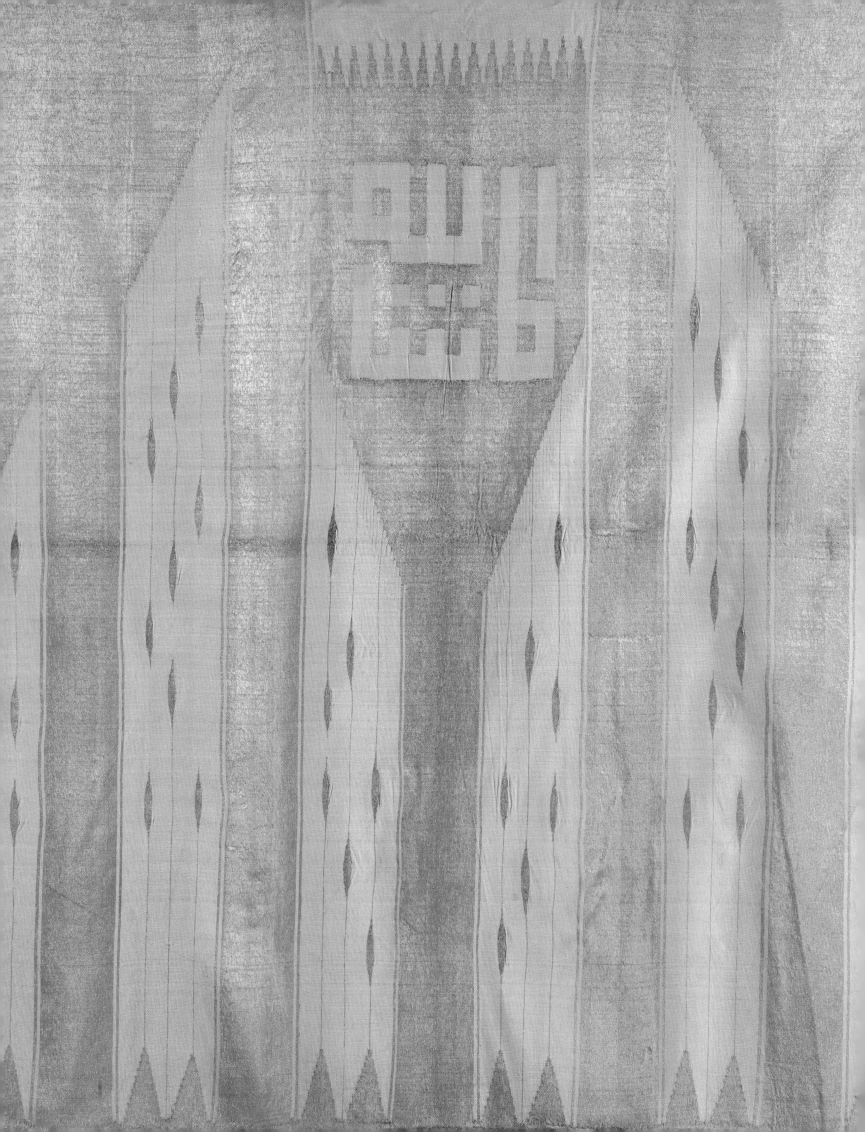

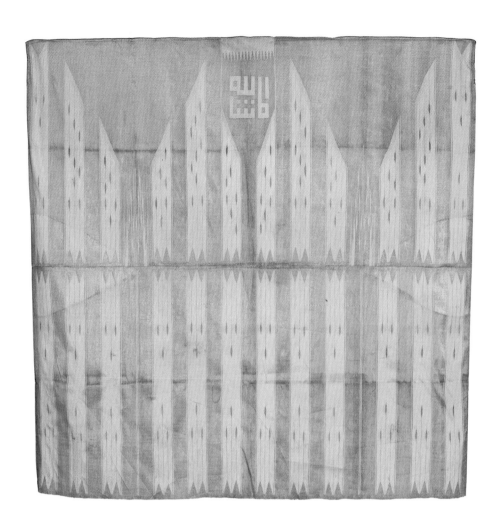

59
Man's *abba*

Silk and metal thread with brocaded
and tapestry woven decoration
Probably Syria, 20th century
L: 138 cm × w: 140 cm

Such outer garments were traditionally
constructed from two loom widths of fabric,
joined along their length to form a long
rectangle; the ends were folded in towards
the centre and sewn along one edge to form
shoulder seams. It is an extremely simple
robe, there is no tailoring and crucially
there is no wastage of fabric – everything
that is woven is used, nothing is discarded.
When worn, the *abba* drapes around the
body and its rigid pattern of stripes is
broken and softened. The only part that
remains unaltered, no matter how much

the wearer moves, is across his shoulders,
at the back of his neck, and it is here that
we find an inscription: *Masha'Allah*. Placed
prominently across the back of the garment
this phrase would have been used to
protect the wearer from evil. It was woven
in a simplified, geometric form of kufic
script, a style of writing which developed
in Kufa, Iraq, in the late 7th century and
was the main script used in early Qur'ans.
The technique used for the inscription is
known as tapestry weave, and the weaver
would have passed the weft backwards and
forwards in small areas to create the lines of
the letters. With this technique it is easier
to create straight lines and more difficult
to curve them, so the angularity of kufic is
ideally suited to it. *Inv.1*

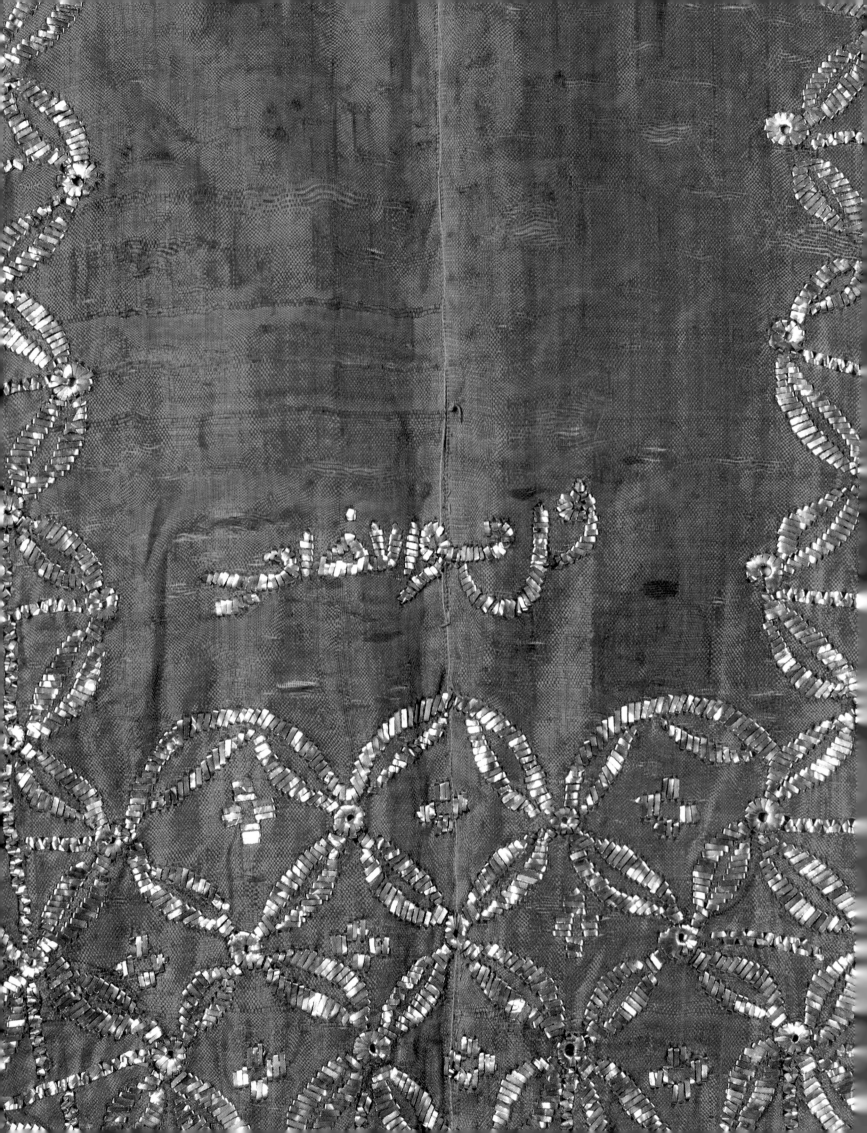

قُلْ هُوَ اللَّهُ أَحَدٌ

60
Wedding tunic

Woven silk embroidered with metal thread
Tunisia, Mahdia, 1st half 20th century
L: max. 90 cm × w: 76 cm

On the day henna was applied to her hands
and feet, a bride in eastern Tunisia would
wear this tunic as part of an elaborate
outfit which included a headpiece (see
no. 67) and eight other richly decorated
garments and accessories, plus jewellery
of gold and pearls. The bride was to shine
like the sun on this day and the saffron-
dyed silk tunic, almost totally covered
with gilded silver plate, ensured that she
would radiate golden light. The embroidery
is concentrated across the shoulders,
extending to the edge of the tunic and
stiffening the fabric so that it forms a
rigid shell. It is the ultimate shoulder
pad, increasing the apparent width of the
bride and making her larger-than-life,
emphasizing the central role she played.
The weight of the metal thread and the
yoke-like shoulders may have symbolized
the heavy responsibilities of marriage.
This tunic and the other pieces of the
ensemble were expensive to make or to
purchase and were a significant part of
the bride's wealth. To protect her from the
evil eye it was common to embroider a
symbol across the back. On this tunic her
protection is an inscription from the Surat
Al-'Ikhās (The Sincerity), which reads:
'Say "He is Allah [who is] One"'. *Inv.153*

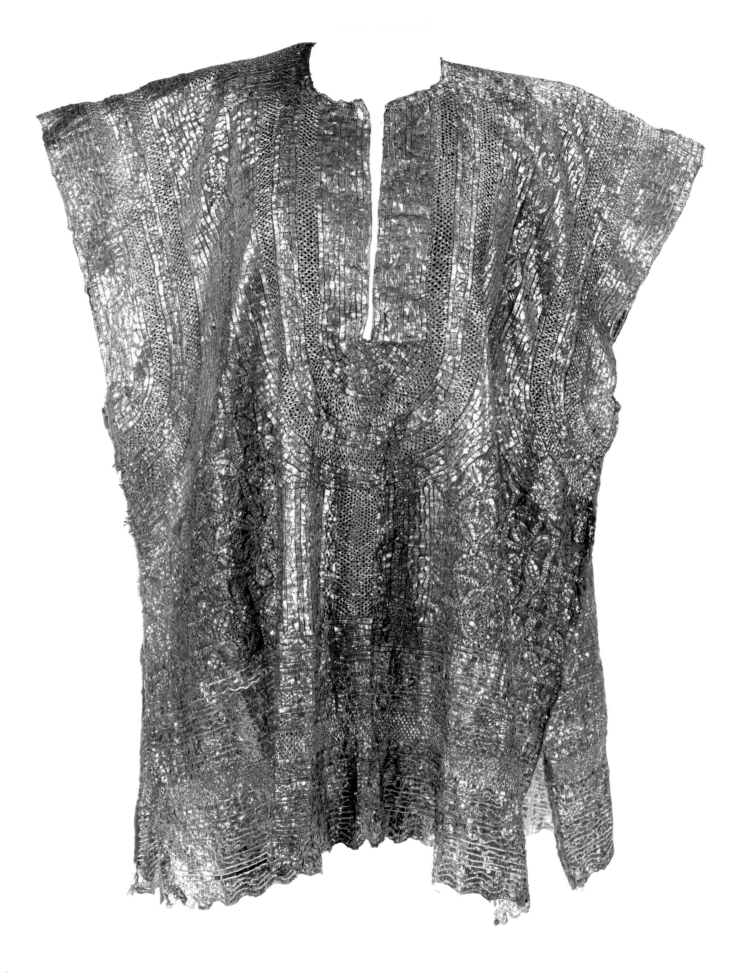

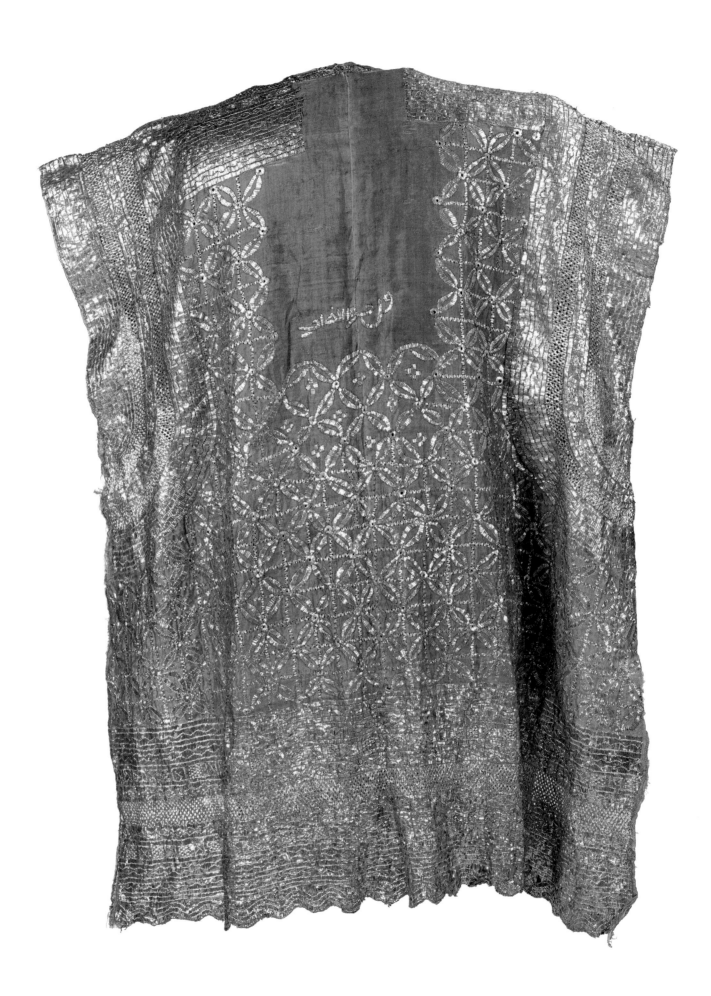

61
Man's *abba*

Woven wool embroidered with
metal thread
Syria, Homs, for the Palestinian market,
1st half 20th century
L: 130 cm × W: 137 cm

An *abba* woven like this with broad stripes
using natural brown and white wool was
worn by the Ta'amreh Bedouin from
Bethlehem, but the attractive simplicity
of the design and the ease of using undyed
wool mean that this style of garment
may also have been worn by men in
neighbouring parts of the Middle East.
The embroidered gold decoration around
the back of the neck indicates that this
is not an everyday *abba* to be worn in
tribal encampments, but rather one to
be worn by a relatively affluent man on
a special occasion. The short inscription
embroidered across the back reads
'A Garment of Contentment' and expresses
a beautiful desire to bestow a happy state
of mind on the wearer. The style and
execution of the embroidered inscription
are not as accomplished as those in the gold
patterns around the neck, and this suggests
that the garment was purchased and then
taken to someone who added the phrase.
Inv.146

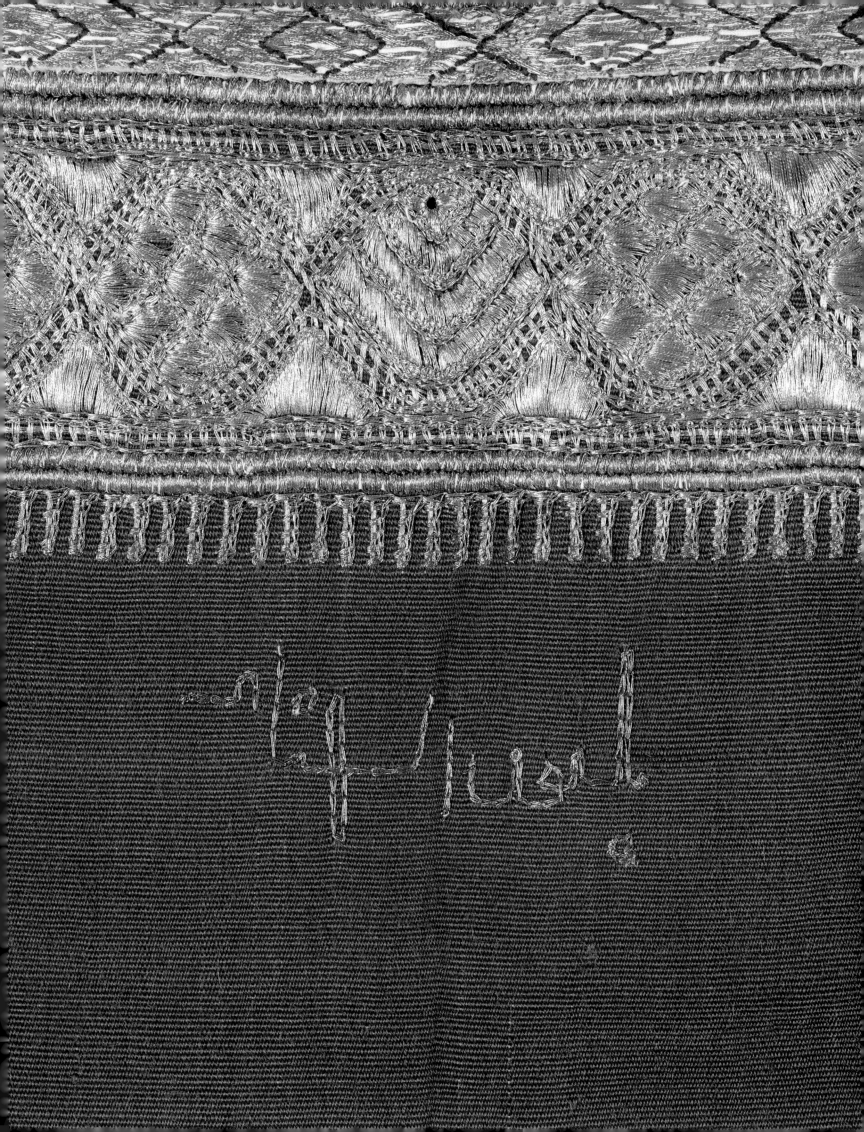

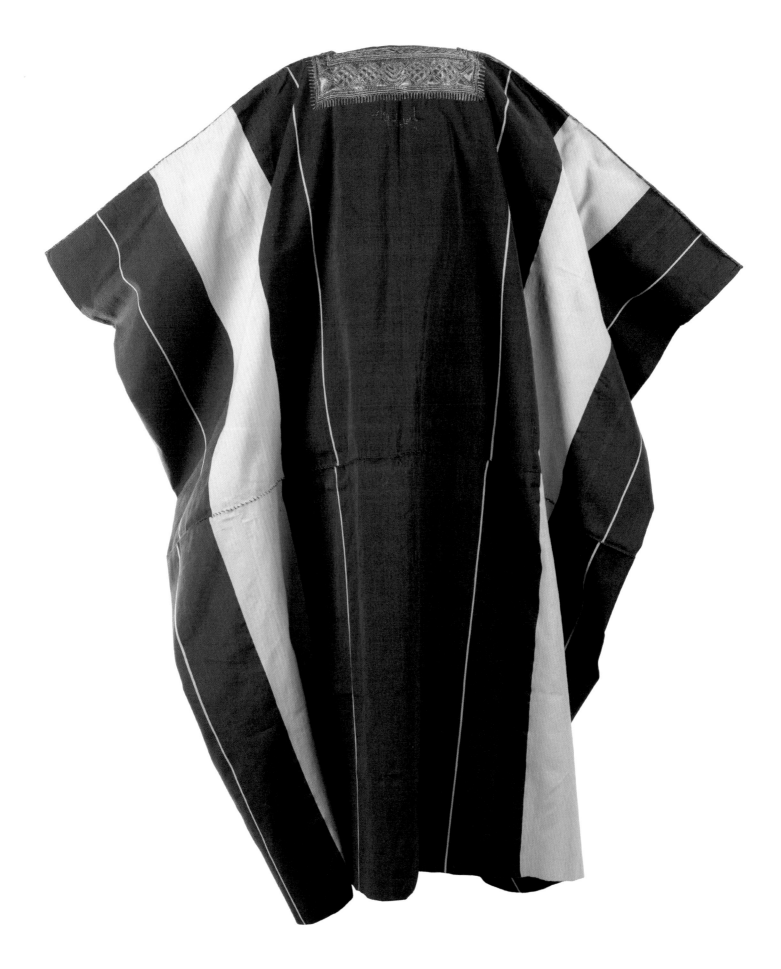

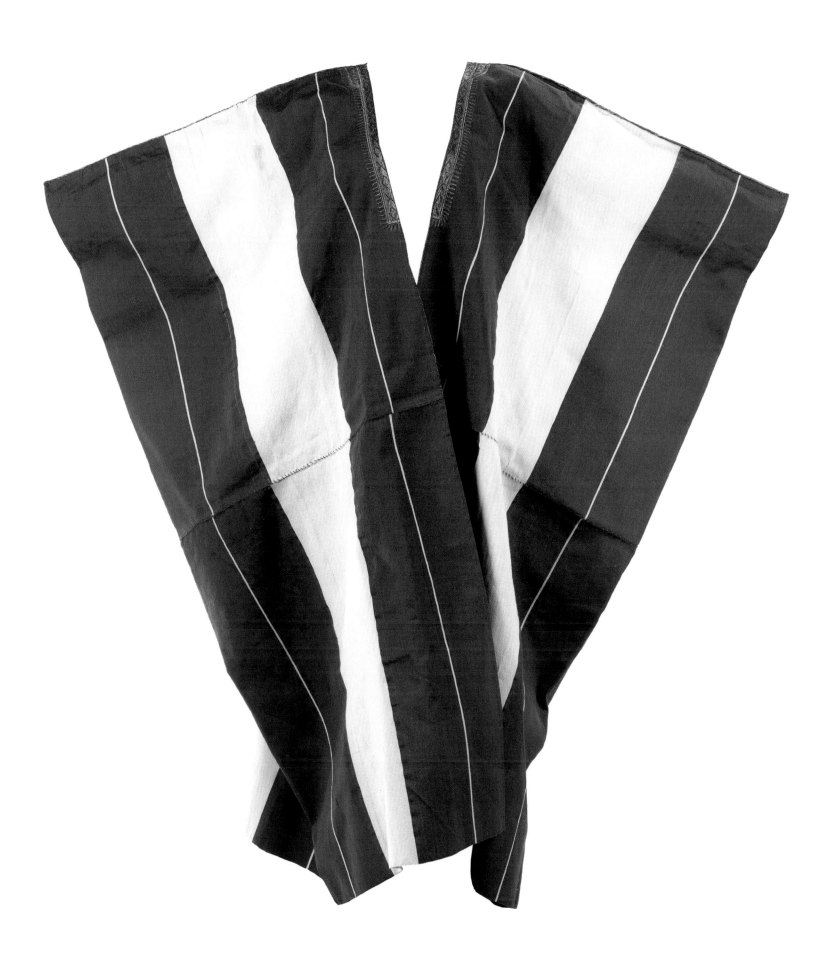

62

Talismanic wrap

Painted cotton
Ghana, West Africa, Asante, 19th/20th
century
L: 235cm x w: 340cm

In the middle of the 18th century the several kingdoms of the Gold Coast region of West Africa were united under the Asante to form a large empire roughly covering the area of modern Ghana. Large rectangular cotton cloths block-printed with geometric symbols were worn wrapped around the body by royalty and religious leaders on very special occasions such as funerals. The cloth was divided into a grid and each square was filled with small printed symbols, known as *adinkra*. Each had a special meaning in that pre-literate society, representing proverbs and ideas. The oldest surviving *adinkra* cloths

date from the years 1817–25. At first sight this cloth looks like an *adinkra* wrapper but instead of block-printed symbols it has been decorated with painted 'Arabic' inscriptions. Within the Asante Empire there was a small but economically influential community of Muslims linked to North Africa by well-established trade routes across the Sahara. These educated and highly literate Muslims were invited to act as diplomats, historians and traders on behalf of the Asante and were asked to pray for the health of the ruler, guaranteeing protection against his physical and spiritual enemies. A similar wrap in the British Museum has been catalogued as a 'medicine cloth' because it is thought that the inscriptions imbued such pieces with talismanic or healing properties.
Inv.150

63
Head and shoulder cloth

Resist-dyed cotton (batik)
Indonesia, Sumatra or Java, 20th century
L: 215 cm × W: 110 cm

The pattern was made by drawing with wax on white cotton cloth and then dyeing it in a solution of indigo; when the wax was removed the pattern was revealed as undyed areas on the dark blue ground. The technique of using a wax resist is known as batik, and cloths with calligraphic designs are known in Sumatra as '*batik besurak*', meaning 'batiks containing verses of the Qur'an'. The lozenges down the centre contain legible inscriptions – 'Mohammed' in the centre and 'Allah' above and below – but the repeated writing-like patterns over the rest of the cloth have no meaning, although they may be seen as expressions of devotion and loyalty to the Islamic faith and serve as protective talismans. These large cloths are usually considered to be sacred and are used at rite-of-passage ceremonies either as head and shoulder cloths or as shrouds for the dead. Characteristically the outer border at either end is decorated with a series of fine white lines which mimic a fringe. The precise origin of these beautiful calligraphic batiks is disputed. Some scholars believe they were made in Cirebon on the neighbouring island of Java and were exported to Sumatra, but others believe they were made locally in Sumatran workshops. *Inv.151*

64
Khayamiya

Cotton appliqué
Egypt, late 19th century
L: 116 cm × w: 111 cm

Appliqué (sometimes called 'applied work') is one of the oldest forms of decorative stitching and probably began when patches were sewn on to clothing or furnishings to strengthen or repair worn areas. It is a needlework technique in which pieces of different fabrics, cut to specific shapes, are sewn on top of a single piece of cloth to create patterns or pictures. It is a relatively quick process and makes economical use of small scraps. For centuries the Cairo district of Bab al-Zuwayla has been associated with the men who made both tents and appliqué hangings. The hangings have recently been given the name '*khayamiya*' from the Arabic word for tents, '*khayam*'. Pieces were usually decorated with a combination of calligraphy and geometric patterns, often derived from the complex interlaced patterns found on metalwork and inlaid woodwork dating from the early Islamic period in North Africa. These strong, geometric designs are ideally suited to appliqué, which relies on boldness for its visual impact. Reds and blues were the most popular colours, and old cotton cloth was recycled, being washed and dyed by the tent makers. The inscription surrounding the central panel reads: 'I found contentment a complete wealth'. Appliqué hangings vary in size and function from small panels and wall hangings to larger banners, tomb covers, tents and curtain fences for use at public gatherings. A small panel, such as this, may have been a complete object or it may have been a component of a much bigger decorative scheme in which panels of different sizes, all sharing the same style and colouring, were combined to create a large structure. *Inv.172*

173

65
Khayamiya

Cotton appliqué
Egypt, late 19th century
L: 261cm × w: 156cm

This Khedival *khayamiya* is, in fact, two panels stitched together down the centre (the lower border is slightly misaligned at the seam). The pale cloth, on to which the coloured cottons have been applied, can be seen at the top and a little at the bottom; there are fine blue stripes running through it. Great care has been taken in cutting the pattern pieces; their edges have been turned under to prevent them from fraying and tiny stitches secure them to the ground. Templates may have been used, or the patterns may have been transferred using the 'prick and pounce' method (see no. 3). The design is cleverly balanced, leading the eye from the solid lower border, up through the densely packed rising branches to the more delicate upper border, and, by using small red cypress trees along the top, bringing the observer's eye back down to the pair of large cypress trees at the bottom. Despite the variety of shapes used, there is a pleasing unity which required great skill to achieve. The inscriptions read: 'Look again here is the proof' and 'This will take a long time to explain'. Pieces like this and no. 64 are now called *khayamiya* because they were made between 1867 and 1914 when Egypt, part of the Ottoman Empire, was governed by a Khedive. The term also distinguishes these traditional geometric designs from the pictorial ones copied from wall paintings in Pharaonic tombs and marketed for tourists.
Inv.174

صنع جمالا

الذاكر الذ

اعلا نظر تجا

وهانا قد الفت

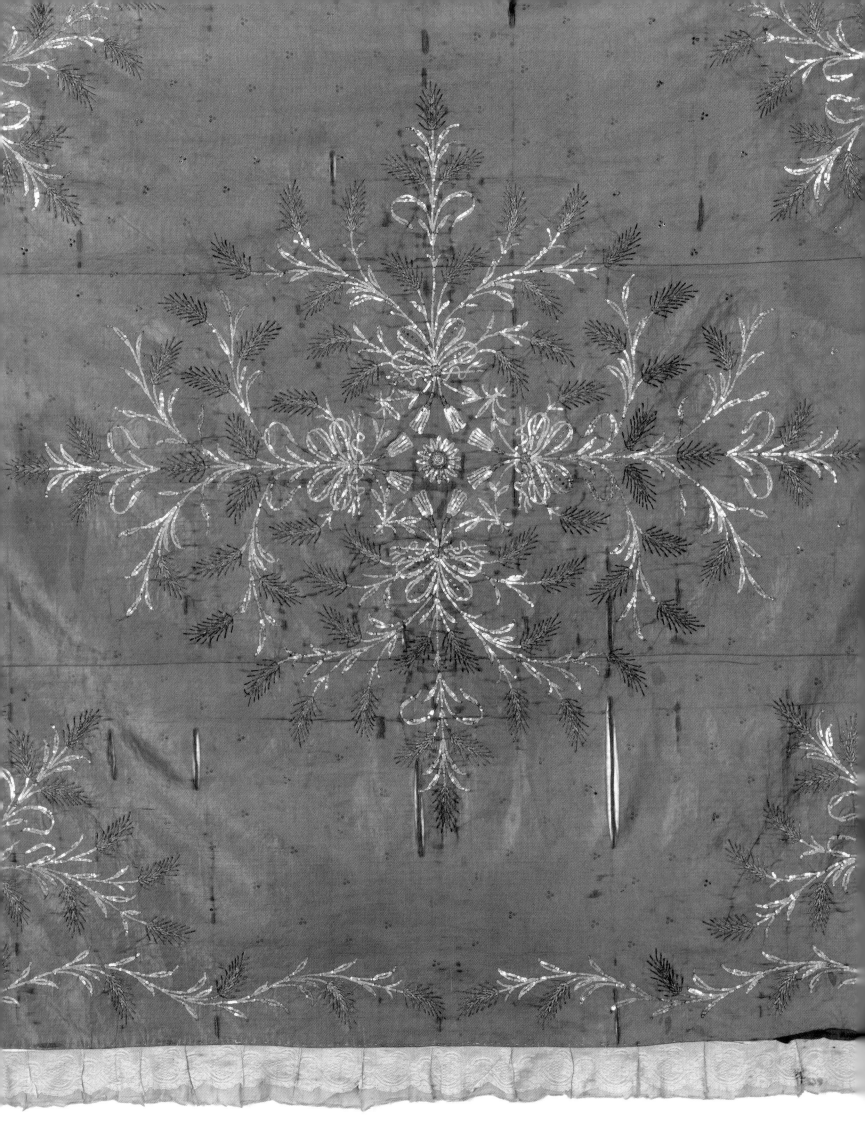

Applied decoration

Applied decoration – things sewn on to fabric – can be an integral part of the design or they can add an extra dimension of pattern or of protection. Glass or metal beads, metal spangles, plastic sequins and short lengths of spiralling metal thread (purl), braids, ribbons and buttons are the most common type of applied decoration, but absolutely anything can be used and it can be used in a multitude of ways. Individual elements can be used at intervals or in lines to make borders along seams, necklines or hems, they can be used with coloured thread to make tassels and fringes, and, at the other extreme, copious quantities can be massed into densely packed patterns. In the nineteenth century professional textile workers across the Islamic world often used metal spangles and purl in conjunction with other forms of metal thread to decorate exquisite household furnishings, especially bedding. Amateurs, working within their home, seem to have directed their efforts primarily to the embellishment of dress and it is they who were more likely to use applied decoration to add a degree of protection to their garments.

Elements for applied decoration may be 'found' – such as sea shells or coins – or recycled from other things – such as buttons cut off old garments – or they may be purchased, at some expense, from merchants. If using recycled or found objects people are demonstrating their inventiveness; if they buy items they are demonstrating a degree of affluence. Either way, they are personalizing the thing being decorated and thereby ensuring it is unique. Many types of applied decoration are no more than that – pretty things to add colour and pattern – but some types were chosen and added to fulfil a specific and important function.

Throughout history and across the world people have often sensed the presence of evil and have feared its power, seeing misfortune, ill health, poor harvests and general adversity as its manifestation in their community. Because of high mortality rates, children have been believed to be at very great risk, especially from the evil eye, which is thought to cause harm through envy of a person's good fortune or following a compliment given to them. In Islamic cultures it is customary to say *Masha'Allah* (What God wills) and *Insha'Allah* (If God wills) to preface a compliment or when speaking of some good fortune. Amulets and charms were commonly used to ensure protection, with the intention of attracting the very first glance, which would then deflect any evil that might otherwise harm the wearer. Shiny surfaces were thought to be particularly effective at distracting the evil spirits and red coral and blue lapis lazuli were also seen as imbued with protective qualities. Even one small bead or reflective plaque was better than none.

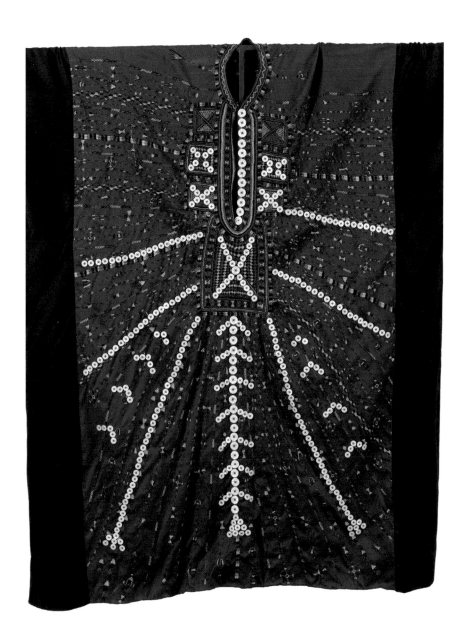

66
Detail of woman's dress

Cotton twill embroidered with floss silk and with applied buttons
Egypt, Siwa Oasis, mid 20th century
L: 132.5 cm × W: max. 223 cm

Lengths of black and of red cotton have been joined to form this wide, T-shaped dress which is plain black at the back with a wealth of pattern and colour at the front. The densely packed embroidery over the breast is worked through two layers of fabric to give a degree of rigidity and support. Radiating from the six squares and one large rectangle filled with a chequered pattern of tiny diamonds are dozens and dozens of narrow embroidered lines. Some are simple lines of cross stitch in alternating colours, some are wider lines formed by blocks of couched silk, and others are isolated stitches which link small geometric motifs – wheels, crosses, fish and triangles with pendants, which represent a type of amulet often worn as a charm against misfortune. Rows of intensely white buttons have been added; they serve no practical purpose and even the ones along the neck opening have no function except to add highlights to the red, orange, yellow and black of the embroidery, and their weight would have ensured that the dress draped attractively. It is thought that the colours and the radiating lines may have once been associated with the Egyptian sun-god Amun-Re because Siwa had a well-documented link to him. As a consequence this type of dress is sometimes called a 'sun dress'. *Inv.49*

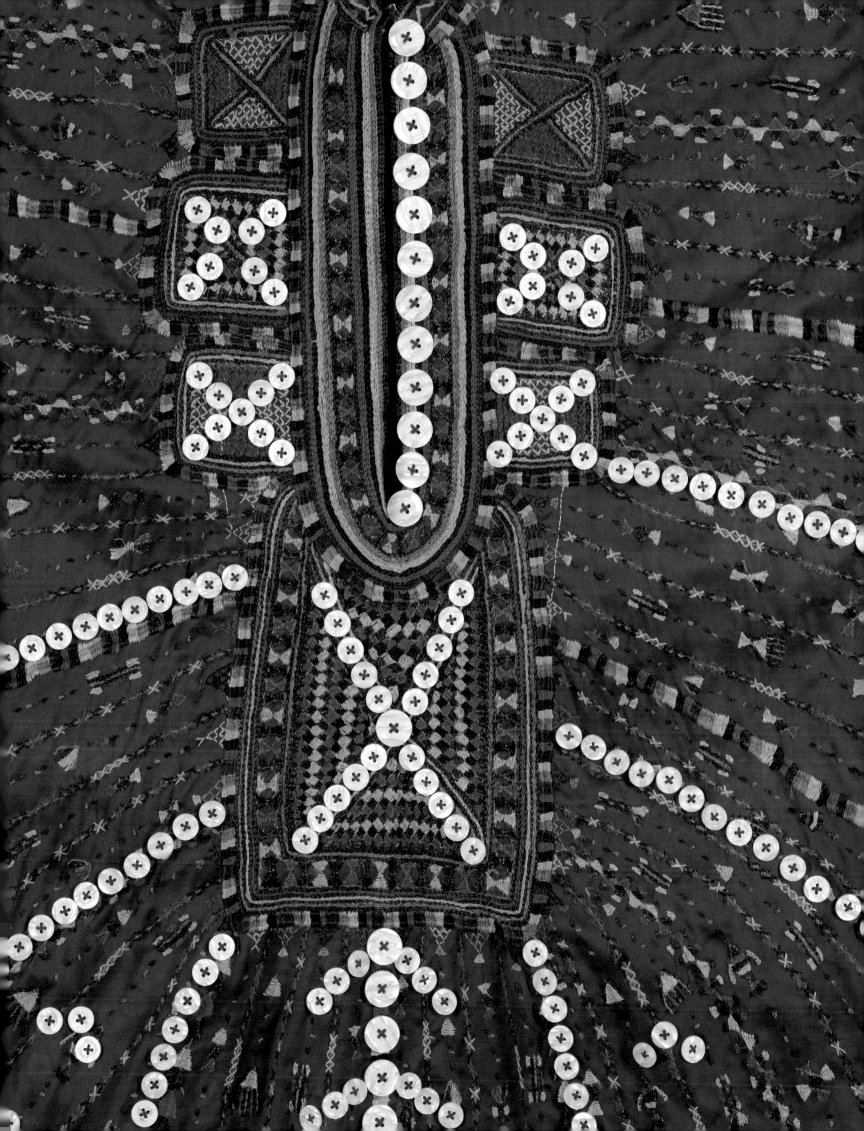

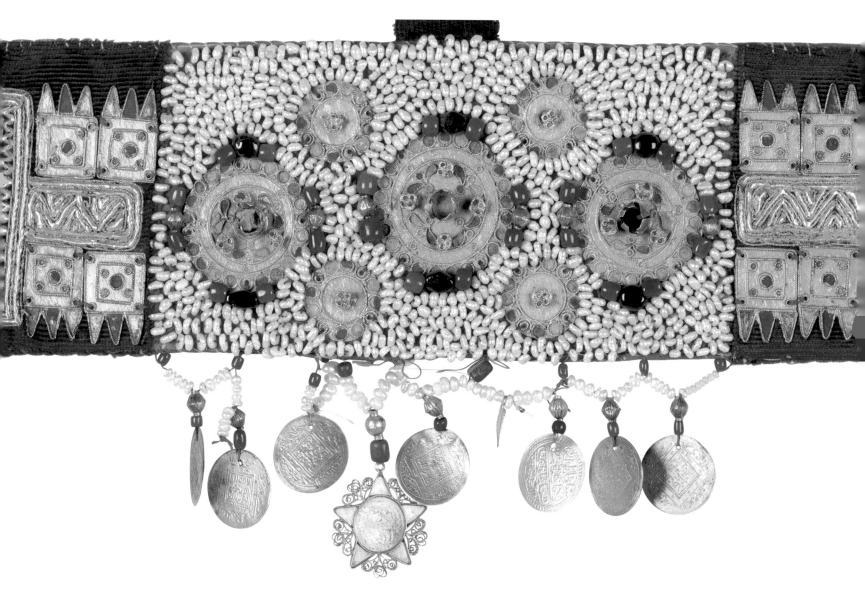

67

Tegeia

Panels of silk and of corduroy
embroidered with silk and metal thread
and with applied ornaments
Tunisia, Mahdia, probably 1920 to
mid 20th century
L: 107 cm × W: max. 17 cm

This richly embroidered headpiece, or
tegeia, decorated with coloured glass, coral
and pearls, was part of the outfit worn in
eastern Tunisia by a bride on the day henna
was applied to her hands and feet (see also
the tunic no. 60). Freshwater pearls are
sewn on to the central panel together with
seven metal plaques edged with beads.
All but one of the plaques have lost the
glass jewel from their centre. To the sides
are panels of corduroy, each decorated
with metal plaques and an angular fish

(fishing was an important local industry),
embroidered with silver-gilt thread and
coloured silk details. A saffron-dyed silk
panel at either end is also embroidered
with silver-gilt thread to produce a pattern
that was reversible, which was important
because the panel hung down the bride's
back and moved freely, revealing both sides
of the embroidery. A fringe falling from
the central panel to frame the upper part
of the bride's face is made with everything
precious – freshwater pearls, coral beads,
red glass beads, metal tokens and a star-
shaped medallion with filigree work
containing a small English gold sovereign
with the head of King George V, dating
either from the period 1911–17 or from the
year 1925, when such coins were minted.
Inv.97

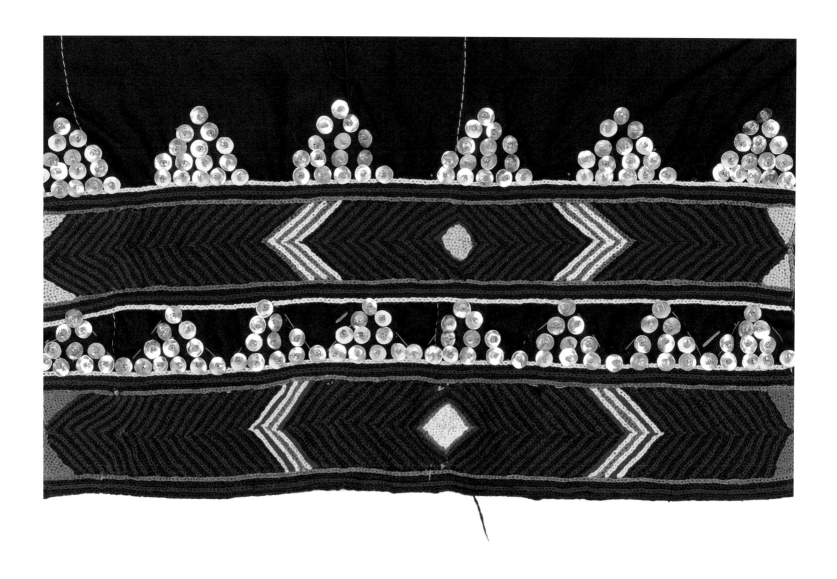

68
Detail from the sleeve
of a woman's dress

Cotton twill embroidered with cotton and with applied metal spangles
Saudi Arabia, Ta'if region, Bani Sa'ad tribe, mid 20th century
L: max. 25 cm × w: max. 36 cm

These decorative bands are from the lower part of a sleeve. They form a cuff which would have fallen between the elbow and the wrist, and, while they added colour and pattern, they also added weight and ensured that the sleeve hung correctly and comfortably. The black cotton is a twill weave which gives it a fine but distinct diagonal rib. Certain embroidery stitches, such as cross stitch, are difficult to work on a twill ground, so the embroiderer of this sleeve chose to use chain stitch, which sits easily over the diagonal ribs and has the advantage of being quick to do. This panel would have been folded and stitched to form the cylindrical sleeve so the small yellow and white diamonds would have been prominent along the outer part of the lower arm and the chevrons would form bracelet-like bands. Bands of large silver spangles have been added to form triangles, each spangle being secured in place with a clear glass bead. The materials used are all machine-made and would have been bought from shops or from travelling merchants. Lines of white cotton machine-stitching and large tacking stitches are clearly visible and, as no attempt at concealment was made, they were not thought to detract from the beauty of the decorative work. *Inv.40*

69
Detail from the sleeve
of a woman's dress

Rayon embroidered with metal beads
Saudi Arabia, Ta'if region, Bani Sa'ad tribe,
mid 20th century
L: max. 38 cm × w: max. 53 cm

The metal used for the beads is an alloy,
a mixture of silver with a high lead content
which has the advantage of melting at a
relatively low temperature (327° c) and
retaining its shine far longer than pure
silver would. Silver and lead ores are often
found in close proximity, but it is easier

to recycle metal by melting down old or
broken utensils over a fire. A long, thin
twig or thorn was dipped into the molten
metal and pulled out with a droplet sticking
around it; when this cooled it formed a
bead. These vary considerably in size but
the very finest beads measure only one
millimetre in diameter and length. To
support the weight of so many metal beads
they have been stitched through two, and
in places three, layers of fabric. Lengths
of beads strung on to thread have been

stitched down using yellow cotton, which
seems to turn the silver beads golden. In
places they have been worked over small
panels of red cloth to create contrast and
add colour. *Inv.39*

70
Woman's dress

Cotton twill embroidered with cotton,
metal thread and with beads
Saudi Arabia, Ta'if region, Bani Sa'ad tribe,
2nd half 20th century
L: 140.5 cm × w: max. 134.5 cm

This dress is a simple, traditional T-shape
with triangular panels inserted at the sides
to add extra width for ease of movement.
While the sides and the lower part of the
dress have been embroidered with coloured
cotton thread, the bodice and the sleeves
have been decorated with beads. Clear glass
beads were first strung on to white cotton
and then stitched into an intricate pattern
of diamonds on the front of the bodice.
The beads on the sleeves, however, are
made from lead. They have an opalescent
quality, glowing with hints of yellow and
blue. The central part of the upper band has
been sewn on top of a panel of light brown
woollen cloth, which echoes this yellow
glow. The lower band of beads has been
worked above and below two rows of red
stitching, which itself may be a substitute
for expensive coral beads. Unlike the beads
on the bodice, which were strung on to
thread and then stitched in place, most of
the beads on the sleeves were stitched on
to the cloth one by one. These differences
– leads beads stitched individually and glass
beads threaded and then stitched en masse
– suggest that the sleeves were older than
the rest of the dress, that they had, perhaps,
been inherited and were being re-used at
a time when lead beads were too expensive
to use and time was too precious to waste.
Inv.48

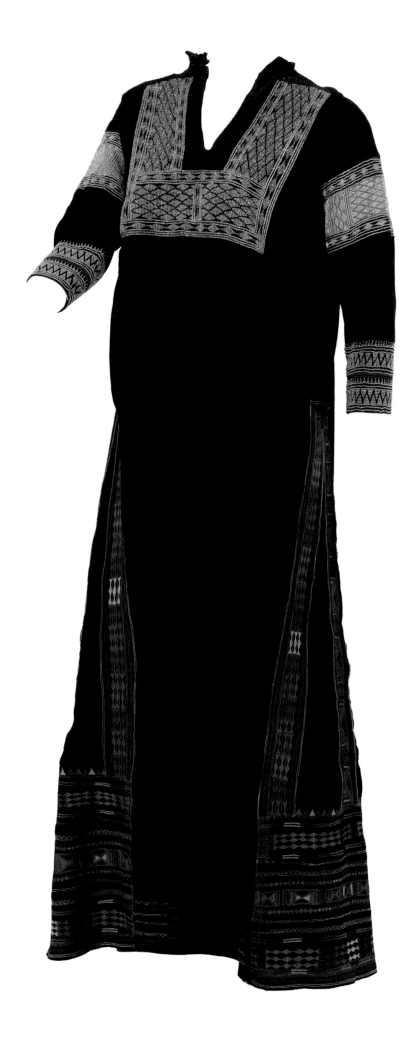

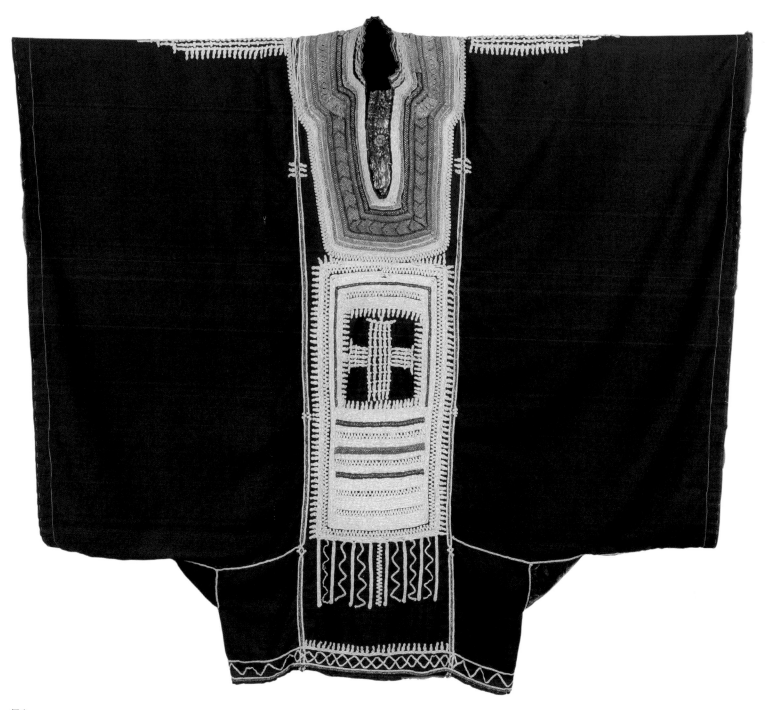

71

Woman's dress

Cotton twill with applied cotton and metal thread braid
Yemen, Tihama, early 20th century
L: 115 cm × w: max. 137 cm

The wide sleeves of this dress would have allowed a cooling draught to counter the heat of the coastal desert which forms the Red Sea coast of Yemen. The main decoration of the garment is concentrated down the front and is divided into two sections – a series of applied borders around the neckline and, below this, a rectangular panel of couched geometric patterns. The borders are made with cotton braids each woven with a silver strip; from a distance they give the appearance of beadwork. Different coloured cotton has been used – red, black, white, green and pale apricot. In the lower panel a silver thread has been combined with white cotton threads and has been laid in lines, twisted into patterns and stitched in place. The embroidery around the neck has been worked through two layers of cloth to stiffen it and support the weight of the braids. At a later date a band has been added to make a stand-up collar and some commercially woven fabric has been added to one side of the front slit to make a modesty panel. These minor alterations indicate that the traditional dress was valued and updated so that it could continue to be worn. *Inv.51*

72
Thobe or *thoub*

Net embroidered with metal thread and
spangles and with panels of silk brocaded
with metal thread
Arabian Pensinsula, 1950s
L: max. 317 cm × w: max. 358 cm

Seldom does a garment challenge the
wearer to take control and tame it, but
the Arabian *thobe* (or *thoub*) requires not
only confidence but also knowledge of its
secret ways. The uninitiated would founder
beneath metres of fine net, but those who
know how to fold the long, wide sleeves
over their head are able to wear a garment
of great beauty and graceful lines. The
thobe is a simple but over-sized T-shape
with large triangular panels of brocaded
silk inserted under the arms. To be most
effective as an overdress it should be made
from a sheer fabric so that it hangs as a
transparent film over the other clothes.
Although the most obvious decoration
is around the neck in the form of solid
bands of spangles, the most important
decorative elements are the large, isolated
motifs which have been applied all over
the garment. Four trefoil leaves curving
to the right have stems which intertwine
to form a cross around a diamond-shaped
space and to these have been added four
similar trefoils curving in the opposite
direction but without stems. They have
been worked with lighter and darker shades
of gold spangles and with silver ones for
highlights, every one added by hand. It is
little wonder that such a splendid garment
is worn only on special occasions. *Inv.54*

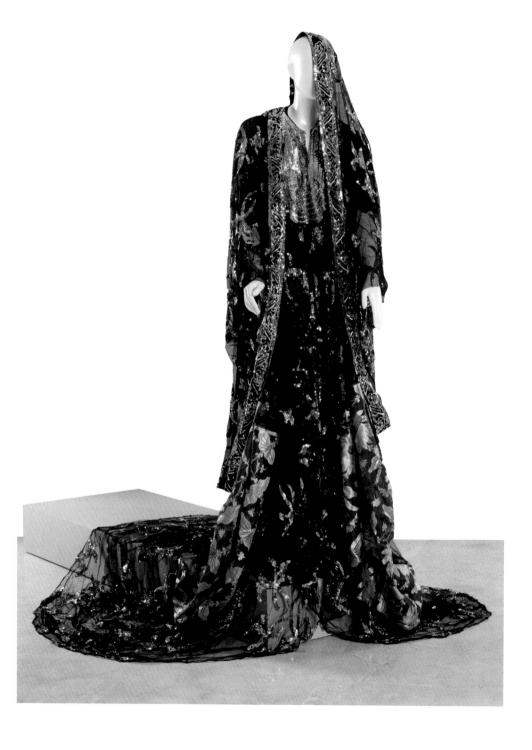

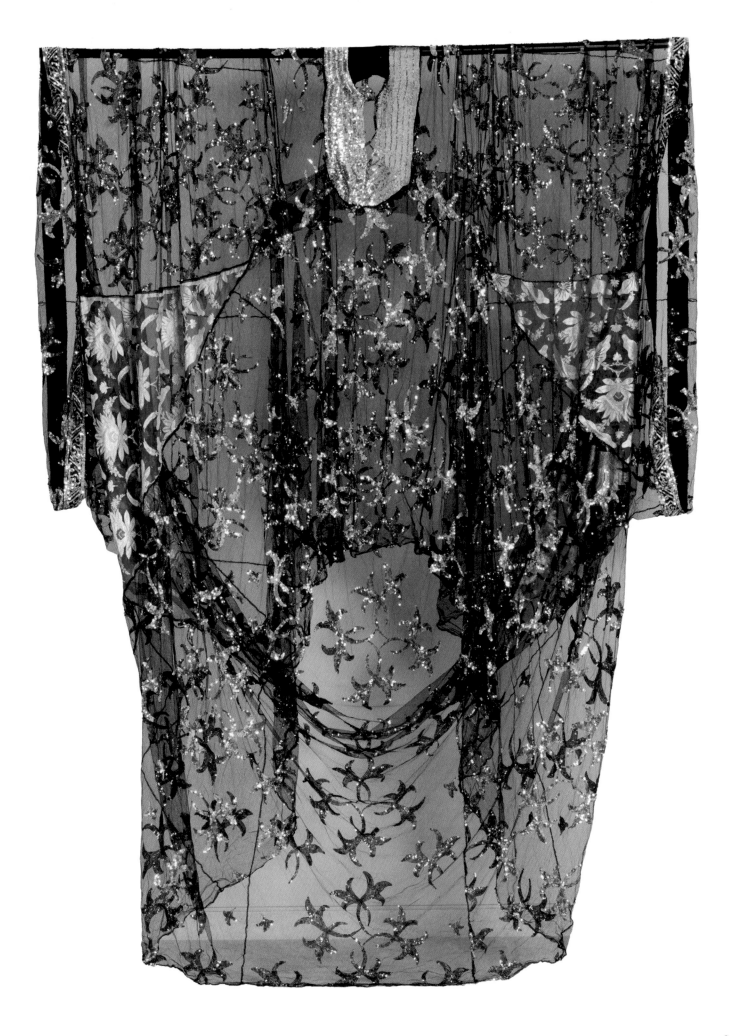

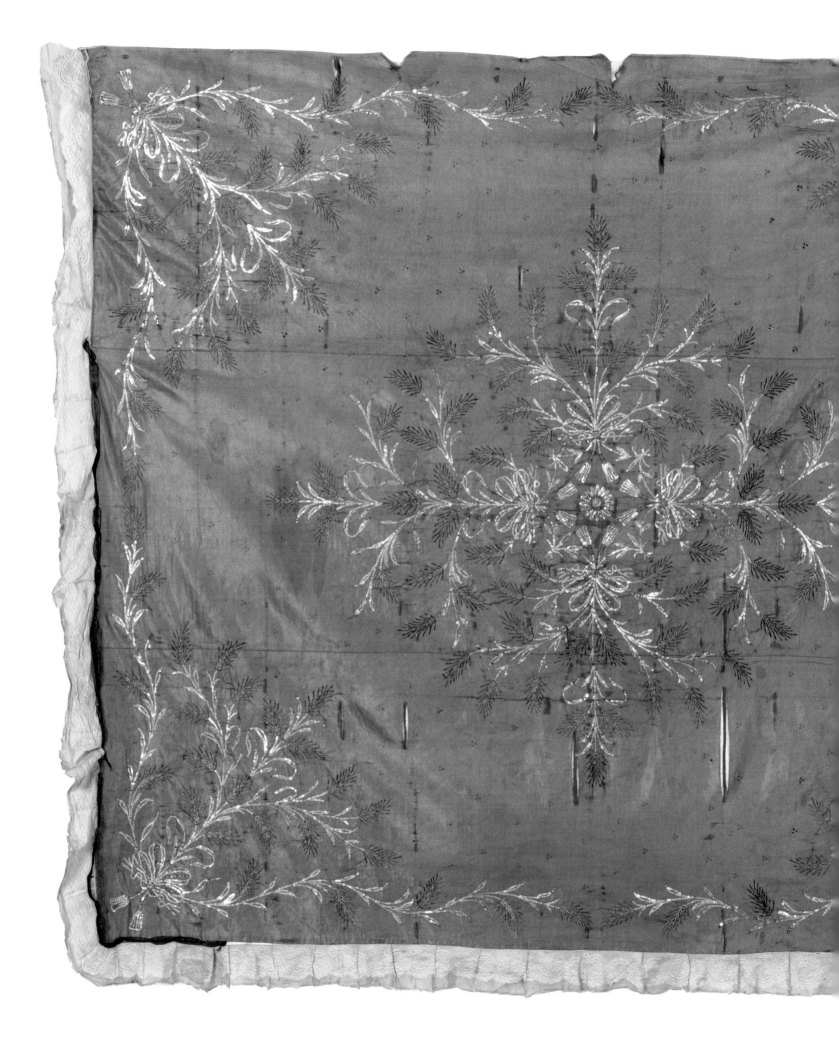

73
Bed cover

Silk and cotton satin embroidered with
metal threads, with applied spangles,
ribbon and linen bobbin lace
Ottoman, late 19th century
L: 213 cm × w: 185 cm

This delicately coloured satin cover is
encrusted with quantities of silver thread,
cleverly worked to create light and shadow,
smoothness and grittiness, flatness and
plumpness, and is edged with ribbons and
lace to add softness and femininity. In
places where the sequins and metal threads
have fallen off, it is possible to see the
under-drawing – the original design which
was probably block-printed, rather than
drawn, on to the satin. The embroiderer
has used two types of silver thread, which

have been wound into short, tightly coiled
springs, called purl, through which a needle
and thread can be passed – an angular purl
and a rounded purl, each reflecting the
light in slightly different ways. Hundreds
of shiny silver spangles have been sewn on
to the satin, sometimes overlapping like
scales and glistening like liquid silver and
sometimes used in isolation and secured
with a small piece of equally shiny purl.
The ears of wheat, tied with tasselled
ribbons, have been worked over a base of
cotton stitches to give the wheat a natural,
rounded shape. The embroidery has been
worked through a backing of white plain-
weave cotton which had been covered with
size, a starch-like paste, to strengthen it and
to support the weight of the metal. *Inv.70*

74
Window hanging for a wedding

Cotton twill with applied metal spangles
Iran, Isfahan, late 19th/20th century
L: 91.5 cm × W: 86 cm

The design is created entirely with flat
metal spangles, almost all of which are
made of brass, an alloy of copper and zinc
which has a bright, gold-like appearance;
a few silver spangles of differing sizes and
designs have been used in the decoration
of the two vases in the lower part of the
hanging. Where spangles have been lost
there are bright red spots – this was the
original colour of the cotton ground but
over time it has faded. Light fades all
dyes, some more quickly than others,
and it is not always possible to ascertain
what the original intensity of colour had

been. Sometimes the back of the textile
is not as faded as the front, sometimes
the colour remains hidden within the seams
of garments or panels and sometimes traces
of it can be seen under embroidery stitches,
beads and spangles. This design would have
been drawn or possibly printed on to the
fabric and then the spangles were stitched
on one by one. There is a bird sitting on
a cypress tree at each corner and beneath
a canopy with a fringed edging there is a
fifth tree with a pair of birds perched on
its branches and another sitting on top
holding a fish in its mouth. To either side
are vases with more birds, the biggest of
which is also holding a fish, and along the
bottom of this garden scene are two little
men. *Inv.72*

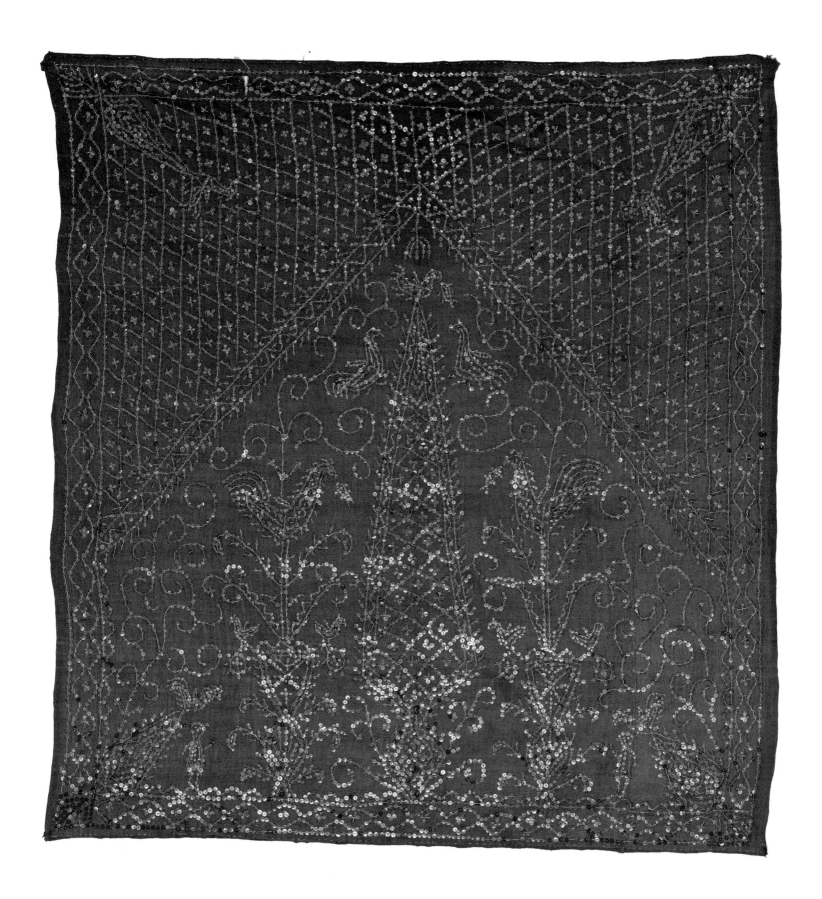

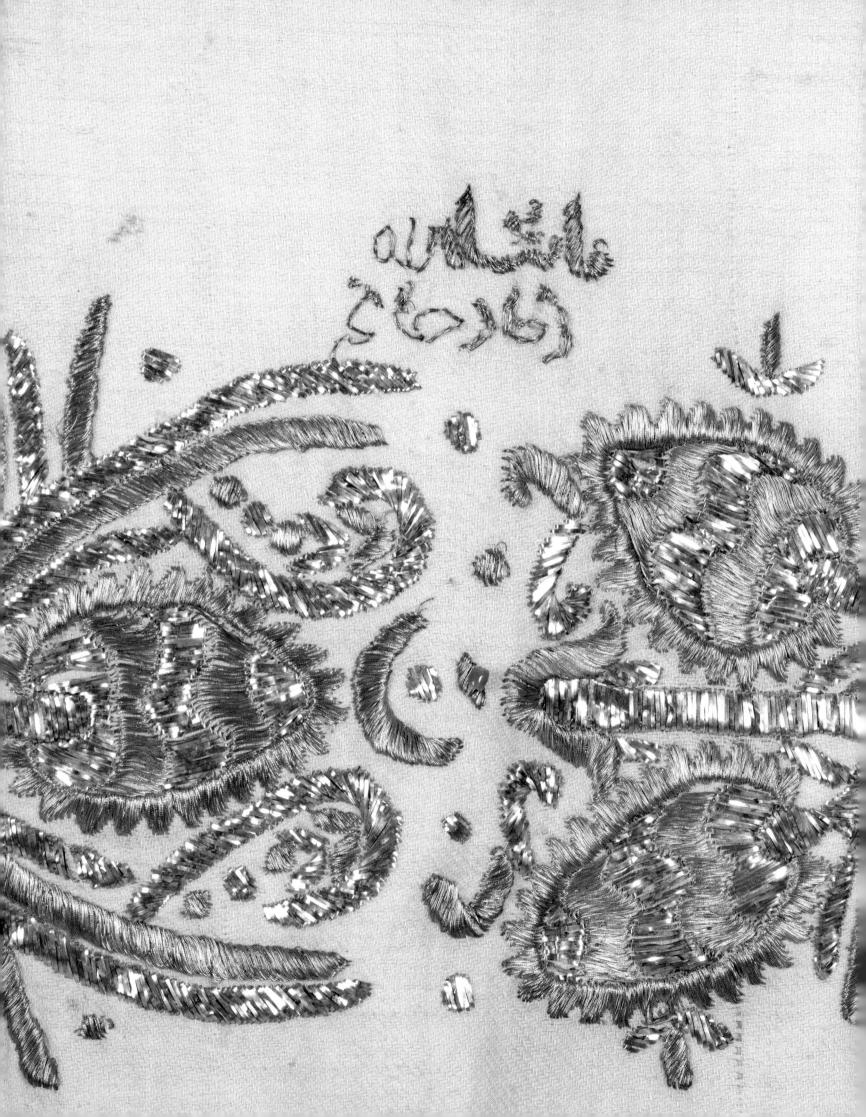

75
Havlu

Cotton twill woven with bands of looped
pile and embroidered with metal thread
Ottoman, 2nd half 19th century
L: 88 cm × W: 45 cm

This type of towel, the *havlu*, with its
absorbent looped pile, intrigued European
visitors to Anatolia for centuries. In 1614
Pietro della Vella, a traveller from Rome,
wrote that towels were "truly marvellous
after bathing, either swimming or in a hot
bath, and for women when they wash their
hair, and [they] deserve to be imitated
in our country, though", he added, "I
do not know how". In the late 1840s an
Englishman called Henry Christy brought
a Turkish towel back to England and he
and his brother developed a loom to weave
this remarkable fabric mechanically. They
displayed their 'Christy' towel at The
Great Exhibition in London in 1851 and
then presented it to Queen Victoria, who
immediately ordered more. They are so
familiar now that we have forgotten how
highly prized they once were. The ends of
this towel were left free of pile so that a
decorative border could be embroidered.
Two types of metal thread were used – a
flat gilded strip, which reflects the light,
and a finer but less shiny thread made by
winding a silver-gilt strip around an orange
silk core. The warp threads have been
gathered into groups to form tassels, with a
group of five knotted together alternating
with a pair of loose ones. The word
Masha'Allah has been embroidered above
one border and a small, bright blue glass
bead has been stitched securely below it to
protect its user from jealous glances, from
mischief and from evil. *Inv.62*

Glossary of terms

APPLIQUÉ: a decorative technique in which shapes or panels of one fabric are sewn on top of another fabric. Such shapes or panels are said to have been 'applied'.

BACKING: generally speaking, a backing is added to a textile and a lining is added to a garment but the term 'backing' can be used when a piece of fabric is stitched to the inside of a garment with the specific purpose of providing support.

BATIK: a form of resist-dyeing in which areas of the cloth are covered with hot wax; when the cloth is dyed the parts under the wax remain the original colour. The process of waxing and dyeing may be repeated to create elaborate and colourful designs. It is closely associated with South-East Asia.

BLOCK-PRINTING: using carved wooden blocks to transfer a design on to woven cloth (usually plain weave cotton). The black outlines are printed first and usually only three other colours are needed – red, blue and yellow, which combine to produce other colours.

BOBBIN LACE: a net-like fabric made by twisting and braiding threads which are held on bobbins.

BOTEH: a Persian word used to describe a droplet-shaped floral motif which became popular in the very late 18th century; in Britain and North America it is often called the Paisley motif because it was the main feature of shawls woven in mills in the Scottish town of Paisley.

BROCADE: a textile in which the wefts making the pattern are carried only across the width of the motif and not from selvedge to selvedge.

BROCADING: this refers both to the action of the weaver and to the area of the textile that has been brocaded. When silk, and especially metal thread, were more expensive than labour, it was economic to make a pattern by this time-consuming method.

COTTON: a white or sometimes light brown fibre obtained from the boll, or seed pod, of the plant genus *Gossypium*.

COUCHING: an embroidery technique in which threads are laid on the surface of a fabric to form a pattern; they are held in place by small stitches either of the same thread or of another type of thread. This technique is especially useful when expensive metal threads are required for the design: by holding them in place with small silk stitches, none of the precious metal need be wasted by taking it through to the wrong side of the cloth where it would not be seen. See diagram 1 (overleaf).

COUNTED THREAD WORK: embroidery worked evenly by counting the number of threads over which the needle is taken. For examples see under Embroidery Stitches (Cross Stitch, Double Darning, Double Running and Surface Darning).

CORDUROY: a hardwearing ribbed cotton fabric, said to have been used in the royal households of France for servants' livery, where it became known as '*cord du roi*'.

FACING: a narrow piece of material sewn along the reverse edges of a garment (at the neck, cuff or hem) or around the reverse edge of a cover to strengthen and neaten the edge and to add extra decoration.

FELTED WOOL: a woven woollen cloth which is beaten in warm, soapy water to produce a solid and firm fabric. It is similar in quality to felt, which is made from loose woollen fibres (not woven) which are treated in the same way.

FIGURED: a patterned textile.

FLOSS SILK: untwisted silk thread. It reflects light well.

FLYING SHUTTLE: the 'flying shuttle technique' was invented by Coptic weavers in Egypt. When weaving patterned textiles they sometimes used a second ('flying') shuttle to carry a thin weft in a contrasting colour in order to add fine details to the design. This technique is not to be confused with the mechanical device invented by John Kay in England in 1733, known as Kay's Flying Shuttle, which greatly speeded hand-weaving and was crucial to the development of the Industrial Revolution.

HISPANO-MORESQUE: a style of art created in Muslim Spain during the 13th and 14th centuries. It is usually related to the decoration of ceramics but can be used as a general term to describe textiles produced in southern Spain and north-west Africa with similar designs.

IKAT: a fabric in which the pattern is resist-dyed on to the yarn before weaving begins. In Central Asian, Ottoman and Iranian ikats it is usual for only the warp threads to be dyed (warp ikat). In South-East Asia the weft threads are usually the ones dyed (weft ikat). In parts of India both the warp and the weft are dyed (double ikat).

JACQUARD LOOM: a mechanical loom invented by Joseph Marie Jacquard and first demonstrated in 1801 although not in

widespread use until several decades later. It simplified the process of weaving textiles with complex patterns by using a large number of cards with holes punched in them, laced together into a continuous belt, to control the individual threads.

LINEN: a strong thread obtained from the stalks of the flax plant *Linus simum*.

LINING: within a garment a lining, or inner layer of fabric, conceals the raw edges, loose threads and other construction details; it also makes it easier to slip the garment on and off.

MAMLUK EMBROIDERY: counted thread embroidery worked on linen, typically with blue silk thread, dating from the Mamluk dynasty in Egypt (1250–1517). Early pieces are worked in double running stitch and greatly influenced European embroidery in the 16th century. Later Mamluk pieces include pattern darning, which is worked with running stitches in a regular sequence to form simple repeating patterns (see Stitches).

METAL THREADS: metal threads are normally made from silver. A small bar of silver is drawn out and beaten and drawn out again, being pulled through a series of progressively smaller holes in an iron plate until the silver is about 2 mm in diameter. It is then pulled even more until it is so fine that it can be easily coiled into a spring-like wire or can be flattened and then wound around a silk thread. If a gold effect is required this is added to the silver in the final stages of drawing it out either by drawing it through a gold-coated hole (in which case the heat from the friction allows the silver to acquire a coating of gold) or by a chemical process (which is cheaper). Copper chemically plated with silver was sometimes used instead of pure silver in the late 19th and 20th centuries. There are several types of metallic thread used in weaving and in embroidery:
(a) metallic-wrapped threads – produced by professionals who wrap flattened metal strips around a silk (or more often in the late 19th century around cotton) thread. The colour of the core was selected to enhance the colour of the metal, so yellow threads were used for metal which had been gilded and white threads for metal which was silver. Dark yellow and orange silk threads were more often used towards the end of the 19th century;
(b) flattened metal strips, called 'plate';
(c) coiled wire – round or angular metal wires coiled into spring-like spirals, called 'purl';
(d) small flat discs with a central hole, known as 'spangles' or 'sequins'. Generally speaking, spangles are made from metal and sequins from other material such as glass or plastic.

MIHRAB: the arched niche in the wall of a mosque that indicates the *qibla*, the direction of the Ka'aba in Mecca and the direction that Muslims should face when praying.

MORDANT: a colourless substance which is applied to fibres to make them receptive to dyes. Common mordants include alum, tannic acid and urine, and metallic salts of chrome, iron, tin or copper. When the cloth is immersed in a dye bath, the colour reacts with the mordant and binds to the fibres. It is the mordant that is printed directly on to the cloth, not the dyes.

PLAIN WEAVE: this is the simplest and most common of the three basic weave structures (the others are satin and twill), with each warp thread passing over and under alternate wefts.

PLATE: see metal thread (b).

PURL: see metal thread (c).

RAYON: in 1884 a French count called Hilaire de Chardonnet created rayon, the first successful man-made fibre, from cellulose, a starch found in plants. In 1904 Samuel Courtauld & Co., English silk weavers, became interested in the process and bought the patents. Viscose rayon (also known as artificial silk or art silk) is the most versatile of all man-made fibres: the viscose process produces a continuous filament which can be spun and it can be bright or dull, it can be blended with any other fibre, it can be as soft as silk or as hard as sisal.

RESIST-DYEING: a resist agent, often wax or paste, is applied to parts of threads or woven fabric before they are immersed in a dye bath. The resist agent prevents these parts from taking the dye. The resist agent is then removed and by repeating this process a multi-coloured pattern can be created. See batik, ikat.

RESIST-PRINTING: a resist agent is printed on to fabric using a wooden block or an engraved roller.

ROCOCO: a decorative style that developed in France in the early 18th century and became very influential. It was graceful and playful, full of curves and asymmetry, emphasizing white and gold and lightness of touch.

ROLLER-PRINTING: a technique of printing using engraved metal rollers was patented in Britain in 1783. It allowed an entire length of fabric to be printed continuously. The maximum diameter of the rollers was about 76 cm, but they were often much smaller, meaning that the pattern they could print would always be small-scale.

SAFFRON: this is both a spice and a yellow dye obtained from the flower *Crocus sativus*.

SATIN: a weave that produces a smooth and apparently unbroken surface, which reflects lights well.

SCREEN PRINTING: based on the technique of stencilling, screen printing was introduced into commercial production in Europe in the 1920s as a hand process; it was automated in the 1950s and further improvements have been made. It now dominates the textile printing industry.

SILK: the continuous filament produced by the silkworm *Bombyx mori* to form its cocoon. It can be softened in hot water and reeled off; one cocoon may produce as much as a mile (1.6 km) of silk thread.

SPANGLE: see metal thread (d).

STITCHES:
Chain Stitch: a looped stitch made with a needle. It is a quick and easy way to create lines of pattern. See also Tambour, which is worked with a hook. See diagram 2.

Cross Stitch: this is usually worked as a counted thread stitch to build up blocks of pattern and create a solid and hard-wearing fabric with an equal amount of thread on the front and on the back. It may also be used free-hand to make lines or isolated motifs. See diagram 3.

Double Darning: this is a counted thread stitch characteristic of fine Ottoman embroideries; its Turkish name is '*pesent*'. By carefully counting the warp and weft threads over which the needle and embroidery thread pass, it is possible to achieve a double-sided embroidery in which both faces are identical. It is a very difficult technique to master. See diagram 4.

Double Running: this is a variation of the simplest of all embroidery and needlework stitches, Running Stitch. It is a counted thread stitch worked in two stages: first a line of running stitch is worked in which the spaces and the stitches are the same length; then the needle and thread are taken back along the line making stitches to fill the spaces. This results in a line of stitching which is the same on the back and on the front. It can be used to make delicate lines and is also the basis for Double Darning. See diagram 5.

French Knots: these require a little practice to perfect but are an effective way to add texture to an embroidery. They are often used to work the centre of flowers. See diagram 6.

Long and Short Stitch: this stitch, used mainly to embroider flowers and leaves, is an effective way to create subtle shading. Rows of alternating long and short stitches enable the embroiderer to blend changing tones and shades in order to model realistic, natural forms. See diagram 7.

Running Stitch: the simplest and easiest stitch to make, it is used in all sewing and is the most basic embroidery stitch. See diagram 8.

Satin Stitch: if this is worked carefully, so that the stitches are regular in length and are close together, the resulting surface will be smooth and unbroken and the reflected light will add a glowing sheen to the embroidery. See diagram 9.

Split Stitch: this is worked from left to right, with a long stitch forwards and a short stitch back with the needle splitting the working thread; it makes a fine, chain-like stitch. See diagram 10.

Surface Darning: a form of counted thread embroidery in which the thread travels over several warp and weft threads on the surface of the cloth and is taken under only one or two at intervals. This results in the vast majority of the embroidery thread remaining on the surface, where it forms the patterns; only small stitches can be seen on the reverse. See diagram 11.

TAMBOUR: the name derives from the rounded, drum-like embroidery frame on which the fabric would be stretched – in French the word for a drum is '*tambour*'. The embroidery thread is held underneath and an extremely fine hook is pushed through from the top to catch it; it is brought back to the top forming a loop and repetition of this action creates a continuous line of chain stitches. See also embroidery stitches, Chain Stitch, which is worked with a needle.

TAPESTRY: a technique of weaving a pattern in plain weave with coloured weft which does not pass continuously from one edge of the fabric to the other, but is worked backwards and forwards in small areas to create blocks of colour. In its simplest form this produces a small vertical slit between the differently coloured areas; these are often stitched together once the weaving has been completed. Slits can be avoided if the junction between the coloured threads is zigzagged, so that one warp thread is shared by two colours. This is called dovetailing.

TWILL: a weave that produces fine diagonal lines. It is a much more supple weave than plain weave and is often used when fabrics are required to drape. It is also the strongest of the three basic weaves and is often used when toughness and durability are needed (e.g. denim jeans are made from cotton twill).

TWILL TAPESTRY: see tapestry; twill is used instead of a plain weave structure, possibly because it drapes better.

VELVET: a pile fabric made by the warp and intrinsically the most expensive material on the market, both because of the quantity of silk used and because of the technique. A foundation warp has to bind the fabric and each pile warp thread is wound on to its own bobbin: this means that the loom itself is complex and expensive. Weaving is very slow because wires have to be inserted under the pile warp at the correct intervals; the wires are grooved, allowing the pile warp to be cut with a knife to produce the pile.

WARP: the threads entered in the loom before weaving begins; these run the length of the textile.

WEFT: the weft is carried on bobbins, normally within shuttles, and is passed by the weaver across the warp or across a section of the warp.

1. couching

2. chain stitch

3. cross stitch

4. double darning

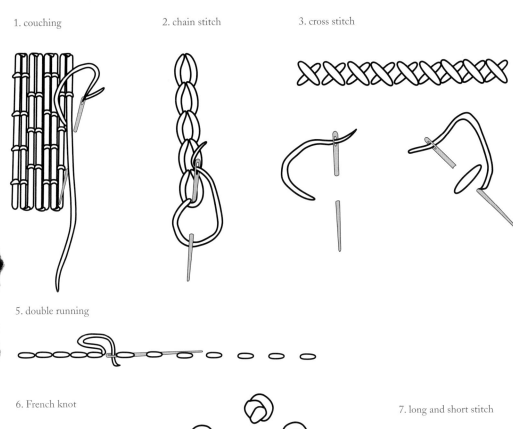

5. double running

6. French knot

7. long and short stitch

A B

11. surface darning

8. runnning stitch

9. satin stitch

10. split stitch

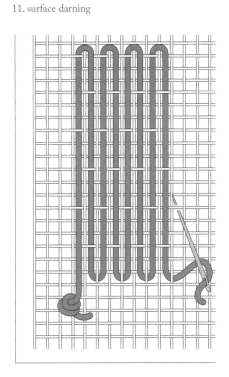

Index

In support of the revival of craft traditions in the Arab world